MANET'S
LE DEJEUNER SUR L'HERBE

Edouard Manet's controversial painting *Le Déjeuner sur l'herbe* is one of the best-known images in French art. The subject of critical analysis for more than a century, it still defies singular interpretations. This book offers six different readings of the painting. Based on new ideas about its context, production, meaning, and reception, these essays, written specially for this volume by leading scholars of French modern art, incorporate close examinations of the picture's radical style and novel subject, relevant historical developments, and archival material, as well as biographical evidence that prompts psychological inquiries. Shedding new light on the artist and the touchstone work of modernism, *Manet's "Le Déjeuner sur l'herbe"* also introduces readers to current methodologies in art history and to the multiple ways that this complex painting can be framed.

This series serves as a forum for the reassessment of important paintings in the Western tradition that span a period from the Renaissance to the twentieth century. Each volume focuses on a single work and includes an introduction outlining its general history, as well as a selection of essays that examine the work from a variety of methodological perspectives. Demonstrating how and why these paintings have such enduring value, the volumes also offer new insights into their meaning for contemporaries and their subsequent reception.

VOLUMES IN THE SERIES

Masaccio's "Trinity," edited by Rona Goffen, Rutgers University

Raphael's "School of Athens," edited by Marcia Hall, Temple University

Titian's "Venus of Urbino," edited by Rona Goffen, Rutgers University

Caravaggio's "Saint Paul," edited by Gail Feigenbaum

Rembrandt's "Bathsheba with David's Letter," edited by Ann Jensen Adams, University of California, Santa Barbara

David's "Death of Marat," edited by Will Vaughn and Helen Weston, University College, University of London

Manet's "Le Déjeuner sur l'Herbe," edited by Paul Hayes Tucker, University of Massachusetts Boston

Picasso's "Les Demoiselles d'Avignon," edited by Christopher Green, Courtauld Institute of Art, University of London

MANET'S
LE DEJEUNER SUR L'HERBE

Edited by

Paul Hayes Tucker

CAMBRIDGE
UNIVERSITY PRESS

PUBLISHED BY THE PRESS SYNDICATE OF THE UNIVERSITY OF CAMBRIDGE
The Pitt Building, Trumpington Street, Cambridge, CB2 1RP, United Kingdom

CAMBRIDGE UNIVERSITY PRESS
The Edinburgh Building, Cambridge CB2 2RU, United Kingdom
40 West 20th Street, New York, NY 10011-4211, USA
10 Stamford Road, Oakleigh, Melbourne 3166, Australia

© Cambridge University Press 1998

First published 1998

Printed in the United States of America

Typeset in Bembo

Library of Congress Cataloging-in-Publication Data

Manet's Le déjeuner sur l'herbe / edited by Paul Hayes Tucker.
 p. cm.
 Includes bibliographical references.
 ISBN 0-521-47466-3 (hardback: alk. paper). – ISBN 0-521-47984-3
(pbk.: alk. paper)
 1. Manet, Edouard,. 1832–1883. Luncheon on the grass. 2. Manet,
Edouard, 1832–1883 – Criticism and interpretation. 3. Female nude in
art. I. Tucker, Paul Hayes, 1950– .
 ND553.M43A72 1998
 759.4 – dc21 97-27062
 CIP

*A catalog record for this book is available from
the British Library.*

ISBN 0-521-47466-3 hardback
ISBN 0-521-47984-3 paperback

CONTENTS

ILLUSTRATIONS

ACKNOWLEDGMENTS

This book owes its initial inception and ultimate realization to Beatrice Rehl, who generously invited me to consider doing it back in 1994. Her patience during these many years, together with her humor, good will, and keen intelligence have been a source of inestimable comfort. Of course, the book could not have been written without the welcome cooperation of its contributors. In addition to the inordinate amount of time and effort they devoted to the project, they deserve my deepest gratitude for their endurance. I suspect, like myself, they may have thought it might not ever actually appear in print. I would like to thank William D. Tucker, Jr. and Bob Herbert, who read my essay and who have been constant touchstones for editorial clarity and breadth of thinking. I would like also like to express my appreciation to my devoted family – Maggie, Jonathan, and Jennie – who have been an enduring source of inspiration, stability, and joy. Finally, I dedicate this book to the individual who introduced me to the marvels of Manet some twenty-five years ago and whose wisdom, humanism, and infective love of looking led me to believe art history was a field I should consider exploring. Thank you, S. Lane Faison.

CONTRIBUTORS

PAUL HAYES TUCKER is professor of art history at the University of Massachusetts Boston. He is the author of *Monet at Argenteuil* (1982), *Monet in the 90s. The Series Paintings* (1990), *Richard Upton and the Rhetoric of Landscape* (1991), and *Claude Monet. Life and Art* (1995). He has written numerous articles, reviews, and chapters in books on nineteenth- and twentieth-century art and has organized many exhibitions, including *Monet in the 90s. The Series Paintings* (Boston-Chicago-London, 1990) and *Monet. A Retrospective* (Tokyo-Nagoya-Hiroshima, 1994). Currently, he is organizing an exhibition of Monet's work of the twentieth century (Boston-London, 1998) and of the Impressionists at Argenteuil (Washington-Hartford, 2000). He also is writing the catalogue of the French paintings in the Lehman Collection at the Metropolitan Museum of Art.

ANNE MCCAULEY is professor of art history at the University of Massachusetts Boston. She is the author of *A.A.E. Disdéri and the Carte de Visite Portrait Photograph* (1985), *Industrial Madness: Commercial Photography in Paris, 1848–1871* (1994), and many articles on nineteenth-century photography and caricature. She is currently preparing books on the historiography of photography and on Edward Steichen's career in France.

JOHN HOUSE is professor of the history of art at the Courtauld Institute of Art, University of London. He is the author of *Monet: Nature into Art* (1986) and was co-organizer of the *Post-Impression-*

ism exhibition at the Royal Academy of Arts (1979–80) and of the *Renoir* exhibition, Hayward Gallery, London, and the Museum of Fine Arts, Boston (1985–6), as well as guest curator of *Impressions of France* at the Hayward Gallery, London, and the Museum of Fine Arts, Boston (1995–6).

CAROL ARMSTRONG is associate professor of art history at the Graduate Center of the City University of New York. She is the author of *Odd Man Out: Readings of the Work and Reputation of Edgar Degas* (1991). She has just finished a book on nineteenth-century photographic illustration and has written numerous essays on Degas, Manet, and nineteenth- and twentieth-century photography. She is currently at work on a book on Manet.

NANCY LOCKE is assistant professor of art history at Wayne State University in Detroit where she teaches nineteenth- and twentieth-century art and theory. Her current research focuses on the figurative work of Cézanne and on representations of the body in Cubist sculpture. She is also completing a book entitled *Manet. A Family Romance.*

MARCIA POINTON is Pilkington Professor of History of Art at the University of Manchester. She has written extensively on British and French art of the eighteenth and nineteenth centuries, on portraiture, and on patronage and issues of gender in visual culture. Her recent publications include *Naked Authority: The Body in Western Painting 1830–1908* (1990); *The Body Imaged: The Human Form and Visual Culture since the Renaissance* (1993), edited with Kathleen Adler; *Hanging the Head: Portraiture and Social Formation in Eighteenth-Century England* (1993); and *Strategies for Showing: Women, Possession and Representation in English Visual Culture 1650–1800 (1997)*. She is currently engaged in research on the display of jewels and jewelry in early modern Europe.

PAUL HAYES TUCKER

MAKING SENSE OF EDOUARD MANET'S *LE DEJEUNER SUR L'HERBE*

In late summer 1959, some ninety-six years after Edouard Manet completed his ambitious painting depicting a group of contemporary men and women picnicking and bathing in a lush forest glade, Pablo Picasso began a series of variations on his elder's famous image (Figs. 1 and 2). It was hardly the first time the Spaniard had devoted his energies to reworking a specific Old Master painting; he had plundered the past for most of his career. In the fifteen years prior to his engagement with the *Déjeuner sur l'herbe,* he actually had done variations on nearly half a dozen major canvases, from Nicolas Poussin's *Triumph of Pan* of 1635 (National Gallery, London) and Eugène Delacroix's *Women of Algiers* of 1834 (Louvre, Paris) to Diego Velázquez's *Las Meninas* of 1656 (Prado, Madrid), producing no less than forty-five paintings of the latter alone.[1]

This "window opening" process, as Picasso called his practice, was prompted as much by Picasso's advancing years and his desire to measure himself against recognized masters as by his rightful sense of the importance of those paintings to their respective artists and the contributions those individuals made to the advancement of Western art. The paintings also often held specific meanings for Picasso, confirmed interests he had long expressed, and challenged him to rethink his aims as an artist, "to get behind the canvas," as he put it, in the hope that "something will happen."[2] The series devoted to Manet's *Déjeuner sur l'herbe,* or *Luncheon on the Grass,* while part of Picasso's personal campaign, would be decidedly dif-

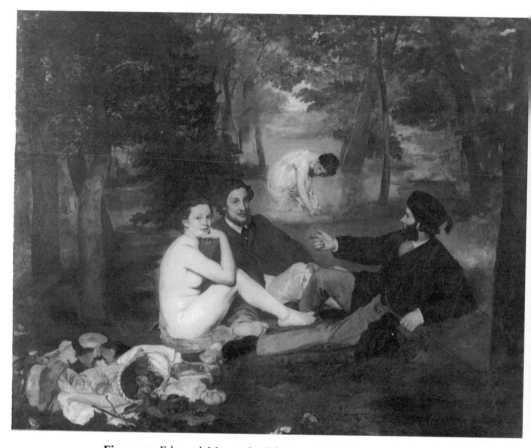

Figure 1. Edouard Manet, *Le Déjeuner sur l'herbe,* 1863. Musée d'Orsay, Paris. (Photo R.M.N.)

ferent, as Douglas Cooper sensitively pointed out shortly after Picasso completed it.

First, the group was enormous in size, totaling one hundred and fifty drawings, twenty-seven paintings, five concrete pieces of sculpture that were preceded by eighteen cardboard studies, several ceramic plaques, and three linoleum cuts. This constituted the single largest concentration of material prompted by any individual work of art that the twentieth-century master had ever produced.[3]

Picasso also devoted more time to this series than to any other; he worked on it off and on for more than three years in three dif-

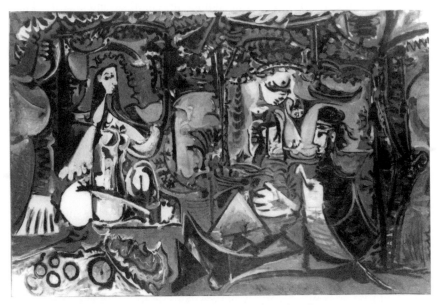

Figure 2. Pablo Picasso, *Le Déjeuner sur l'herbe after Manet,* Vauvenargues, March 3–August 22, 1960. Musée Picasso, Paris. (Photo R.M.N.)

ferent locations.[4] In addition, the group was more diverse than any previous ones. Besides employing different media, Picasso has the figures change clothing, appearance, and location; the landscape shifts, slides, and disappears; the accouterments – fruits, breads, canes, boats, and birds – are featured in some paintings and drawings and edited in others.

Most poignantly, perhaps, particularly for this volume of collected essays on Manet's picture, Picasso offers an unprecedented number of ways to interpret the original scene by devising variation after variation on the action Manet depicted. At one moment, the protagonists in Manet's reformulated picture are engaged in what appears to be a normal conversation; at another, they are embroiled in an interrogation or are admonishing one another. In some scenes, the women offer themselves to the viewer and their male companions; in others, they withdraw or become involved in forms of self-examination. Occasionally, all of the figures appear casual and relaxed, at other times, stiff and uneasy, at still others, blank-faced or terrorized. They vacillate between being humorous

and horrible, intimate and indifferent, childlike and mature. They also change identity – from bourgeois student to Jewish intellectual to arcadian shepherd to Grecian bard and from model to seductress to heroine to victim.

One could say that all of this has more to do with Picasso than with Manet. And in part that is correct. After all, it was Picasso who created the series, conceiving it both as an homage to an artist he admired (one who also had appreciated the art of Picasso's own Spanish past) and as a way to test his powers against a renowned figure. Given Picasso's competitive nature, the series also was a means to bury the achievement of his predecessor under the onslaught of Picasso's own inventiveness.

But for whatever it tells us about Picasso, the series affirms even more the incredible complexity of Manet's picture. For it clearly was the painting's insolence and enigmas, its historical resonance and aesthetic idiosyncrasies that pushed the aging twentieth-century artist to such iconographic and painterly extents, encouraging him to be as contradictory as he was consistent, as impenetrable as he was straightforward, just like his nineteenth-century counterpart.

It is precisely these dialectics – so typical of the modern age from Manet's moment to our own – as well as their relation to contemporaneous issues that have contributed to the iconic status of Manet's inimitable canvas.[5] That Picasso would have noted many of these oppositions – and suggested many more – is a sign of his keen sensitivity to Manet's intelligence and skill and to the *Déjeuner's* powers of suggestion.

His series, however, like Manet's painting, presents us with a host of unresolved questions because Picasso had little to say about the group. This is not surprising. The ever-evasive master was essentially confirming what Manet and his nineteenth-century avant-garde friends had often suggested: that the language of painting is funda-mentally different from most written or spoken forms, just as the artist's stylus or brush is not the same as the critic's keyboard or pen.[6]

The exclusivity of those tools, just like the mutual compulsion of most artists to let their art speak for itself, forces the historian to search for whatever meanings a painting like the *Déjeuner* may pos-sess in a variety of tangential, if not sometimes contradictory, realms, as the essays in this volume reveal.

This has always been the case. Writers in Manet's own day,

struggling to make sense of his baffling canvas, looked to a number of sources for assistance – contemporary art and events, past images and art-historical hierarchies, Manet's training or lack thereof, writings on the artist, friends' statements about the picture, Manet's own references to it.[7] Many of these authors may have felt they were privy to something that approached the truth – about the picture and their observations. Some of them knew the artist personally; others knew of him; most were at least vaguely familiar with his work. All of them lived at the same moment as he, in the same country and city. Many came from the same middle-class background if not the same Parisian neighborhood.

For all of their advantages – and they were considerable – these observers unfortunately prove to be only partially reliable guides. The meanings they found in the *Déjeuner,* the problems they felt compelled to enumerate, even the pleasures they derived from the picture or their reading about it depended as much on their point of view – or on their editor's – as on the painting itself. Dispassionate assessments were rare, if they existed at all. This may be self-evident to readers who are accustomed to divergent voices, but it is worth repeating, particularly in the late twentieth century when similacrum often poses for the real and differences easily evaporate in the homogenizing process of globalization. The comments of all of these contemporaries, therefore, while important grist for the mills of later historians, nonetheless cannot be taken at face value.[8]

The same must be said of statements made by or attributed to Manet himself. Like the critics, the artist and those who may have recorded his observations clearly were not unbiased observers. Manet in particular had a very specific agenda – to become one of the leading French painters of his day. To be sure, he did not hold exclusive title to that desire; every aspiring artist laid claim to it in one form or another, which meant the Parisian art world of Manet's day was nothing if not competitive, again not so dissimilar, in that respect at least, to the art centers of our time.

What then can we rely on to make sense of Manet's painting? The picture itself, one might think. But even here much remains unknown. We are not certain, for example, exactly when Manet began the canvas, where he painted it, or when he declared it finished. We don't know who all the models were, how he had the idea of posing one of them stark naked and the others in their own

worlds, seemingly oblivious to everything around them. We don't know how many preparatory works he may have done for the picture, what other works of art from his own hand or by others he may specifically have been thinking about as the picture evolved, or what relation he wanted to establish between this picture and others he planned to exhibit with it. We don't even know why he gave it the title he did; he originally called it *Le Bain,* or *The Bath,* not *Le Déjeuner sur l'herbe.*[9] Most surprising, perhaps, we have no assurances about the meaning of the picture. It offers us so many possibilities – just like Picasso's series – that it is virtually impossible to separate one from the others and declare it definitive.

It is, therefore, an ideal candidate for a book such as this, the timing of which also could not be better. That is because the ways in which we can understand Manet's painting have been increased in recent years by the happy expansion of art-historical inquiry to include methods derived from the criticism of other media, most notably literature and film, from gender and philosophical studies, and from more textured probes based on revised notions of the interrelation between history, biography, and the production of art. The following essays, all written exclusively for this volume by leading scholars of nineteenth-century art, were chosen to provide the reader with a sense of the discipline's present breadth and the range of opinions it can generate.

Limitations of time and space prevented the inclusion of many other voices; every project has its boundaries. This collection, therefore, does not claim to cover all of the problems the picture raises or represent all of the methods presently used by art historians. It thus does not pretend to be the last word on the subject. The number of things we do not know about the picture should be sufficient caution about the latter. Nonetheless, it is hoped that these essays prove to be sufficiently satisfying or, conversely, challenging – both individually and as a group – that they reap their rightful praises and prompt further probes of Manet's painting.

There is an obvious question, however, that should be posed before we turn to those discussions – namely, why have we singled out this particular picture? What makes it so important?

In order to answer these questions, we need to ask others. For example, did the painting mark a radical change in Manet's work or reorientate the evolution of modernist art? Did Manet invest so

much in it intellectually or emotionally that it provides us with unique access to his thinking as an artist? Was it sold for some fabulous amount of money like so many celebrated pictures today and thereby reveals something special about the passions or peculiarities of Manet's collectors? Or was it a painting that was rediscovered after a period of neglect and deemed worthy of attention on the basis of its obscurity or formal qualities?

The answer to all of these questions is no. The painting did not drastically affect the development of Manet's art or that of his modernist contemporaries. Manet did not endow it with the kind of emotional or intellectual weight that would make it the sole key to his mind-set (though it certainly tells us much about him). Nor did he sell it for any spectacular sum. In fact, it remained in his hands until 1878 when the opera singer and active collector of Impressionist art, Jules Faure, purchased it for 2,600 francs, a respectable price but far below the 25,000 francs that Manet had claimed to be the painting's value in 1871.[10]

Part of its claim to fame comes from the clamor it caused when it was first exhibited in Paris in 1863 – it attracted considerable attention from contemporary critics – and from the fact that it almost immediately became a touchstone for avant-garde painters; Claude Monet, for example, did a monumental version of the picture (Fig. 3) only twenty-four months after it appeared, cleansing the original of its nudity and ambiguities in an apparent effort to make it even more modern and believable. Paul Cézanne painted several variations on it shortly thereafter (Fig. 4), and Paul Gauguin revisited it for the most important painting of his career, *Where Do We Come From? Who Are We? Where Are We Going?* of 1897 (Fig. 5), which includes various references to Manet's picture, the most apparent being the Tahitian girl seated on the right who is based on the *Déjeuner's* foreground nude. Henri Matisse borrowed the picnic theme and the combination of clothed and nude figures for his *Luxe, Calme, et Volupté* of 1904–5 (Fig. 6), and Picasso exploited the foreground nude again for the masked female on the right in his groundbreaking *Les Demoiselles d'Avignon* of 1907 (Fig. 7). That Picasso would come back to Manet's picture nearly half a century later is ample testimony to its continuing powers and to the prodigious line of artistic responses that it produced.[11]

What attracted avant-garde artists to the picture and what made

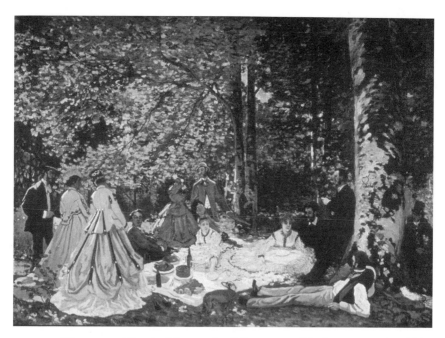

Figure 3. Claude Monet, *Le Déjeuner sur l'herbe,* 1865–6. Pushkin Museum, Moscow.

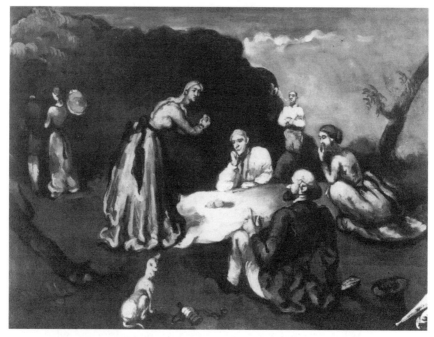

Figure 4. Paul Cézanne, *Le Déjeuner sur l'herbe,* c. 1870–71. Private collection, Neuilly-sur-Seine.

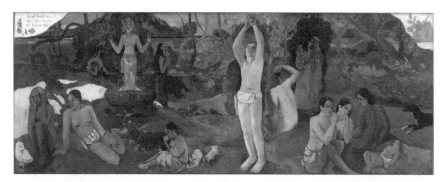

Figure 5. Paul Gauguin, *Where Do We Come From? Who Are We? Where Are We Going?*, 1897. Tompkins Collection. Courtesy, Museum of Fine Arts, Boston.

Figure 6. Henri Matisse, *Luxe, Calme, et Volupté,* 1904. Musée d'Orsay, Paris. (Photo R.M.N.)

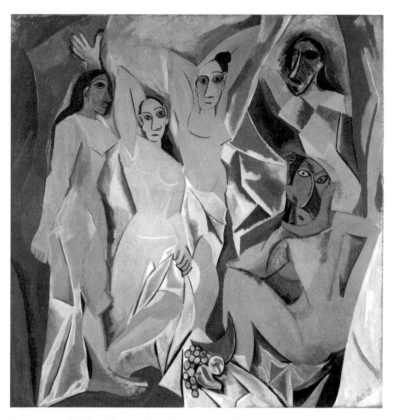

Figure 7. Pablo Picasso, *Les Demoiselles d'Avignon,* 1907. Museum of Modern Art, New York. Acquired through the Lillie P. Bliss Bequest. (Photo © 1998 The Museum of Modern Art, New York)

it so controversial when it was first exhibited are not necessarily what viewers today generally find so startling – namely, the boldness of the female figure who sits without a stitch of clothing on in front of us and her male companions and who has the audacity to stare at us in such a self-conscious, unflinching manner. She knows that we know she is naked. She also is fully aware that we are staring at her with the same directness that she foists upon us. This curious exchange makes most people feel slightly uneasy or at least a bit perplexed, particularly because Manet offers no clues as to what is occurring in the picture or what our relationship is supposed to be to the scene as a whole. Have we stumbled upon some

kind of intimate sexual encounter? Are we implicated in some way? Why does the woman look at us so unabashedly, and why are the men beside her so disengaged with her and each other?

Mystery does not make for immortality, however, just as it does not automatically elevate the mundane to the meaningful. For all of the interest these unresolved relationships can generate – one of the more astute critics in Manet's day could "not imagine what made an artist of intelligence and refinement select such an absurd composition" – they were not the only nor even the primary point of contention for Manet's contemporaries.[12] The power of Manet's painting then as well as now lies beyond these enigmas; it has something to do with that naked female, to be sure, but also with the size and subject of the painting, the way Manet conceived and executed it, the environment in which he wanted to display it, and the ways in which it relates to past precedents as well as to the art of Manet's time.

To appreciate the profundity of these issues, let us turn to the picture and those facts about it that we can more or less corroborate. First, it is large – 208 × 264 cm – and is painted on a twill woven canvas. The support was standard; the size was not. From the eighteenth century onward, canvases were available in standard sizes, from 21.6 × 16.2 cm or 8 × 6 inches up to 194.4 × 129.6 cm or 72 × 48 inches. They were all referred to by number; a number 10 canvas was 20 × 17 inches, a 20 was 27 × 22 inches, a 30 was 34 × 27 inches, and so on. By the 1840s, artists could purchase these canvases prestretched and primed. If an artist wanted a canvas larger than 194.4 × 129.6 cm or a number 120, it had to be specially ordered or stretched by hand in the artist's studio.[13] Given the expense of the labor and materials, it is unlikely that Manet would have had a fresh canvas this size on hand. It is reasonable to assume, therefore, that this was a custom affair, that the size of the final painting was determined long before Manet began work on it, and that its dimensions were dictated by the scene Manet had in mind.

It so happens the *Déjeuner* is about the same size that history painters frequently used for their re-creations of noble events. This was not a coincidence. Artists were not required to use specific formats for specific subjects, but they were expected to follow guidelines, and generally they did. Big canvases were reserved for subjects deemed important, which meant those drawn from history, religion, and mythology. More modest canvases were for subjects of

corresponding significance – that is, still lifes, portraits, genre paint-
ings, and landscapes – in other words, for subjects of lesser
standing.[14] Manet's choice reversed these norms because his scene
was decidedly lower on the hierarchy, but it was painted on a scale
that implied the opposite. That Manet elevated a commonplace
subject to a level it did not warrant is crucial to understanding his
picture because it underscores his knowledge of the contemporary
codes of artistic conduct and his determination to undermine at
least one of their basic premises. As we shall see, he was out to chal-
lenge many others as well.

The size of the painting attests to Manet's ambition not only in
relation to prevailing norms but also in terms of Manet's own
efforts; it was the largest painting he had attempted since entering
the profession in January 1850 as a student of the respected acade-
mician Thomas Couture. He clearly was out to make a name for
himself, though he may not have foreseen – or appreciated – the
notoriety that his name would earn him.

Some of Manet's contemporaries asserted that he could predict
the reactions his pictures would provoke and that he specifically
knew the *Déjeuner* would draw negative blasts even before he
began it. The primary source for these assertions is his boyhood
friend Antonin Proust, who became minister of the interior in
1870 and minister of fine arts in France in the early 1880s. In his
often cited memoirs, Proust describes a day when he and Manet
were lying on the banks of the Seine at Argenteuil, a suburb of
Paris, watching some boats under sail when they spotted women
bathing in the river, which made Manet think of the Italian
Renaissance artist Giorgione's painting *Pastoral Concert* (Fig. 8).
"When we were in [Couture's] studio," he apparently confided to
Proust, "I copied Giorgione's women, the women with musicians.
It's black that painting. The ground has come through. I want to re-
do it and to re-do it with a transparent atmosphere with people
like those you see over there. I know it's going to be attacked, but
they can say what they like."[15]

Whether Manet actually said this or not is difficult to deter-
mine. Proust is relatively reliable, but this combination of clairvoy-
ance and defiance smacks of the prejudice of the author and the
advantages of hindsight. It allowed Proust to trumpet his friend's
cunning and intelligence and to support his contention that the

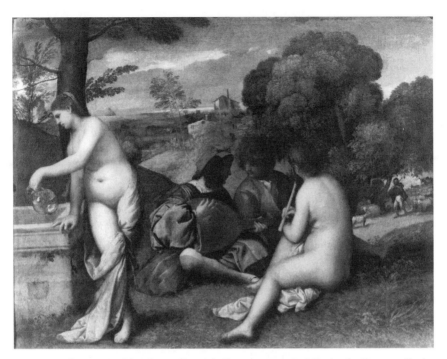

Figure 8. Giorgione, *Pastoral Concert,* c. 1508. Musée du Louvre, Paris. (Photo R.M.N.)

Déjeuner was uniformly criticized, which, as we shall see, it was not. To cast further doubt on the matter, Proust did not publish his memoirs until the 1890s, more than ten years after Manet's death and more than thirty after the supposed conversation. In addition, as even Edgar Degas pointed out in the 1890s, the *Déjeuner* does not have the kind of atmospheric effects that would lead one to believe it had been painted outdoors or inspired by the sight of women actually emerging from the Seine. It is a contrived, studio picture with the nude in the foreground for all she may represent acting like a model in an artist's atelier. Degas claimed Manet may have made this statement but only after seeing later paintings by his younger challenger Monet.[16]

Regardless of these discrepancies, the connections Proust made between the *Déjeuner* and Giorgione's painting are important and are ones Manet certainly must have made himself at some point

during the gestation of his picture, whether in Argenteuil or back in Paris. After all, the *Pastoral Concert* was one of the treasures of the Louvre, a museum Manet stalked. Moreover, Manet had already copied other celebrated works by Old Masters such as Titian, Velázquez, Tinteretto, and Rubens. And he had developed an interest in appropriating motifs from his predecessors' pictures for use in his own. He even had a copy of the Giorgione by his friend Henri Fantin-Latour hanging in his studio at the time. That he may have been interested in modernizing Giorgione's scene, therefore, would have been in keeping with his own interest and practice.[17]

The ultimate proof lies in Giorgione's picture, which shares an undeniable number of similarities with Manet's. The two males in the Giorgione, for example, are dressed in clothing typical of their day, as are the two in Manet's picture. They sit in an idyllic landscape like the lush setting Manet provides. The two seem equally unaware of the females in their company, which is all the more surprising since both are contrastingly naked. The primary figures in both pictures occupy their respective foregrounds, with the space behind them receding in planes that run parallel to the picture plane, enlivened by a similar scattering of strong lights and darks. Finally, Manet's canvas is linked to its antecedent by its size; it is almost exactly twice the height and length of Giorgione's – 208 × 264 cm versus 109 × 137 cm – suggesting Manet took his proportions from Giorgione but challenged his Venetian compatriot by enlarging the latter's scene by almost three and a half times its surface area.

The ambitiousness of Manet's enterprise – his desire to take on a recognized master of Renaissance art and to rework a famous painting in the Louvre on a scale he had never attempted before – was remarkable for an artist who was just beginning a public career. It also is a bit unusual given his less than auspicious debut. Although he spent more than six years in Couture's studio (January 1850 to February 1856) and then passed three years working independently in Paris with two trips to various countries in Europe thrown in (in 1853 and 1856), Manet did not openly test his mettle against his peers and his nation's artistic traditions until the end of the decade when he decided to enter the competition for the biannual Salon. The Salon was a state-sponsored exhibition held in the Palais de l'Industrie on the Champs-Elysées in Paris, near the present-day site of the Grand Palais.[18]

From those who ran it to those who read about it, this immense gathering of paintings, sculpture, prints, and drawings – it was intended to contain 2,000 to 5,000 works – was universally acknowledged as the most important venue in nineteenth-century France for established as well as aspiring artists. Those lucky enough to survive the scrutiny of the jury composed of their peers could demonstrate their talents, make a name for themselves, and perhaps attract collectors or commissions, thereby earn a living and call themselves professional. Thousands of people from all walks of life traipsed through the exhibition every day during its multimonth run. The numbers swelled five- to tenfold on Sundays, when the government eliminated the entry fee and admitted everyone without charge.

During the 1850s, thanks to the generosity of his parents, Manet was able to avoid this stringent system of judgment and supermarket-like display of work and devote himself exclusively to developing his art as a perennial student. His father had risen to a serious post in the Ministry of Justice in the 1830s and then had been appointed a judge in the Court of First Instance of the Seine in Paris. Between salary and investments, he had the means to support his eldest son's aspirations to become an artist despite his initial resistance to Manet's chosen profession. (He had hoped Edouard would follow him into the law.)

Perhaps in an effort to justify his decision to his parents, perhaps to confront the inevitable, Manet abandoned his student status in 1859 and presented one of his paintings to the Salon jury for the first time. Entitled *The Absinthe Drinker* (Fig. 9), the picture depicts a local ragpicker leaning rather tipsily against a stone wall in an undefined space. The painting was rejected without explanation, typical of the jury's proceedings. Manet reworked the painting twice later in his career, thus making it difficult to assess the jury's decision. However, its subject alone would have been grounds for dismissal because art in France was serious business. It was not a place for drunkards rendered on the scale Manet had achieved here, especially when his picture so strongly recalled the disturbing poetry of his contemporary and friend Charles Baudelaire.[19]

Manet's fortunes changed when he submitted two other paintings to the jury for the Salon of 1861, *The Spanish Singer* (Metropolitan Museum of Art, New York) and the *Portrait of M. and Mme. Auguste Manet* (Musée d'Orsay, Paris). Both were accepted. Again, this is not

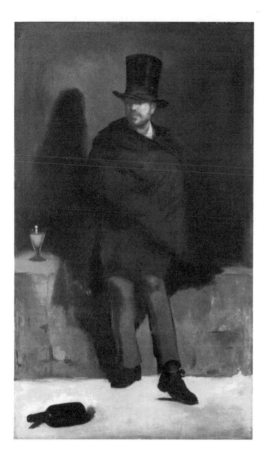

Figure 9. Edouard Manet, *The Absinthe Drinker,* 1859. Ny Carlsberg Glyptotek, Copenhagen. (Photo R.M.N.)

surprising because both display a greater degree of decorum. The brushwork in each is more restrained, the color more localized, the shading more gradual. In addition, the subjects, although undistinguished, at least are more palatable, the former appealing in particular to the vogue for things Spanish that swept Paris at the time.

Gaining admission to the Salon was triumph enough for the then twenty-nine-year-old artist, but Manet did even better; he received positive notices in the press for his submissions, and best of all, from the jury, an honorable mention for *The Spanish Singer.* This was a coveted award, particularly for an artist who was just starting out. It not only confirmed Manet's talent but it also portended a successful future.

The latter was not to be, at least not immediately, since the com-

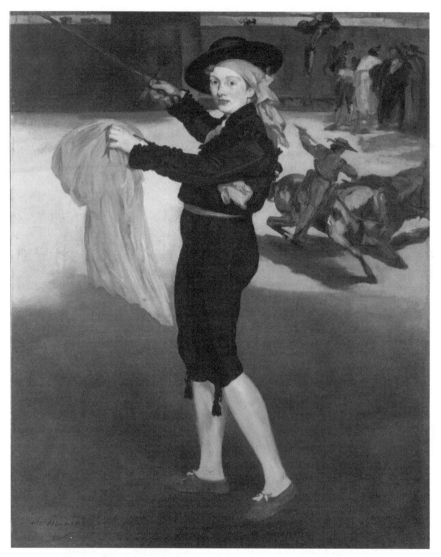

Figure 10. Edouard Manet, *Mlle. V . . . in the Costume of an Espada,* 1862. Metropolitan Museum of Art, New York. H. O. Havemeyer Collection. Bequest of Mrs. H. O. Havemeyer, 1929. (29.100.53)

bination of his achievements in 1861 undoubtedly led Manet to consider painting the *Déjeuner.* The canvas did not pass the jury when Manet submitted it in March 1863; nor did the two other paintings he offered for the jury's consideration – *Mlle. V . . . in the Costume of*

an Espada (Fig. 10) and *Young Man in the Costume of a Majo* (Metropolitan Museum of Art, New York.) This was a serious setback that must have disappointed the promising artist despite what he may have confided to Antonin Proust about the *Déjeuner.*

Manet was not the only painter to feel the pangs of rejection. The jury was especially severe that year and had refused to admit more than half of the nearly 5,000 canvases that had been submitted: 2,783 to be precise. This provoked such outrage among artists and critics that Napoleon III, Emperor of France since his coup d'état in 1851, himself announced the creation of a special exhibition that would be devoted to the rejected pictures. Artists who had been denied entry to the regular Salon could decide for themselves whether they wanted to participate in what soon became known as the Salon des Refusés; no jury would screen their resubmissions. Not every rejected artist took up the invitation, with good reason. There was the very real possibility that the public would agree with the official Salon jury, which would make the Refusés exhibition a double mockery for the participants.[20]

Several hundred artists accepted, however, Manet among them. He showed all three works that had been rejected, hanging the two costume pieces on either side of the *Déjeuner.* The trio attracted considerable attention, with most critics focusing upon the central canvas. Contrary to what is often written about these critics, they did not uniformly attack the picture. To be sure, they made plenty of disparaging remarks: "Not one detail has attained its exact and final form," railed Jules Castagnary, one of the more astute apologists for the realist movement.

> I see garments without feeling the anatomical structure which supports them and explains their movements. I see boneless figures and heads without skulls. I see whiskers made of two strips of black cloth that could have been glued to the cheeks. What else do I see? The artist's lack of conviction and sincerity.[21]

But there were many positive things said as well. One critic actually claimed Manet "will triumph one day, we do not doubt, over all the obstacles which he encounters, and we will be the first to applaud his success."[22] Even Castagnary felt Manet's pictures possessed "a certain verve in the colors, a certain freedom of touch which are in no way commonplace."[23]

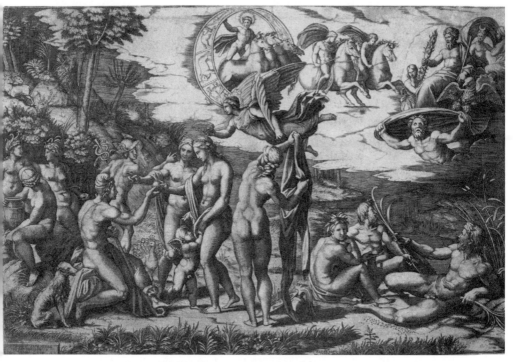

Figure 11. Marcantonio Raimondi, after Raphael, *Judgment of Paris,* c. 1475–before 1534. Bequest of Mrs. Horatio Greenough Curtis in memory of Horatio Greenough Curtis. Courtesy, Museum of Fine Arts, Boston.

Besides the relatively balanced reception the picture enjoyed, what is surprising is the fact that no critic noticed the now often cited appropriations that Manet had made from earlier art. The most rehearsed concerns Marcantonio Raimondi's engraving after Raphael's now lost *Judgment of Paris* (Fig. 11). In Manet's day, this print was widely considered to be Raimondi's best work and would have been known to Manet by its currency in artistic circles as well as from his own interest in graphics.[24] With characteristic deftness, Manet took the three figures in the lower right of Raphael's image – two river gods and a water nymph sitting by the marshes at the foot of Mount Ida during the mythical selection of the most beautiful woman in the world – and transposed them into the two Parisian men about town and their naked female compan-

ion. While retaining the general disposition of the classical figures, Manet not only altered their identities and poses but he also changed their trappings, attitudes, setting, and relationships, giving them greater individuality and presence than they possessed in the original. He maintained their enigma – they make no clear contribution to Raphael's story, nor do they appear to interact among themselves. At the same time, he injected plenty of wit into the scene, substituting the cane for the reed in the dandy's hand on the right, the overturned fruit basket and ribbon-wrapped bonnet for Athena's discarded helmet and shield, and the frog in the lower left corner – a symbol of lasciviousness as well as of France – for Raimondi's reference to Raphael directly below the seated nymph. (It was precisely this kind of imaginative plundering and recasting that must have appealed to Picasso.)

Scholars have offered a host of other artists and images as additional sources for the *Déjeuner*. Michael Fried, for example, has claimed that "Watteau's art presides over the conception of the *Déjeuner* as a whole" in an extended argument about the importance of French precedents for Manet's development.[25] Anne Hanson and Beatrice Farwell have rightfully pointed to lesser-known nineteenth-century painters and printmakers who produced Watteau-like subjects of picnics and outdoor revelry through the 1860s, thus diminishing Manet's reliance on a single eighteenth-century figure and at the same time emphasizing the importance of popular imagery and the social practices of Manet's own day.[26]

There is general consensus that Gustave Courbet was one of Manet's most significant touchstones for the *Déjeuner*. The champion of the palette knife and subjects drawn from real life, Courbet had often put the art of the past at the service of his own needs; he even pillaged the same Raimondi print twice before Manet had set upon it.[27] With good reason, therefore, his *Young Ladies on the Banks of the Seine (Summer)* of 1856–57 (Fig. 12) is often held up as an important antecedent for the *Déjeuner*.[28] It had stirred similar emotions when it was first exhibited at the Salon of 1857, primarily because of its scandalous subject matter – two working-class girls lying on the mossy edge of the river in quite unladylike poses. The one in the foreground has even doffed her dress; she stretches out on top of it, wearing nothing but her undergarments. As contemporaries noted, these women are of questionable repute, although it

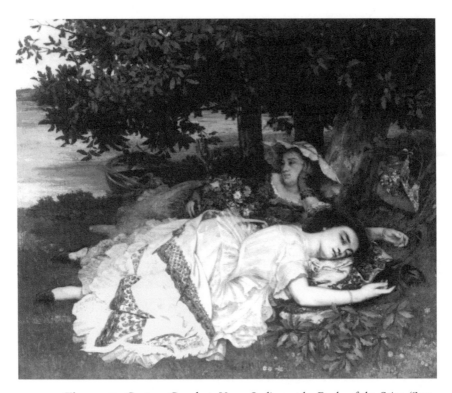

Figure 12. Gustave Courbet, *Young Ladies on the Banks of the Seine (Summer)*, 1856–7. Musée du Petit Palais, Paris. (Photo © Phototèque des Musées de laVille de Paris)

is not certain whether they are prostitutes or lesbians. They may even be both; their sense of mutual satisfaction is reflected in their languid bodies and bleary expressions, and the top hat in the boat laces the scene with the scent of a man. Manet has simply pushed beyond his elder colleague's initiatives, forcing, as Françoise Cachin has argued, in a more "impudent" fashion all of the issues Courbet had raised down to Manet's bolder application of paint and his audacity in depicting such a starkly nude figure.[29]

It is also quite possible that Courbet's *Hunt Picnic* of 1858 (Fig. 13) served as an additional precedent for Manet, as Linda Nochlin pointed out more than twenty-five years ago.[30] In addition to its own references to eighteenth-century prototypes, such as Carle van Loo's *Halt in the Hunt* (Musée du Louvre, Paris), which Manet would

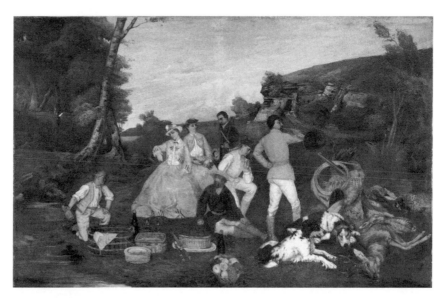

Figure 13. Gustave Courbet, *Hunt Picnic,* 1858. Wallraf-Richartz-Museum, Cologne.

have appreciated, Courbet's painting contains numerous details that reappear in Manet's scene. For example, there are the prominent still life elements in the foreground, the highly stylized poses of the figures, even the curious relationships that Courbet establishes between several of the protagonists – the central hunter with his elbow on his knee, for instance, who appears completely detached from the group as a whole, or the woman behind him to the left who seems to be reacting to the entreaties of the young wine steward by the river, unbeknownst to anyone else in the picture.

These and other details in the *Déjeuner* have been seen as deriving from other possible sources. Cachin, for example, has noted the correspondence between the picnic paraphernalia in the lower left of Manet's picture and the still life complete with similar basket that appears in the same location in Titian's *Virgin with a White Rabbit* (Louvre, Paris), a painting Manet copied in 1854.[31] Various scholars have pointed to the fact that the boat in the *Déjeuner* recalls the craft in Courbet's *Young Ladies on the Banks of the Seine (Summer)* and is reminiscent of the one in Manet's own *Fishing* of 1861 (Fig. 14).

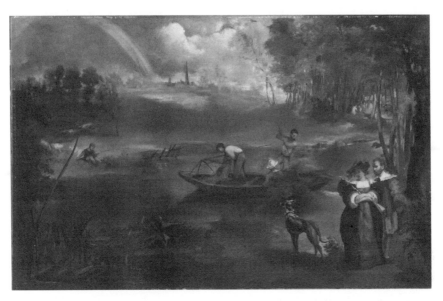

Figure 14. Edouard Manet, *Fishing,* c. 1861. Metropolitan Museum of Art, New York. Purchase, Mr. and Mrs. Richard J. Bernhard, Gift, 1957. (57.10)

They also have noted the similar pose of the bather in the *Déjeuner* and the bending fisherman in the center of Manet's *Fishing.*[32] That same bather has also been linked with the figure of Saint John in an engraving after a tapestry cartoon by Raphael, *The Miraculous Draught of the Fishes* of 1515 (Victoria and Albert Museum, London) as well with the wading woman in Watteau's now lost *The Village Girl.*[33] Wayne Andersen has drawn attention to the bird that appears in the top center of the *Déjeuner,* identifying it as a bullfinch, which symbolizes promiscuity and naturalness. In addition to complementing the general suggestiveness of the scene (much like the frog in the lower left, another symbol of lasciviousness), the bird, Andersen claims, may be poised to perch on the extended finger of the reclining figure on the right.[34] Finally, the female in the foreground is often seen as a more defiant, contemporary version of the biblical Suzanna, surprised during her bath by her lusty elders, a subject Manet had treated in *The Nymph Surprised,* likewise of 1861 (Museo Nacional de Bellas Artas, Buenos Aires).[35]

In addition to the world of art, the *Déjeuner* is firmly rooted in

Manet's personal biography. The landscape, for example, is generally assumed to recall the Ile Saint-Ouen up the Seine from his family's property at Gennevilliers. The female nude is recognizable from *The Nymph Surprised* as well as from many other paintings Manet executed during this early moment in his career. She was Victorine Meurent, Manet's favorite model, who, after the *Déjeuner,* would be transformed into Manet's equally renowned *Olympia* (Fig. 15).[36] The two male figures are also identifiable: the one on the right is based on Manet's two brothers, Eugène and Gustave, and the one in the center on the Dutch sculptor Ferdinand Leenhoff, brother of Manet's future wife Suzanne Leenhoff.[37] Thus, as Nancy Locke in this volume rightfully asserts, the painting is a kind of family portrait.

Physically, the painting yields other pertinent facts. From x-rays taken in the Louvre's conservation laboratories, for example, we know that Manet made numerous changes while painting the picture.[38] Victorine's discarded blue dress, for instance, lies on top of leaves that once littered the left side of the scene; her hair has been reworked, as have the trees on the left, their trunks swollen so they could act as more substantial foils to the similarly entangled figures. To set those figures off even more, Manet added the bush behind Victorine and Ferdinand; it covers the trunks of thinner trees along the river's edge while providing a darkened backdrop for Manet's models. The bush also breaks the band of water in the background, enhancing the discontinuities of the picture and the difficulties of determining if the pool to the right is on the same level as the water to the left.

Given the formal complexity of the picture, it is surprising that there are not more such changes or pentimenti. Manet must have meticulously prepared the painting with numerous drawings and sketches so that he knew exactly how to proceed. Curiously, however, none of those preliminary works have survived.[39]

This paucity would have played right into the hands of those critics at the Salon des Refusés who did not like the picture and whose biggest concern was Manet's apparent lack of forethought and skill. By this they meant that Manet did not plot out carefully enough all of the relationships in the picture – the placement of the foreground figures, for example, or the spatial recession in the scene that becomes quite implausible behind the trio. These critics also claimed that Manet did not control the paint with adequate rigor, that he frequently allowed too much paint to be on his brush

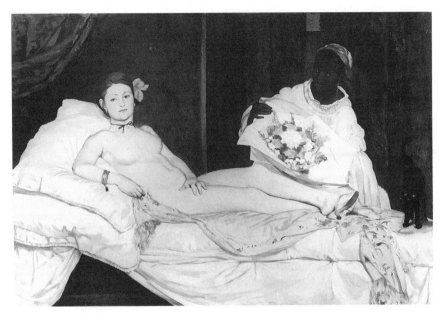

Figure 15. Edouard Manet, *Olympia,* 1863. Musée d'Orsay, Paris. (Photo R.M.N.)

at one time, resulting in a surface with caked or roughened areas. Moreover, Manet's "troweling" of his medium left too much evidence of the passage of the brush over the canvas. Restraint was supposed to be the operative method, not bravado.[40]

That is because the art of painting to the mid-nineteenth-century critic was predicated on illusionism; thus, impasto had to be minimized or put to the service of description, which meant the paint and the bristle marks had to be disguised or made synonymous with the contours of the form being evoked. In addition, wherever strong contrasts were not needed, transitions between light and shade had to be carefully modulated, with colors traversing the tonal scale at almost imperceptible gradations. Drawing also had to be clear and precise, not the broadly applied lines that crudely declared the edges of things in Manet's picture – the folds in Victorine's abdomen or neck, for example, or the fingers of her companion on the right.

The emphasis Manet places on these basic elements of art –

line, color, light, shade, surface, form, and space – was as intentional as his choice of subject. Indeed, he conjoined the two in order to draw attention to the fundamentals of his practice and his skill at manipulating them. To conservative observers, he appeared to be mocking or compromising long-held premises about painting. To more liberal contingents, he was boldly attempting to expand those norms, removing the veils of illusionism and revealing painting's ability to speak on many levels, just like the sister arts of poetry, music, drama, and literature.

This emphasis upon painting's capacities and on "art" in the broadest sense of the word was one of the subtexts of Giorgione's *Pastoral Concert,* just as it informed Raphael's *Judgment of Paris* – the former exploring the relative merits of poetry, the latter the eternal quest for beauty – which may explain some of their appeal for Manet.[41] But Manet seems to have had other issues in mind as well. For his painting was central to his ongoing project of making art that was beholden to his time. This meant not only choosing subjects that engaged modern life but also rendering those subjects in ways that befitted the complexity of his enterprise.[42] These dictates were not of his making; they had been initiated by romantic artists earlier in the century whose rallying cry *"il faut être de son temps"* – "it is necessary to be of one's time" – became the contemporaneous imperative of avant-garde French culture.[43] In literature, it gained formal expression in the novels of Honoré de Balzac and Gustave Flaubert; in drama, in the plays of Henri Murger; in poetry, in the verse of Charles Baudelaire; in music, in the songs of Jacques Offenbach; and in painting, in the canvases of Courbet.

Manet declared his allegiance to this project at the very beginning of his professional career as *The Absinthe Drinker* took its cues from this modernist credo. *The Spanish Singer* and the portrait of his parents continued that commitment, albeit in more tempered form, perhaps as a coy way to circumvent the jury and get in front of the public. But the *Déjeuner* sealed the pact as it cast serious doubts on notions of aesthetic decorum and parodied pictorial traditions that had been in place since the Renaissance.[44] Nothing appears to be sacred, fixed, or verifiable in the picture despite the palpitating presence of many of the elements. Even the fruit that spills out of the basket, while virtually three-dimensional, is totally incongruous – cherries ripen in June, figs in September.[45]

The problems the picture posed – about subject, style, and meaning – had their counterparts in the challenges French society itself was experiencing at the time. Those challenges were the result of monumental forces: the rise of industry and technology, major shifts in population, and the growth of urban areas, particularly Paris, which doubled in size between 1830 and 1850 and almost doubled again between 1850 and 1870. These changes profoundly altered people's perceptions of the world and of themselves, creating as much excitement as uneasiness, as much substance as veneer. What once had been relatively clear or comprehensible, stable or reassuring suddenly had the potential of becoming the opposite. Relationships, for example, roles and performances, spaces and definitions, class affiliations, even gender categories, all became surprisingly unstable as capital and mobility encouraged slippages and uncertainty, parody and confrontation while at the same time breeding opposite yearnings for order and conformity.

Manet's painting operated in this larger complex of competing ideologies and identities, a world in which truths collided with fictions and the past could be revered one moment and reviled the next. It is perhaps largely because of its immersion in this fluid, unpredictable moment that the painting so successfully defied definition. Its contradictions are its truths; its stubbornness and self-consciousness, its inventiveness and dexterity are the sources of the rage, puzzlement, and admiration it has provoked.

It therefore is not surprising that the following essays diverge so widely even though they take this one painting as their starting point. Like modern life, the *Déjeuner* is pluralistic and polemical, filled with contingencies yet appearing vivid, solemn, and self-sustaining, all of which makes it resistant to simple explanation. Thus, like the long line of protégés the painting has inspired, these essays remind us of the richness of Manet's achievement and the challenges that a single picture can continue to pose, especially one as smart as the *Déjeuner*. "Painting is a thing of intelligence," Picasso once said. "One sees it in Manet . . . in each of his brushstrokes."[46]

NOTES

1. On Picasso's *Déjeuner* series see Douglas Cooper, *Pablo Picasso. Les Déjeuners* (New York: Abrams, 1963); and Susan Grace Galassi, *Picasso's Variations on the Masters: Confrontations with the Past* (New York: Abrams, 1996), pp.

185–203. This campaign is also intelligently discussed by Klaus Gallwitz, *Picasso at 90* (New York: Putnam's, 1971); Jean Sutherland Boggs, "The Last Thirty Years," in Sir Roland Penrose, ed., *Picasso in Retrospect* (New York: Praeger, 1973); Mary Mathews Gedo, *Picasso. Art as Autobiography* (Chicago: University of Chicago Press, 1980), pp. 236–9; Marie-Laure Bernadac, "De Manet à Picasso, l'éternel retour," *Bonjour Monsieur Manet,* exhibition catalogue (Paris: Musée d'art moderne, Centre Georges Pompidou, 1983), pp. 33–46; Richard Wollheim, *Painting as an Art* (Princeton: Princeton University Press, 1987), pp. 244–8; Rosalind Krauss, "The Impulse to See," in Hal Foster, ed., *Visions and Visuality,* Dia Art Foundation Discussions in Contemporary Culture, No. 2 (Seattle: Bay Press, 1988), pp. 51–78.

On Picasso's engagement with other Old Masters, see Hélène Parmelin, "Picasso and Las Meninas," *Yale Review* 47 (June 1958), 578–88; Leo Steinberg, "The Algerian Women and Picasso at Large," *Other Criteria: Confrontations with Twentieth-Century Art* (New York: Oxford University Press, 1972), pp. 125–234; and John Anderson, "Faustus/Velásquez/Picasso," in Gert Schiff, ed., *Picasso in Perspective* (Englewood Cliffs, N.J.: Prentice-Hall, 1976), pp. 158–62; Marilyn McCully, ed., *A Picasso Anthology: Documents, Criticism, Reminiscences* (Princeton: Princeton University Press, 1982), pp. 247–58; Jannie L. Cohen, "Picasso's Explorations of Rembrandt's Art, 1967–1972," *Arts Magazine* 58 (October 1983), 119–27; Marie-Laure Bernadac, "Picasso: 1953–1972: Painting as Model," in *Late Picasso,* exhibition catalogue (London: Tate Gallery, 1988), pp. 49–94.

2. Cooper, as in note 1, pp. 32–3.

3. Picasso did fifteen paintings, two lithographs, nine etchings and aquatints, and some seventy drawings after Delacroix's *Women of Algiers* between December 1954 and April 1955. He completed the forty-five variations on Velásquez's painting between August and December 1957. Poussin's painting prompted just one version after France was liberated in 1944. Works by Cranach, Altdorfer, El Greco, Courbet, and Rembrandt all spawned equally modest responses – one or two paintings and a handful of drawings or prints for each executed between 1947 and 1960.

4. Technically, one could say Picasso's *Déjeuner* series began in 1954 when he painted four variations on Manet's picture between June 26 and 29 (Zervos 16, 316–19). It also could be argued that it did not end until the concrete sculptures were installed at the Moderna Museet in Stockholm in 1966. But the period of greatest activity were the three years between August 1959 when the drawings and paintings began in earnest and August 1962 when Picasso completed the maquettes for the pieces of sculpture. During this fertile moment, Picasso carried the project with him from Vauvenargues to la Californie to the mas de Mougins.

5. Manet's painting has always been central to an understanding of his

achievement and thus figures in all serious studies of the artist, the most important of which, in order of their publication, are Etienne Moreau-Nélaton, *Manet raconté par lui-même,* 2 vols. (Paris: H. Laurens, 1926); Adolphe Tabarant, *Manet et ses oeuvres* (Paris: Gallimard, 1941); Nils Gösta Sandblad, *Manet: Three Studies in Artistic Conception* (Lund: G. W. K. Gleerup, 1954); John Richardson, *Manet* (Oxford: Phaidon, 1967); Michael Fried, "Manet's Sources: Aspects of His Art 1859–1865," *Artforum* 7 (March 1969), 28–82; Theodore Reff, "Manet's Sources: A Critical Evaluation," *Artforum* 8 (September 1969), 40–8; George Mauner, *Manet peintre-philosophe: A Study of the Painter's Themes* (University Park: Pennsylvania State University Press, 1975); Anne Coffin Hanson, *Manet and the Modern Tradition* (New Haven: Yale University Press, 1977); Beatrice Farwell, *Manet and the Nude: A Study in the Iconology of the Second Empire* (New York: Garland, 1981); Theodore Reff, *Manet and Modern Paris,* exhibition catalogue (Washington, D.C.: National Gallery of Art, 1982); Françoise Cachin and Charles S. Moffett, *Manet 1832–1883,* exhibition catalogue (New York: Metropolitan Museum of Art, 1983); T. J. Clark, *The Painting of Modern Life: Paris in the Art of Manet and His Followers* (New York: Knopf, 1985); Kathleen Adler, *Manet* (Oxford: Phaidon, 1986); Juliet Wilson Bareau, *The Hidden Face of Manet,* exhibition catalogue (London: Courtauld Institute Galleries, 1986); Vivien Perutz, *Edouard Manet* (Lewisburg: Bucknell University Press, 1993); and Alan Krell, *Manet and the Painters of Contemporary Life* (London: Thames and Hudson, 1996).

Manet's work also has been the focus of serious attention in more general texts such as John Rewald, *The History of Impressionism,* 4th ed. (New York: Museum of Modern Art, 1973); H. W. Janson and Robert Rosenblum, *19th Century Art* (New York: Abrams, 1984); and Robert L. Herbert, *Impressionism. Art, Leisure, and Parisian Society* (New Haven: Yale University Press, 1988).

And it features in a number of important articles, including Linda Nochlin, "The Invention of the Avant-Garde in France 1830–1880," *Art News Annual* 34 (1968), 11–18; Wayne Andersen, "Manet and the Judgment of Paris," *Art News* 72, no. 2 (February 1973), 63–9; Eunice Lipton, "Manet: A Radicalized Female Imagery," *Artforum* 13 (March 1975), 48–53; Beatrice Farwell, "Manet's Bathers," *Arts Magazine* 54, no. 9 (May 1980), 124–33. For the best discussions of its critical reception see note 7 below. Also see the bibliography at the end of this volume.

6. Picasso made his contempt for critics clear in a conversation with Daniel Henry-Kahnweiler in Marilyn McCully, as in note 1, p. 252.

7. For the best discussions of contemporary writings on the *Déjeuner,* see McCauley in this volume; David Carrier, "Manet and His Interpreters," *Art History* 8 (September 1985), 320–35; Alan Krell, "Manet's 'Déjeuner sur l'herbe' in the 'Salon des Refusés': A Reappraisal," *Art Bulletin* 65

(June 1983), 316–20; and the groundbreaking study by George Heard Hamilton, *Manet and His Critics* (New Haven: Yale University Press, 1954).

8. It should be pointed out that visiting an exhibition in the nineteenth century was not a prerequisite to writing a review of the same show; nor was being an art expert considered obligatory. One of the sharpest observers of the Parisian art world in Manet's day, for example, was the poet and writer Charles Baudelaire, who had no formal art training and actually admitted to writing about works of art he had not seen.

9. Manet submitted the painting to the Salon des Refusés as *Le Bain.* He changed the title to *Le Déjeuner sur l'herbe* in 1867 when he included it in a one-man show he staged by the Pont d'Alma. It is likely that he changed the name to give the painting a more contemporary ring, perhaps in response to Monet's huge *Déjeuner sur l'herbe,* which remained unfinished at the time. It also may have become a title friends (and/or critics) had used for the picture. When Manet compiled an inventory of his studio in 1871, he listed the painting as *La Partie carrée,* or *The Party of Four.* The latter has a number of meanings, like the painting itself. Beyond indicating a social gathering of two men and two women, it suggests a parody of classical types in the manner of the popular contemporary songwriter Offenbach. It also had more base connotations as it was common parlance for sexual activity between consenting couples. On these meanings see Krell, as in note 5, pp. 33–4, and Cachin, as in note 5, p. 170; for the inventory of 1871 see Dennis Rouart and Daniel Wildenstein, *Edouard Manet: Catalogue Raisonné,* vol. 1 (Lausanne: Bibliothèque des Arts, 1975), p. 17.

 The fact that Manet's original title referred not to a picnic but to bathing helps to explain the figure in the river in the background and partly justifies the nude in the foreground. It also may have been a coy reference to Gustave Courbet's *Bathers* of 1853 (Musée Fabre, Montpellier), a painting that had caused a stir when it was first exhibited. The whole issue of nineteenth-century bathing practices and artists' depictions of them would benefit from further scholarly attention; happily, it is the subject of present research by Linda Nochlin. For earlier investigations of the issue see Eldon N. Van Liere, "Le Bain: The Theme of the Bather in Nineteenth Century French Painting," unpublished Ph.D. thesis, Indiana University, 1974; Eldon N. Van Liere, "Solutions to Dissolutions: The Bather in Nineteenth Century French Painting," *Arts Magazine* 54, no. 9 (May 1980), 104–14; and Farwell, as in note 5.

 The *Déjeuner's* original title adds some credence to Antonin Proust's suggestion that the painting was partly inspired by the sight of women bathing in the Seine at Argenteuil, although one should approach that suggestion with considerable skepticism. See note 15 in this chapter.

10. The painting remained in Faure's hands until 1898 when he sold it to
 Durand-Ruel for 20,000 francs, 5,000 francs less than Manet had origi-
 nally asked. The dealer sold it shortly thereafter to Etienne Moreau-
 Nélaton, who donated it to the nation in 1906. On the painting's
 provenance see Cachin, as in note 5, pp. 172–3, and Gary Tinterow and
 Henri Loyrette, *The Origins of Impressionism,* exhibition catalogue (New
 York: Metropolitan Museum of Art, 1994), p. 401. On Faure and Manet
 see Anthea Callen, "Faure and Manet," *Gazette des Beaux-Arts* 83 (March
 1974), 157–78.

 Manet's asking price was overly ambitious. One could buy Old Mas-
 ter paintings for that amount. It also was completely out of line with his
 own pricing system. Just a year or two before, he had asked 1,000 francs
 for *Boy Holding a Sword* and admitted he would let it go for 800 francs.
 (See Manet's letter to his dealer Louis Martinet of c. 1860–61/1863, as
 cited in Bareau, as in note 5, p. 29.) In addition, 25,000 francs had little
 relation to prices for paintings by contemporary French artists. Between
 1838 and 1857 the average price for a contemporary landscape painting
 was 1,432 francs, for a genre painting, 2,861, and for a history painting,
 6,637. (See Harrison C. White and Cynthia A. White, *Canvases and
 Careers. Institutional Change in the French Painting World* (Chicago: Univer-
 sity of Chicago Press, 1993), pp. 38–41. To be sure, prices for certain con-
 temporary works by sought-after artists could fetch more than 25,000
 francs, but they were the exceptions. Manet may well have wanted to
 place his picture on a par with such pinnacles as a sign of his competi-
 tiveness. It also may have been a more innocent, though no less telling,
 indication of how much he invested in the work.

11. On Matisse's interest in Manet see Pierre Schneider, *Matisse* (New York:
 Rizzoli, 1984), pp. 40–4. Gauguin copied Manet's *Olympia* in 1891 and
 carried a photograph of the painting with him to the South Seas, using it
 as a touchstone for many of his nudes of the 1890s; see Richard Brettell
 et al., *The Art of Paul Gauguin,* exhibition catalogue (Washington, D.C.:
 National Gallery of Art, 1988), pp. 202–3. Late in his life, Gauguin fondly
 remembered the compliment Manet paid him when "the master," as
 Gauguin referred to Manet, first saw his work; see *Paul Gauguin's Intimate
 Journals,* by Van Wyck Brooks trans. (New York: Liveright, 1949), p. 132.
 Cézanne was no less impressed with Manet and did variations on many
 of his works; see, for example, Lionello Venturi, *Cézanne, son art, son oeu-
 vre,* 2 vols. (Paris: Paul Rosenberg, 1936), #107, c. 1870 [private collec-
 tion]; #238, 1875 [Musée de l'Orangerie, Collection Jean Walter and Paul
 Guillaume]; and #377, 1877–82 [Collection Janet Traeger Salz, New
 York]; on Monet's huge picture see Joel Isaacson, *Monet: 'Le Déjeuner sur
 l'herbe'* (London: Penguin, 1972).

12. W. Bürger [Théophile Thoré], "Salon de 1863," *L'Indépendance belge*

(June 11, 1863); reprinted in his *Salons de W. Bürger,* 2 vols. (Paris: Librairie Internationale, 1870), vol. 1, p. 425, as cited and translated in Hamilton, as in note 7, p. 50.

13. On artists' materials in the nineteenth century see David Bomford et al., *Art in the Making. Impressionism,* exhibition catalogue (London: National Gallery of Art, 1990), especially pp. 44–7 for information about canvases. Also see Anthea Callen, *The Techniques of the Impressionists* (London: Orbis, 1982).

14. This association of size and subject matter dates back in France at least to the beginning of the French Academy in the seventeenth century just as the formulation of the hierarchies of what artists might paint was set down at the same time by André Félibien, among others. See Nikolaus Pevsner, *Academies of Art Past and Present* (Cambridge: Cambridge University Press, 1940), p. 95.

15. Antonin Proust, "Edouard Manet: Souvenirs," *La Revue blanche* (February–May 1897), pp. 171–2, reprinted in *Edouard Manet: Souvenirs* (Paris: A. Barthélemy, H. Laurens, 1913), p. 43. This often cited conversation has been vigorously questioned in recent time. See, for example, Perutz, as in note 5, p. 96, who rejects it as "nonsense." The first person to link the *Déjeuner* and Giorgione's picture was Manet's friend Zachaire Astruc in "Le Salon de 1863," *Le Salon de 1863, feuilleton quotidien,* no. 16 (May 20, 1863), 5. Also see the sensitive reading of the relationship between the two pictures offered by Meyer Schapiro in "The Apples of Cézanne," *Art News Annual* 34 (1968), 34–53; reprinted in Schapiro, *Modern Art, Nineteenth and Twentieth Centuries: Selected Papers* (New York: Braziller, 1978), pp. 1–38.

16. On Degas's comments see Daniel Halèvy, *Degas parle* (Paris: La Palatine, 1960), pp. 110–11, cited and translated in Mina Curtiss, *My Friend Degas* (Middletown, Conn.: Wesleyan University Press, 1964), p. 92; and Tinterow, as in note 10, p. 131. Proust's memoirs began in serial form in *La Revue blanche* (February–May 1897), pp. 125–35, 168–80, 201–7, 306–15, 413–24, and became a book in 1913. Manet died in 1883. Eunice Lipton was one of the first to emphasize the studio nature of the painting, especially the fact that we are forced to confront the nude figure in the foreground not as a representation of some mythological goddess but merely as a model posing for the artist. See Lipton, as in note 5. This reading of the painting has been amplified by Hanson, as in note 5, and rethought by McCauley and Armstrong in this volume.

17. On the Fantin copy see Perutz, as in note 5, p. 216, note 97. Hanson, as in note 5, pp. 75, 92–3, asserts that Venetian painting would have been seen by Manet's contemporaries as realistic. Thus, his remaking of Giorgione's painting with contemporary figures would have been appropriate not only for his personal interest in contemporaneity but also for the paint-

ing itself. Francis Haskell makes similar points in his review of the history of Giorgione's painting. See Francis Haskell, "Giorgione's 'Concert champêtre' and its Admirers," in *Past and Present in Art and Taste. Selected Essays* (New Haven: Yale University Press, 1987), pp. 141–52. Among the many nineteenth-century copies after the Giorgione, Haskell notes ones by Bonnat, Cabanel, Cézanne, and Degas, placing Manet and Fantin in appropriate company.

18. On the Salon see Patricia Mainardi, *The End of the Salon. Art and the State in the Early Third Republic* (Cambridge: Cambridge University Press, 1993); and Albert Boime, *The Academy and French Painting in the Nineteenth Century* (London: Phaidon, 1971). On Manet's student days see Jean Alazard, "Manet et Couture," *Gazette des Beaux-Arts* 35 (1949), 213–18. On Couture see Boime, *Thomas Couture and the Eclectic Vision* (New Haven and London: Yale University Press, 1980).

19. On *The Absinthe Drinker* see in particular Anne-Brigitte Fonsmarck, "'The Absinthe Drinker' – and Manet's Picture-making," *Copenhagen Papers in the History of Art* 2 (1987), 76–92; Ewa Lajer-Burchart, "Modernity and the Condition of Disguise: Manet's 'Absinthe Drinker'," *Art Journal* 45 (Spring 1985), 18–26; and Hanson, as in note 5, pp. 54–5, who suggests it was the picture's close connection with Baudelaire's verse that made Thomas Couture react so negatively to Manet's canvas. On Manet's relation to Baudelaire see Lois Boe and Frances Hyslop, "Baudelaire and Manet: A Reappraisal," in Lois Boe Hyslop, ed., *Baudelaire as a Love Poet and Other Essays* (University Park: Pennsylvania State Press, 1969), pp. 87–130. Hamilton, as in note 7, p. 30, first noted the connection of *The Absinthe Drinker* to Baudelaire's *Fleurs du mal*.

20. On the Salon des Refusés see Ian Dunlop, "The Salon des Refusés," in *The Shock of the New* (New York: American Heritage Press, 1972), pp. 10–53; Albert Boime, "The Salon des Refusés and the Evolution of Modern Art," *Art Quarterly* 32 (Winter 1969), 411–26; Rewald, as in note 5, pp. 69–92; and Daniel Wildenstein, "Le Salon des Refusés de 1863 – Catalogue et Documents," *Gazette des Beaux-Arts* 66, no. 1160 (September 1965), 125–52. The catalogue lists 687 works; the supplement, printed later, contains an additional 94, making a total of 781 entries. It is quite possible there were more given the timing of the event. There was at least one estimate of 1,500. See *La Revue artistique et littéraire* (May 1863), p. 247, as cited in Krell, as in note 7, p. 319.

21. Jules Castagnary, "Le Salon des Refusés," *L'Artiste* (August 15, 1863), p. 76, as cited and translated in Hamilton, as in note 7, p. 48.

22. Edouard Lockroy, "L'Exposition des refusés," *Le Courrier artistique* (May 16, 1863), p. 93, as cited in Krell, as in note 7, p. 318.

23. Castagnary, as in note 21.

24. On Raimondi's stature see Albert Boime, "Les Hommes d'affaires et les

arts en France au 19ème siècle," *Actes de la recherche en sciences sociales* no. 28 (June 1979), 62–3, cited in Cachin, as in note 5, p. 168. Also see Beatrice Farwell, "Manet's 'Espada' and Marcantonio," *Metropolitan Museum Journal* 2 (1969), 197–207. Ernest Chesneau recognized the reference to Raphael, but his insight did not appear until 1864. See Ernest Chesneau, "Le Salon des Refusés," in *L'Art et les artistes modernes en France et en Angleterre* (Paris: Didier, 1864), pp. 188–9. His book must not have circulated very widely or his observation given much credence because no one mentions the connection to Raphael until 1908. See Gustave Pauli, "Raphael und Manet," *Monatshefte für Kunstwissenschaft* 1 (January–February 1908), 53–5.

25. Fried, as in note 5. This essay has been reproduced in its entirety in Fried's recent book, *Manet's Modernism or, The Face of Painting in the 1860s* (Chicago: University of Chicago Press, 1996), which also contains Fried's reconsideration of his thesis as well as rejoinders to scholars who had critiqued it. Chief among the latter was Reff, as in note 5.

26. Hanson, as in note 5, pp. 94–5; Farwell, as in note 5; also see Farwell, *French Popular Lithography 1815–1870* (Chicago: University of Chicago Press, 1981).

27. Courbet appropriated the three contestants for Paris's apple for the three figures in *Young Ladies of the Village* of 1852 (City Art Gallery, Leeds), first noted by Theodore Reff, "Courbet and Manet," *Arts Magazine* 54 (March 1980), 98–103. He also used the figure of Athena (who has her back to us in the print) for the foreground woman in *The Bathers* of 1853 (Musée Fabre, Montpellier).

28. Fried, as in note 5, p. 43, was the first to point to Courbet's *Young Ladies on the Banks of the Seine (Summer)* as a touchstone; subsequent scholars have largely agreed.

29. Cachin, as in note 5, p. 168. On the scandalous nature of Courbet's picture see Sarah Faunce and Linda Nochlin, *Courbet Reconsidered,* exhibition catalogue (Brooklyn: Brooklyn Museum, 1988), pp. 133–4; Patricia Mainardi, "Gustave Courbet's Second Scandal: 'Les Demoiselles du Village'," *Arts Magazine* 53, no. 553 (January 1979), 95–103; Suzanne Kahn and Martine Ecalle, "Les Demoiselles des Bords de la Seine," *Bulletin de la Société des Amis de Gustave Courbet,* no. 19 (1957), 1–17; and Hélène Toussaint, *Gustave Courbet (1819–1871),* exhibition catalogue (Paris: Grand Palais, 1977), 126–9.

30. Linda Nochlin, *Realism* (Harmondsworth: Penguin, 1977), pp. 145–7. Also see Tinterow, as in note 10, pp. 128–9.

31. Cachin, as in note 5, p. 169.

32. On the ties to Manet's *Fishing* see Sandblad, as in note 5, and Anne Coffin Hanson, *Edouard Manet (1832–1883),* exhibition catalogue (Philadelphia: Philadelphia Museum of Art, 1966), pp. 47–9.

33. For the connection to "The Village Girl," see Fried, as in note 25; on the link to Raphael's *Miraculous Draught,* see Reff and Mauner, as in note 5.

34. Anderson, as in note 5.

35. On the *Nymph Surprised* see Rosalind E. Krauss, "Manet's 'Nymph Surprised'," *Burlington Magazine* 109 (November 1967), 622–7; and Beatrice Farwell, "Manet's 'Nymphe surprise'," *Burlington Magazine* 127 (April 1975), 224–9.

36. On the elusive Victorine Meurent see Eunice Lipton, *Alias Olympia. A Woman's Search for Manet's Notorious Model and Her Own Desire* (New York: Scribner's, 1992). On the association of the landscape with Saint-Ouen see Hanson, as in note 5, p. 94, and Cachin, as in note 5, p. 167. On the use of Saint-Ouen as the setting for other paintings see Hanson, as in note 31.

37. There had been a long-standing argument about which brother may have posed for the right-hand figure. Moreau-Nélation claimed it was Eugène; Tabarant said it was Gustave. Proust made the compromise and asserted it was a combination of the two. See Moreau-Nélaton, as in note 5, vol. 1, p. 49; Tabarant, as in note 5, p. 61; and Proust, as in note, 15, p. 172. The bathing figure remains unknown. Cachin says it may have been "Victorine again, or some composite figure," whereas Proust insists it was a young Jewish girl that Manet met on the street. See Cachin, as in note 5, p. 170, and Proust, as in note 5, p. 31.

38. The technical examination of the painting is thoroughly reviewed in Bareau, as in note 5.

39. A watercolor in the Ashmolean Museum, Oxford, was long thought to have been a preparatory drawing for the Orsay painting. See Rouart and Wildenstein, as in note 9. However, it is too close to the final version of the painting to have come before it. Bareau, as in note 5, proposed it may have been done between the Orsay canvas and the only other related work, a painting presently in the Courtauld Collection, London, that Manet gave to Hippolyte Lejosne. She also suggested that parts of it may have been traced from a photograph of the painting due to the stiff and awkward quality of the outlines of many of the elements in the scene.

Although the Courtauld painting also was once considered a study, it now is widely believed to be a copy done after the Orsay canvas. This opinion is based on x-rays of the Orsay picture first published by Bareau. They reveal that Manet made numerous changes while working on the picture. The Courtauld painting in contrast is set down without any alterations.

The Courtauld painting is not an exact replica of the Orsay version. The figures are not in precisely the same positions, the foliage varies, and certain details are different. Victorine's right foot, for example, is flatter on the ground and closer to the crotch of the figure on the right, whose

right hand, on the surface of the painting, touches his companion's jacket. This figure's left hand is bent at the wrist, is longer than its counterpart in the Orsay picture, and holds what seems to be draping gloves, which do not appear in the Paris version. The position of this figure's cane is also different; it overlaps his vest as opposed to his pants. In addition, his head is below the boat in the background. Finally, there are fewer cherries in the still life on the left, the silver flask is less prominent, the tree in the foreground on the right is shorter, and Victorine's hair is red.

Despite their number, these differences are relatively minor. They also are reasonable if the Courtauld version is understood to be a freehand rendering of the original. Arguing against the likelihood of it being a study is the fact that it follows the lines of the Orsay canvas too closely and, most tellingly, contains all of the changes Manet had devised for that version. On the Courtauld painting as a study see Paul Jamot, "The First Version of Manet's 'Déjeuner sur l'herbe'," *Burlington Magazine* 58, no. 339 (June 1931), 299–300; Douglas Cooper, *The Courtauld Collection. A Catalogue and Introduction with a Memoir of Samuel Courtauld by Anthony Blunt* (London: Athlone Press, 1954), no. 32; and Alan Bowness, "A Note on Manet's Compositional Difficulties," *Burlington Magazine* 103 (June 1961), 276–7. On it as a copy see Bareau, as in note 5, and *Impressionist and Post-Impressionist Masterpieces: The Courtauld Collection* (New Haven: Yale University Press, 1987), p. 36.

Henri Loyrette rather ingeniously suggested the Courtauld painting may have been a canvas in which Manet explored the changes he was contemplating for the Orsay picture. However, he also asserted that the painting could just as easily have come after the Orsay canvas, believing it more successfully integrates the figures in the landscape. See Tinterow, as in note 10, p. 402.

40. For some of these negative criticisms see Ernest Chesneau, "Salon de 1863," *Le Constitutionnel* (May 19, 1863); J. Graham [Arthur Stevens], "Un Etranger au Salon," *Le Figaro* (July 16, 1863), p. 3; and Adrien Paul, "Salon de 1863: Les Refusés," *Le Siècle* (July 19, 1863), p. 2. Paul in particular referred to the caked or slabbed surfaces of Manet's submissions and to the lack of nuances and range of shades; cited in Tinterow, as in note 10, p. 399, and in Krell, as in note 7, p. 317. Once again, as Krell points out, Manet's submissions prompted quite a number of positive responses. Even Stevens, despite his reservations, felt that Manet "will make enormous progress for the next Salon." Manet also was not the only artist singled out for criticism. His colleagues in the Salon des Refusés were the brunt of similar complaints. "Instead of looking for outlines which the Academy calls drawing," observed Théophile Thoré, "instead of slaving over details which those who admire classic art call finish, these painters

try to create an effect in its striking unity, without bothering about correct lines or minute details." See W. Bürger, as in note 12, cited and translated in Hamilton, as in note 7, p. 49.

41. On Giorgione's picture see Patricia Egan, "Poesia and the 'Fête Champêtre'," *Art Bulletin* 41 (1959), 302–13; and Schapiro, as in note 15.

42. Manet's modernist project was first articulated by Meyer Schapiro in "The Nature of Abstract Art," *Marxist Quarterly* 1 (January–March 1937), 77–98; reprinted in Schapiro, as in note 15, pp. 185–211. It subsequently has been the subject of numerous studies, the best of which include Clark, Crow, Hanson, Herbert, and Reff, 1982, as in note 5.

43. On *"il faut être de son temps"* see Nochlin, as in note 30, pp. 103–78. As one writer of the period noted, "L'oeuvre du romancier est donc peindre la vie comme elle est; il serait souverainement immoral et dangereux de la peindre autrement; ce serait induire en erreur une masse de lecteurs et conseiller implicitement l'hypocrisie." See Antonio Watripon, "De la moralité en matière d'art et de littérature," *Le présent* (August 16, 1857), p. 246, as quoted in part in Gabriel Weisberg, *The Realist Tradition: French Painting and Drawing 1830–1900,* exhibition catalogue, Cleveland Museum of Art (Bloomington: Indiana University Press, 1980), p. 125; and in Perutz, as in note 5, p. 210, note 10.

44. Sandblad, as in note 5, was the first to draw attention to the issue of parody in the *Déjeuner,* something Nochlin, as in note 5, took up with verve. More recently, this point is made by Cachin, as in note 5, pp. 170–2; and quite differently by Pointon in this volume.

45. Cachin, as in note 5, p. 169, was the first to point out this incongruity.

46. Picasso as quoted in Dore Ashton, ed., *Picasso on Art: A Selection of Views* (New York: Viking, 1972), p. 16.

SEX AND THE SALON
DEFINING ART AND
IMMORALITY IN 1863

"A history painter takes a nude woman, makes a portrait of her with a few modifications most often inspired by vague recollections of the Old Masters, and then says: 'It's a Venus!' Nothing of the sort: it's a model and nothing more. These paintings are only *académies.*"[1] With these words, written in his review of the 1863 Salon, Maxime Du Camp condemned the false pretensions not of Edouard Manet's *Le Bain* (or *Le Déjeuner sur l'herbe,* as it is now known), exhibited in the Salon des Refusés, but of Alexandre Cabanel's *Naissance de Vénus* [*Birth of Venus*] (Fig. 16) and Paul Baudry's *La Perle et la vague (Fable persane)* [*The Pearl and the Wave (Persian Fable)*] (Fig. 17). Du Camp's comments, like those of many other critics who decried the overly contemporary hairdos, body types, and alluring glances of nudes depicted in official Salon paintings, suggest that the current reputation of Manet's *Déjeuner* as a *succès de scandale* because of its shocking combination of two contemporaneously dressed males with two unclad and unidealized females both simplifies and misrepresents the critical climate surrounding the 1863 exhibitions. By isolating observations by Salon critics about this painting and by relying on later, primarily Third Republic, biographies of Manet, art historians have often failed to register the stylistic clichés and political and aesthetic agendas that underlay all critical and biographical writing. Furthermore, since the language of criticism participates in a field of *écriture,* ranging from philosophy to jokes, just as the pictorial imagery that it purportedly explains partakes of all preceding visual imagery, the pub-

Figure 16. Alexandre Cabanel, *Birth of Venus,* 1863. Musée d'Orsay, Paris. (Photo R.M.N.)

Figure 17. Paul Baudry, *The Pearl and the Wave (Persian Fable),* 1863. Museo del Prado, Madrid.

lished responses to Manet's painting can be understood only by probing what concepts such as ideal nude, Venus, and moral art meant to artists, censors, politicians, and novelists. At the heart of reactions to the double Salon of 1863 were current debates over

the lines between the aesthetic and the erotic. But underlying all condemnations of inappropriate pictorial representations were fears of social contagion, political anarchy, and moral decay that had been triggered by the Realist movement and the famous literary censorship trials of the 1850s.

That Manet's three paintings exhibited in the Salon des Refusés were discussed at all is a testimony to his already well-established ties to the world of petty journalists and aspiring *littérateurs* who generated such writing by the inch.[2] He had admittedly won a third-class medal in the 1861 Salon for his *Espagnol jouant de la guitare* [*Spanish Singer*] and had attracted the attention of the formidable critic Théophile Gautier, but his presence in the Paris art scene was recent and primarily confined to the circle around the unconventional poet Charles Baudelaire. As correspondence among critics and artists confirms, the production of Salon criticism was by no means the result of an innocent confrontation between writer and works, but a negotiated affair of mutual favors, requests by editors to feature certain artists, solicitations by artists, submissions of photographs to reviewers before the vernissage, and careful concessions to the recipients of imperial patronage.[3] As we shall see, most of the critics who mentioned Manet favorably had good reason to do so.

The single greatest determinant of whether or not a critic cited Manet was whether he or she discussed the controversial Salon des Refusés at all. Virtually none of the family, ladies, or illustrated magazines did so; neither did the Catholic press.[4] Serious journals such as the *Revue des Deux Mondes, Revue contemporaine, Le Correspondant,* and *La Revue de progrès* were also silent on the alternative exhibition. Coverage in the large Parisian dailies or weeklies was, however, much better. Although *Le Moniteur universel, Le Pays,* and *Le Temps* concentrated on the official exhibition, *Le Siècle, La Patrie, La France, La Gazette de France, L'Indépendance belge,* and *Le Constitutionnel* cited not only the Refusés show but also Manet. The art, comic, and entertainment press was fairly mixed, with Manet cited in *Le Théâtre, Le Petit Journal, Le Figaro, La Vie parisienne,* and *Le Courrier artistique.* The rare journals that featured discussions of paintings in the Refusés but did not cite Manet included the *Musées des familles,* the *Gazette des Beaux-Arts* (as we will see, an interesting omission), *L'Opinion nationale, L'Esprit publique,* and the *Revue française.*[5]

As Alan Krell has demonstrated,[6] the critical responses in 1863 to Manet's *Déjeuner* and his other paintings, when they appeared, were far from unfavorable. The most commonly lauded aspect was his technique of paint application, which was hailed as fresh, vigorous, young, lively, and individualistic. Zacharie Astruc, a Republican painter and critic who by 1863 was friends with the Realist champion Champfleury as well as younger artists such as Fantin-Latour, Legros, and Manet himself, wrote some of the most enthusiastic praise in the short-lived journal *Le Salon*.[7] This journal's support for Manet is understandable, since the previous year its publisher, Cadart, had underwritten the Société des Aquafortistes, of which Manet was a member.[8] Astruc's defense of the Refusés appeared only in the paper's last issue, published on May 20 after the prefecture of police had closed it down, ostensibly because the journal was sold near the sales area in the official Salon. In fact, as Astruc asserted, his journal was being persecuted because he had criticized Hippolyte Flandrin's official portrait of the Emperor in an earlier issue. His comments on Manet must be seen, then, as a parting shot at an oppressive artistic and political establishment, and he paints the artist as a victimized avant-gardist. Citing Manet's recent show in Louis Martinet's commercial gallery, Astruc praised the landscape in the *Déjeuner* as having "such a youthful and living character that Giorgione seems to have inspired it." No mention is made of the painting's puzzling subject.[9]

Second to Astruc in his promotion of Manet was Edouard Lockroy, another young Republican artist and writer who had fought with Garibaldi in Italy before becoming a war illustrator in the Middle East for *Le Monde illustré* and serving as Ernst Renan's artist during his researches in the Holy Land in 1861. Lockroy had just returned to Paris and joined the Saint-Simonian community at Ménilmontant when he began his journalistic career and reviewed the Salon for *Le Courrier artistique*.[10] The paper was predisposed to promote Manet, since it was the house organ for Martinet's gallery at 26, boulevard des Italiens, where Manet had exhibited since 1861 and had had a large show in March 1863.[11] While humorously noting that Manet had the talent to displease the jury, Lockroy added that he had many more abilities: "M. Manet has not said his last word. His paintings, whose qualities the public can't appreciate, are full of good intentions. We have no doubt that M. Manet will over-

come one day all the obstacles that he meets, and we will be the first to applaud his success."[12]

Continuing the tone of Astruc's and Lockroy's pieces, a writer for *Le Petit Journal,* using the pseudonym Le Capitaine Pompilius, characterized Manet as the victim of an unjust jury who possesses "frankness, conviction, power, universality, that is to say, the stuff of great art. He sees nature clearly and translates it simply, luminously."[13] This writer, who may be Baudelaire's and Courbet's friend Fernand Desnoyers (or his brother, Carle),[14] asserted that Manet's *Déjeuner* (which he identifies as *Baigneuses*), with its "male" and vigorous color, brings the countryside right onto the Salon wall. Tying the young painter to the tradition of Goya and Courbet, Desnoyers, like Lockroy, admitted that only the connoisseur could appreciate this "exceptional sketcher." His one caveat was that the work was still only a sketch and that Manet must develop his powers further.

The qualified comments by Desnoyers find their echoes in mixed reviews of the *Déjeuner* by Jules Castagnary, Arthur Stevens, Arthur Louvet, Adrien Paul, Louis Etienne, and Théophile Thoré. Castagnary, a long-standing friend of the Realists and of those artists who interpreted the everyday life of their time, noted the hubbub surrounding Manet's works and praised them as good sketches.[15] But he then criticized a certain flabbiness of painting, a loss of definition in the details of anatomy, an absence of what he termed "conviction and sincerity."[16] Arthur Stevens, the brother of the popular Belgian genre painter Alfred Stevens, writing for *Le Figaro,* a journal friendly to Manet, praised Manet's talents as a colorist but argued that he neglected form, drawing, and modeling: in the *Déjeuner* there were vigorous blacks and "air," but "relief was absolutely lacking."[17] Thoré, Paul, and Louvet likewise commended the energetic facture and qualities of color, light, and air in the *Déjeuner'*s landscape background but found fault with particular aspects of the painting, such as the evenness of strokes with which all objects were treated.[18] Manet's "quick and lively manner" also pleased Etienne, who published a brochure defending the Salon des Refusés.[19]

These writers, who appreciated Manet's technique, and many of those who saw nothing of value in Manet's submissions, nonetheless were confused or amused when they confronted his choice of subject in the *Déjeuner.* Etienne dubbed the painting a *"logogriphe,"*

or word puzzle, and described its foreground female as "a Bréda of some sort, as nude as possible, lolling boldly between two swells dressed to the teeth. These two persons look like high school students ('*collégiens*') on holiday, committing a great sin to prove their manhood."[20] Stevens likewise apologized that he "could not explain what the painting was trying to say."[21] Paul described the scene as two students chatting with "the most vulgar nude woman" who at first looks as though she's been robbed of her clothes, but "no, her clothes are there, two steps from her, and she doesn't seem to even think of them. She struts, chatting calmly about the Closerie de Lilas [a popular dancehall and restaurant], at which she must be less an ornament than a fright."[22] For Didier de Monchaux, the subject was "fairly scabrous";[23] for Louvet, the foreground woman was "pointed, angular, without modeling. . . . What a strange fantasy to undress completely the woman who is seated on the grass and to leave the shift on the one who is bathing."[24] Thoré found the nude female ugly, the subject "very risqué," but reserved his venom for the reclining male on the right "who doesn't even have the idea to take off his horrible padded hat outdoors . . . it's the contrast of such an antipathetic animal to the character of a pastoral scene, with this undraped bather, that is shocking."[25]

Perhaps the critic who was most offended by the indecency of the picture was Philip Hamerton, an aspiring English painter and etcher writing for the *Fine Arts Quarterly* whose sympathies lay with the photographic detail of the Pre-Raphaelites rather than with the crass realism of the new French school.[26] Recognizing the *Déjeuner*'s similarities to Giorgione's *Pastoral Concert,* whose dubious morality he felt was "pardoned for the sake of its fine colour," Hamerton found Manet's "modern French Realism" offensive in its contemporary dress and situation. In a burst of what might be written off as Anglo-Saxon puritanism, Hamerton dismissed Manet's and other Realist works "in the same class, which lead to the inference that the nude, when painted by vulgar men, is inevitably indecent."[27]

Underlying many responses to Manet's submissions to the Salon was the belief that the artist had purposefully tried to scandalize the public with his outlandish color, sloppy finish, and incomprehensible subjects. Ernest Chesneau remarked that Manet would possess taste "the day he renounces subjects chosen to scandalize."[28] The

implication was, of course, that the critic was onto Manet's game and was not, in fact, outraged. Even though Manet's painting showed nude women next to dressed men in a situation that was certainly foreign to respectable bourgeois behavior, the figures' failure to interact with one another and the women's lack of coy gestures and glances did not identify the male viewer as either a passive voyeur or an active consort. The painting in that sense remained "chaste," inspiring laughter perhaps but not moral offense. The laughter may have hidden a certain anxiety about the meaning of the picture and its ambiguous sexuality, but the act of laughing repressed or sublimated sexual tension and made it unthreatening (one cannot presumably laugh at a nude woman and feel sexual desire for her at the same time).

Even within the Salon des Refusés, Manet's painting was not always considered the most immoral. That prize was shared with Rodolphe Julian, a twenty-three-year-old debutant who was a student of Alexandre Cabanel and Léon Cogniet. Better known today for the long-lived private painting academy that he founded after the Franco-Prussian War, Julian exhibited three works, including *Le Lever* [*The Awakening*], a view of a couple greeting the dawn after a night of love.[29] Inspired by Alfred de Musset's famous poem *Rolla,* the painting, like all of Julian's early works, has disappeared, but it can be recognized in a caricature of the Refusés just above Manet's *Déjeuner* (to the left of the foot of the Polichinelle judge [Fig. 18]). Girard de Rialle called it the "succès fou" of the Refusés and said that it had been rejected because of the eccentric pose of the woman. Like the figures in Manet's large painting, Julian's were dubbed vulgar: "This woman seems to be dirty; she is covered with black spots on a skin that is already too dark to be feminine."[30] Louvet, who was generally sympathetic to the Refusés, cited "this noisy joke that draws us to Julian's *The Awakening.* I don't know how to talk about it with decency." He added that "the legs, the back, the feet (ah! the feet!), finally all the hideousness that this Andalusian of the Faubourg-St. Marceau offers for sale are painted with a hitherto unknown color, and that we would dub, if you will, the belly of a coalman."[31] The references to prostitution and vulgarity that surface in writing on Manet are echoed here.

Positive comments also mark Julian as someone to watch in the future. Louis Enault, who didn't mention Manet, said the public

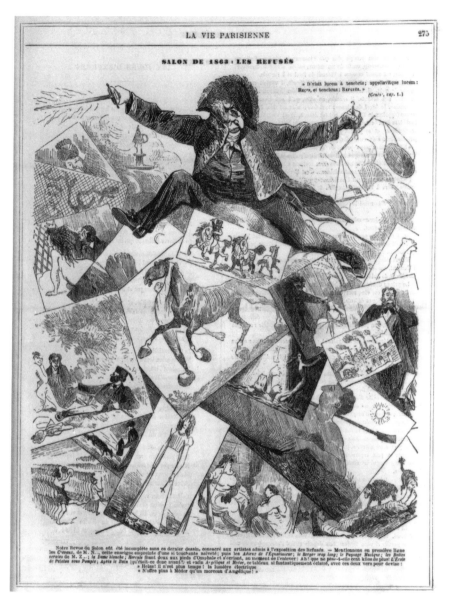

Figure 18. Marcellin, *Salon de 1863: Les Refusés,* from *La Vie parisienne* (July 11, 1863), p. 275.

laughed at Julian, but that he perceived the germ of a painter and a colorist in his work.[32] Thoré commented that *The Awakening* showed a nude getting up next to a dressed man and that the work, despite its tasteless composition, was broadly painted from life.[33] Unlike Manet, however, Julian was willing to compromise with the jury in order to win acceptance. On April 17 he had written the administration volunteering to paint a drapery around his female nude to modify her indecency.[34] The administration apparently ignored this request, and the work was relegated to the Salon des Refusés.

In contrast to the flutter of reproaches inspired by Julian and Manet's mixtures of undressed females and dressed males, the two "official" Venuses by Cabanel and Baudry prompted long-winded discussions of the immorality of the current age and the inappropriate arousal of sexual desire in high culture.[35] Prior to the public opening of the Salon, Napoleon III had purchased the Baudry, and the Empress had paid a reported 40,000 francs for the Cabanel.[36] The two painters, both former Prix de Rome winners, were already identified with the Bonapartist regime. Attacks on them may be read as indirect stabs at the Emperor and his court, whose sexual intrigues were avidly discussed at dinner parties even though they could not surface in the censored press until the Commune, when they became explicit in countless scurrilous caricatures.

The overwhelming presence of nude female flesh in the 1863 Salon struck most critics and visitors, causing Gautier to dub it the "Salon des Vénuses." As is documented in a two-page caricature by Marcellin in the June 13 issue of *La Vie parisienne* (Fig. 19), in addition to Cabanel and Baudry (see nos. 316 and 91), Amaury-Duval, Meynier, and Briguiboul submitted Venuses, while Appert, Bouguereau, Lansac, Monvoisin, Schutzenberger, Mazerolles, Ehrmann, and Blin, among others, introduced nudes in mythological, bathing, and biblical scenes. Since most of these genres of painting were high on the academic scale of importance, reviewers who used subject matter as an organizing principle started with Cabanel and Baudry and then ranked the other nudes in descending order of success.

Writers who wanted to stay in the good graces of the court and to defend the time-honored tradition of the juried Salon accepted Cabanel's *Birth of Venus* and Baudry's *The Pearl and the Wave (Persian Fable)* (normally considered a Venus despite its fabricated reference

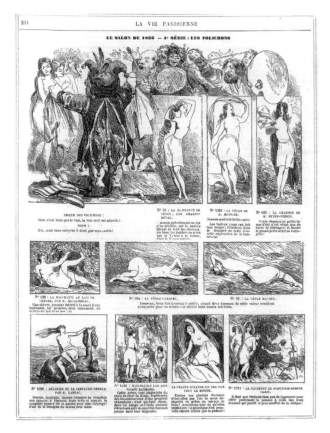

Figure 19. Marcellin, *Le Salon de 1863 — 4e Série: Les Foli-chons,* from *La Vie parisienne* (June 13, 1863), p. 231.

to an Orientalist source) as models of feminine beauty and idealized art. The only debate was over which of these works (or, rarely, the other Venuses in the Salon) was the more successful. The Cabanel was generally acclaimed as more idealized, better drawn, and more classically "chaste," whereas the Baudry was commended for its luscious Venetian color and more unctuous paint application. Most critics acknowledged that both so-called Venuses were creatures of love who cast seductive glances. Hamerton, who had chided Manet for indecency, waxed eloquent over Cabanel's dazzling goddess: "The form is wildly voluptuous, the utmost extremities participating in a kind of rhythmical, musical motion. The soft

sleepy eyes just opened to the light are beaming with latent pas-
sions; and there is a half childish, half womanly waywardness in the
playful tossing of the white arms."[37] He did not, however, condemn
this figure. The half-opened eyes also attracted Didier de Mon-
chaux, who claimed that they successfully expressed the idea of the
birth of life: Cabanel was a spiritualist, and "one can look at his
Venus without a bad impression."[38]

Baudry won the laurels from critics who were more "progres-
sive" – in their advocacy of color over line – and, in some cases, had
even found value in Manet. Leading the reader through a verbal
stroke down the various parts of the model's body, Gautier extolled
the return of artists to beauty as their main subject and favored the
serpentine line and "adorable femininity" of Baudry's figure, whose
prepubescent smile contrasted with her body "showing the signs of
love."[39] Astruc added a footnote to his supplementary issue on the
Salon des Refusés, stating that he particularly regretted not being
able to discuss Baudry's "siren with a mysterious body whose head
beamed and terminated with a troubling and fantastic twist."[40] The
Manet defender Lockroy admired Baudry's ability to combine indi-
viduality with classical beauty and dubbed him a "modern Athen-
ian." Unlike Cabanel's Venus, whom Lockroy found too clean and
pristine, Baudry's girl was a "pretty, abandoned child."[41] Tellingly,
defenders of both Cabanel and Baudry projected "childlike" quali-
ties of innocence on the nudes' expressions and body types in an
effort to argue for the paintings' morality.[42]

The most violent criticism of the prominent display of nudity in
the Salon came from two opposing camps that shared a disapproval
of the Emperor: the first was those Republicans, Orleanists, and lib-
erals who had been censored during the 1850s and were part of the
Bonapartist opposition; the second was the Catholic right, who felt
that the Emperor's Italian policy had not been supportive of Pope
Pius IX. To represent the first category, we can return to the Salon
criticism of Du Camp, with which we began this essay. Du Camp, a
defender of Realism and the poetry of industry in 1855 whose jour-
nal, *La Revue de Paris,* had been closed down in December 1856 for
publishing the first installments of Flaubert's *Madame Bovary,*[43] was
writing his first Salon criticism for the Orleanist *Revue des Deux
Mondes* in 1863.[44] He rather self-righteously argued that "one of the
first qualities, perhaps the principal, of art is chastity. Titian's Venus,

Correggio's Danae, Raphael's Galatea are chaste. . . . They are god-
desses and they have none of the provocations of women." In con-
trast to the Venus de Milo, which is admired first as a form and only
later recognized as a woman, he felt that the nudes of his day should
be banished to an Oriental harem:

> They have nothing to do with our tormented life, where
> woman has her great and beautiful function to fulfill. If she's
> temptation and voluptuousness, she's Delilah and Omphale. If
> she's rewards and shared duties, she's the woman of our time. To
> these Venuses who have been painted with such ease, we can cry
> Heine's anathema: "You are only a goddess of death, Venus Lib-
> ertine!" for they are less than courtesans.[45]

Cabanel's figure, according to Du Camp, was only a pretext: "His
Venus isn't being born, she is revealing herself. . . . To justly appreci-
ate this work . . . you must see it in its true milieu, at a ball, at that
moment of intoxication that music, perfume, and dancing create."[46]
Likewise, Baudry's *The Pearl* was not a real subject: remove the shell
and you have "a woman, and in what a posture! with what a
glance!"[47] In conclusion, Du Camp mused that "the nude ceases to
be honest when it is treated in such a way as to intentionally exag-
gerate certain forms at the expense of others and is forced to pro-
duce an impression totally different from that of beauty."[48]

Similarly, Stevens, Castagnary, and Thoré condemned the official
paintings as immoral. Stevens, echoing Du Camp, wrote that "the
morality of this Salon I find in the success of the Cabanels and
Baudrys, and I cry with my compatriot Shakespeare, 'Sad! Sad!
Sad!'" The Cabanel, he moaned, was not heroic but erotic art: "one
step more and we would fall into works destined to charm the last
days of an old habitué of the Opera or excite the precociousness of
collégiens."[49] Castagnary, a writer opposed to the regime, called
Baudry's work a "Venus of the boudoir . . . the pretty woman with
her look of a Parisian dressmaker would be better on a sofa."[50] Fur-
ther associating these Venuses with prostitution, Thoré proclaimed
that not only did they lack reality but they were bloodless phan-
toms who could be made into "colored lithographs for the small
boudoirs of the rue Bréda."[51]

Although not writing a Salon review, the philosopher and for-
mer political exile P. J. Proudhon most explicitly associated the

eroticism of the 1863 Salon with the social decay that he felt was encouraged by the Empire. In his posthumously published *Du principe de l'art,* in which he defended Courbet's anticlerical *Retour de la conférence* [*Return from the Conference*] (a painting excluded even from the Refusés), Proudhon described his visit to the Salon:

> [T]here was in a room, in the place of honor, a figure of a nude woman [Baudry's *The Pearl*], reclining and seen from the back, that I assumed was a Venus Callipyge. While exhibiting her shoulders, supple waist, and rich locks, this Venus, by an effort of will, turned her head to the viewer: blue, naughty eyes like those of Love, a provocative face, a voluptuous smile. She seemed to say, like the streetwalkers on the boulevard, do you want to come see me?[52]

This was art that served no uplifting social purpose and could become moral only by the artist "putting a chancre on the anus" to show the syphilitic outcome of unfettered sexuality. Proudhon felt that the public should cry out against such licentiousness, but it had lost its will since such works sold well. Elite patronage, including that of the Emperor, who had even purchased a Leda holding a swan between her legs, was the cause of this decline.[53]

The Catholic press not only condemned Cabanel and Baudry but reprimanded critics such as Gautier and Claude Vignon, who had defended them. Bathild Bouniol, a staunch Bonapartist writing for *La Revue du Monde Catholique* in June 1863, was scandalized by the crowds around the Salon nudes, which even included young ladies with their mothers as cicerones.[54] In a postscript the next month devoted to "La Morale de ces messieurs," this writer chided Gautier for his praise of the Venuses and even accused Du Camp of hypocrisy in his purported outrage at the paintings. For the opposition magazine of M. Buloz (*Revue des Deux Mondes*) to become a "docteur ès morale" was surprising, and "gentlemen, excuse me for saying it, but for people who have pretensions to philosophical gravity you risk seeming to want to compete with the Guignol theatre with these peculiar parades of virtue."[55] What this writer found even more astonishing was that the critic Claude Vignon (a pseudonym for Cadiot, Noémie) in *Le Correspondant,* "which the Church counts among its most zealous defenders," had deigned to admire Cabanel's work.[56]

Despite the importance of the female nude in the history of

Western art and her seeming celebration in classical sculpture, the
Catholic press in 1863 cited a body of archaeological and historical
literature which contended that all depicted nudes aroused desire
and were signs of social decadence. Désiré Laverdant, a former
Fourierist who embraced Catholic socialism after 1848,[57] in *Le
Mémorial Catholique* repeated the familiar association of Cabanel's
and Baudry's immodest figures with "the most degraded streetwalk-
ers in the heart of the brothels of Paris, London, Vienna, or Saint
Petersburg."[58] Referring to the writings of Ernest Beulé, Alfred
Maury, Prosper Mérimée, Ludovic Vitet, César Daly, Léon de
Laborde, Hyacinthe Husson, Louis de Ronchaud, and others, he
further reminded the reader that "representations of nude women,
even in sculpture, are the sign of decadence in Greek art."[59] Accord-
ing to a substantial body of nineteenth-century archaeological liter-
ature, archaic and even Periclean Greek sculpture depicted female
goddesses, including Venus, draped.[60] In the fullest discussion of the
evolution of Greek religion and sculpture, Maury, extensively cited
by Laverdant, traced the degeneration of the cult of Aphrodite from
the goddess of marriage and chastity into *Aphrodite pandémos* (lover
of many gods), or *Venus vulgivaga* in Latin, "the goddess of courte-
sans, the personification of the *vie galante.*"[61] Maury also repeated
the story that Praxiteles' celebrated nudes were modeled after
famous courtesans.[62] Therefore, for Laverdant, Second Empire
painters were merely repeating the degenerate practices that marked
the decline of Greek civilization in which prostitutes influenced
heads of state and served as models for artists. What was needed was
the substitution of Christian art for these pagan practices and the
depiction of the soul and holy spirit, not just the body.[63]

Laverdant's position, albeit justified by a large body of scholarly
writing that was itself moralizing, remained unusual in the 1860s.
Most critics accepted the idea that Greek sculpture set an unrivaled
standard for ideal beauty and the "healthy" aesthetic contemplation
of the naked body. The very issue of the differences between Greek
and modern attitudes toward the nude had come to the fore in the
1861 Salon, where Jean-Léon Gérôme's *Phryné devant le tribunal*
[*Phryne before the Tribunal*] (Fig. 20) was prominently featured. The
painting depicted the climax of the story of the celebrated Greek
courtesan Phryne, who had been accused of impiety by Euthias
and had been brought before the Athenian judges. Her former

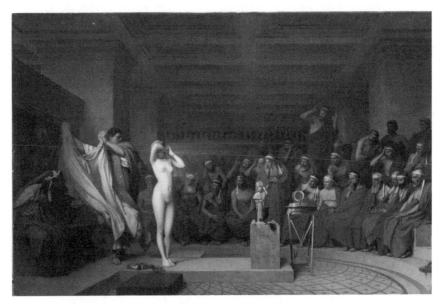

Figure 20. Jean-Léon Gérôme, *Phryne before the Tribunal,* Salon of 1861. Kunsthalle, Hamburg. (Photo © Elke Walford/Fotowerkstatt Hamburger Kunsthalle)

lover, Hyperides, a noted orator, defended her and, at a crucial moment, pulled off her veils to reveal her sacred beauty. The judges, thinking they saw Venus herself, acquitted her.[64]

Although Gérôme had already achieved wealth and fame for his small, meticulously finished, neo-Greek scenes, this canvas was criticized not only for the contemporaneity and ugliness of its female protagonist but for its unlikely depiction of the figures' gestures and expressions.[65] As Gautier, Thoré, Claude Vignon, and Léon Lagrange all observed, the Greeks were accustomed to seeing nude bodies, and that of Phryne would have inspired only admiration, not the lasciviousness expressed by Gérôme's leering old men.[66] Furthermore, Phryne herself should not have been depicted hiding her face with her arms, since she too would have found nothing indecent in her state of undress.

If there was debate over how a nude in a classical setting should be depicted, there was even more confusion about how a contemporary undressed woman should be shown. As A. J. Du Pays com-

mented in his review of the 1863 Salon, "today we know what a pretty face, beautiful shoulders, handsome arms, a pretty figure are; but as a result of the profound difference between the moeurs of the moderns and those of the people of antiquity, the beauty of corporeal forms, the science of the nude have become some sort of mystery into which only sculptors and painters are initiated."[67] Most writers (except Laverdant) agreed that the most perfect and, consequently, chaste rendering of female flesh was the Venus de Milo. Ever since its arrival in Paris and presentation to King Louis XVIII in 1821, this statue had had an impact on French classical studies comparable to that of the Elgin Marbles in Great Britain. Quatremère de Quincy in April 1821 hailed it as "a lesson in ideal beauty";[68] Comte de Clarac the same year pronounced that the statue was not "Venus, goddess of the pleasures of the senses" but a goddess "reuniting all the celestial beauties of the soul with all the perfections of the body."[69] Whereas recent scholars have dated the work to 120–80 B.C.,[70] Quatremère de Quincy associated it with the studio of Praxiteles, and Clarac placed it older than the Medici Venus. The mysterious goddess from Milo thus became archaized and purified, removing it further from the "degenerate Roman copies" scorned by Quatremère de Quincy.

Second Empire writers reiterated the breathless praise of the first European viewers of the Venus de Milo without specifying exactly what features marked her as an aesthetic ideal. Thoré in 1863 wrote: "One finds with reason that the Venus de Milo is chaste; she provokes love by feelings of beauty."[71] Proudhon, complaining of the lewd stares of the elders in most depictions of the chaste Suzanna, said such a biblical nude should inspire respect, the way the Venus de Milo did.[72] We can surmise that the oft-noted "chastity" of the statue derived from her draped lower body; her expressionless, serene face; her missing arms, which left her action to the imagination; and the slightly worn and pocked surface of the stone, which lacked the slick, sensual finish of neoclassical sculptures by Canova. Perhaps comparable to Leonardo's *Mona Lisa,* whose charm derived from the ambiguities of the facial expression and what the viewer could *not* see, the Venus de Milo was (and remains) timeless, unlike any living woman in costume, body type, or expression.

Beneath the Venus de Milo could be ranked, in clearly definable steps that varied slightly with each author, a series of nudes that

were increasingly less beautiful, less virginal, and more contemporary. In a June 1863 column on the latest literary trends, Alphonse de Pontmartin, a legitimist conservative, recalled that "the Venus de Milo is more chaste than the Venus de Medici, that the latter is more chaste than Ingres's *The Source,* which, in its turn, is more decent than the Venus of M. Baudry, which is much less indecent than the statuettes of Pradier, which are less immoral than the corner photographs."[73] Midway in this list, which progressed through time and down social classes, were often inserted the great Venetian Renaissance Venuses of Titian, which Du Camp deemed chaste but Eugène de Montlaur and Thoré recognized as more sensual.[74] Close to the cloying, mass-produced statuettes by Pradier and the reprehensible provocation of paintings in the 1863 Salon would have been placed rococo works by Boucher, which were mentioned by several critics as frivolous and erotic.[75] Uniformly at the bottom of the scale were the nude photographs that had begun circulating in Paris in the mid-1850s and that suffered not only from the unmediated imperfections of the bodies of the young models who posed for them but also from the widespread disdain for the entire medium by the intelligentsia (Fig. 21).[76]

These laundry lists of chaste art and appraisals of which lips and hips were the most beautiful should cause us to question what was really at stake in art and literary criticism. References to courtesans and prostitutes – whether as causes of the decay of Greek civilization or as inappropriate models for Cabanel, Baudry, and Manet – disguised widespread anxiety over the shifting social status of contemporary women and the difficulties of reconciling sexuality and public morality.[77] As we have also suggested, charges of proliferating immoral art also implicated the decadent imperial leadership that had encouraged conspicuous consumption and apparently condoned adultery and lewd behavior. In the early 1860s the hottest amusements were the wild cancans of Rigolboche, the vaudevilles featuring adulterous wives and ruthless courtesans by Sardou, Barrière, and Dumas fils, and the carte de visite portraits commemorating all these performances.[78] Cynically, the Goncourt brothers in 1860 summarized what seemed to be a calculated play by Bonapartist officials: "Pornographic literature does well under a Low Empire. I remember a couplet inserted by M. Mocquard in *The Wandering Jew* that I heard the other night at the Ambigu: the sense

Figure 21. Pesme, *Nude "académie,"*
c. 1862, carte de visite, albumen
print from a collodion-on-glass
negative. Private collection, France.

of it was that it's no longer necessary to engage in politics, but to
amuse oneself, tell dirty jokes, and have fun. One tames people, like
lions, by masturbation."[79]

At the same time, the relation of art to such a debauched con-
temporary scene continued to be contested. In what critics recog-
nized as a continuation of the seventeenth-century debates
between the "ancients" and the "moderns," journalists, novelists,
and visual artists used the Salons as a forum for assessing art's
appropriate subject matter and its responsibilities to its public.
Implicated in this discussion was the role of the state as an artistic
patron. If art did not incite the public to improved moral and civic
behavior, then how could one justify state purchases and subven-
tions? Was it good enough for art to be only "beautiful" form, and
did beautiful form necessarily inspire better citizens?

The critical reactions to Cabanel's and Baudry's Venuses and to

Manet's less noticed *Déjeuner* reveal that whereas writers found it easy to locate the official female nudes within a tradition of art history, they typically were groping for precedents for the large Manet canvas. The painting's undressed female protagonist lacked the idealization of the Venus de Milo, the modesty of the Medici Venus, the flirtatiousness of the Baudry, the contorted poses of Pradier's figurines, and the glossy flatness and small scale of the photographic *académie*. The figures, both male and female, were contemporary, but the scenario was unlike any picnic at Asnières. The gestures seemed rhetorical, suggesting dialogue, but the faces were immobile and stared off in inexplicable directions. The work was large, approaching the scale of history and mythological paintings, but the subject was at once a landscape, a genre scene, a pastiche of portraits, and a study from the nude model.

In its illegible narrative and forthright presentation of a potentially scabrous situation, Manet's painting recalls the radical style and subject of the earlier *succès de scandale, Madame Bovary*. The trial of Flaubert's novel in 1857 for outrage to public and religious morality and good behavior, under the censorship laws that had been reinstated after Bonaparte's 1851 coup, centered not so much on the novel's tale of adultery and suicide but on Flaubert's failure to establish a clear narrative voice that condemned Emma Bovary's behavior. The prosecutor, Ernest Pinard, argued that the novel undermined Christian morality and glorified adultery; the defense attorney, Marc Antoine Sénard, countered that the novel inspired virtue through its horrible depiction of vice. Recent literary critics have demonstrated that these two opposing readings of the novel's intent and relationship to contemporary life were conditioned by the disjunctions between Flaubert's subject matter and his style, which varied from "objective" third-person description to quoted dialogue to what has been designated "free indirect style." Free indirect style is a narrative technique in which, according to Stephen Ullman, "reported speech masquerades as narrative."[80] It uses the third person and narrative, usually past, tense, but translates the character's internal thoughts in a way that often confuses whether the author or the character is speaking.

Although the peculiarities of Flaubert's narrative voices were not noted in the critical responses to the novel when it was published after its author's acquittal in February 1857, the overall effect

of its style and its seeming neutrality were often discussed. Cuvil-
lier-Fleury in the May 1857 *Le Journal des Débats* commented that
Flaubert put into the novel "as little of himself as possible, neither
imagination, nor emotion, nor morality. No reflection, no com-
mentary; a supreme indifference to vice and virtue."[81] Flaubert was
repeatedly compared to a photographer who dumbly recorded all
the trivial world placed before him,[82] or a surgeon who dissected
reality with his scalpel.[83] Both analogies hinged on the apparent
mechanical qualities and lack of human feeling common to
Flaubert's style, photography, and the newly professional domain of
surgery that critics found revolting and even fearful.

Despite, or perhaps even because of, the violent reactions to
Madame Bovary, the novel inspired numerous imitators and fueled a
debate over the appropriate role of art as an agent for moral
improvement. In 1858 Ernest Feydeau, a friend of Flaubert's whose
only previous publications consisted of a collection of nationalistic
poems and a history of ancient funerary practices, published his first
novel, *Fanny*, another tale of an adulterous relationship between an
older married woman with children (in this case a Parisian) and her
vulnerable young lover, whose life revolves around the stolen
moments that the couple passes in his apartment. Justly forgotten
today, the novel has none of Flaubert's stylistic innovations, but at
the time of its appearance it was considered a successor to the
unidealized Realism of Flaubert's work. The influential critic
Sainte-Beuve praised the novel's visual imagery and, making the
same allusions to dissection and the camera, compared it to a per-
fected instrument that seized and fixed the changing plays of sun-
light from life.[84] However, other critics, including de Pontmartin,
continued their attacks on the invasion of crass materialism and
immoral behavior into the arts and even directly chided Sainte-
Beuve for defending such a work. In a later letter in 1860 respond-
ing to attacks in *Le Moniteur universel*, Sainte-Beuve upheld his
earlier judgments as a moral critic and praised Feydeau's two most
recent novels.[85]

The apparent failure of young writers to have underlying moral
principles prompted Emile Montégut in an essay that appeared in
1861 to warn of the dangers of a new "scientism." Wandering
through the landscape of life and stopping before a thousand trivial
fragments, an anthill or a mole hole, these writers in his opinion

lacked "a great moral, philosophical, or religious preoccupation" that would give value to their work.[86] What they produced seemed to be "notes of a surgery student or minutes of a clinic course."[87] The important thing for Montégut was not to understand reality scientifically but "to feel it poetically."[88] Montégut's comments were echoed in the criticism of Gustave Merlet, a literature and rhetoric professor at various Parisian lycées who launched an attack on Realism in the early 1860s. Responding to the Goncourts' *Germinie Lacerteux* (1865) and their *Idées et sensations* (1866), Merlet compared Realist novelists once again to photographers: "the moral world doesn't offer to the photographer the accidents of the face, color, and line; by preference he is enclosed in the physical world that is like an immense studio, full of models that all have equal importance to his eyes."[89]

Feydeau's own defense of his writings and that of his friends appeared as the preface to his novel *Un Début à l'opéra,* dated April 1863. Complaining that none of his detractors considered whether or not a book was well written, Feydeau traced the history of the relation between art and morality and emphasized that bad characters and licentious situations were often featured in literary masterpieces. A great artist, he claimed, did not obey rules but only himself, "his nature, that collection of aptitudes, tastes, affectations, antipathies, inclinations, qualities, and faults that constituted his individuality, his temperament, his character."[90] To the charge that he was a Realist, Feydeau agreed only if Realism was defined as "the modern system that consists of painting nature (or humanity) as one sees it," rather than the taste for low subjects or the depiction of nature as it is.[91] Novels did not destroy morals, he argued, but rather contemporary morality, which Feydeau painted as weak and corrupt, affected morals: "Too many morals in the works; not enough morality in moeurs," he concluded.[92]

The exhibition of Manet's *Déjeuner* during the heat of these debates over art and morality was yet another test of the artist's right to privilege style over subject matter. Even though his emphatic, broad brushwork and perspectival distortions were more apparent and personal than the seemingly invisible, precise verbal notations of Flaubert, Feydeau, and the Goncourts, Manet's artificially constructed and pastiched scenario broke the inherited rules for coherent allegorical compositions and careful painting, just as

Realist novels mixed dialogue, botanical description, and snatches of slang conversation. The undressed model recalled the uncorseted adulteresses and prostitutes of the new fiction but failed to rest comfortably either in the present-day world or in the mythological past.[93] The painting, in short, had no clear subject, and blatantly seemed to flaunt that fact.

The comparisons that a few contemporary critics noted between the *Déjeuner* and Giorgione's works, specifically the *Pastoral Concert* in the Louvre now attributed to Titian, reinforce the idea that Manet's oil was not *about* a story but at some level about the act of painting. Certainly the two nude women and elegantly dressed young men as well as the landscape background and sensual color prompted this comparison, which was made by Hamerton and Astruc.[94] But these critics, and even Manet himself when he reinterpreted the scene, may have been aware of Giorgione's reputation as an artist who was interested in form and color and not content. Francis Haskell, in an article on the reputation of the Giorgione painting, has posited that it became known as a subject-less scene only after the exhibition of the *Déjeuner* and Manet and Zola's invention of the argument, "forget the subject and its implications."[95] This interpretation, according to Haskell, was then taken up by Gautier, who described the *Pastoral Concert* as "a bizarre composition with an astonishing intensity of color" and noted the peculiar lack of involvement of the elegantly dressed gentlemen with the adjacent nudes. Speculating on Giorgione's motivations and anchoring him within the art for art's sake camp, Gautier observed that

> the painter, in this supreme artistic indifference that thinks only of beauty, has only seen a happy opposition of beautiful fabrics and flesh, and in effect there is only that. . . . The *Pastoral Concert* doesn't draw many people [in the Louvre], but rest assured that those who are looking for the secrets of color stop in front of it for a long time . . . and make full sketches and copies that they keep on their studio walls as the surest color scale an artist can consult.[96]

Gautier's reading of Giorgione as a revolutionary painter and his figure composition as subjectless was not original, however. It has often been noted that the Venetian School ever since the writings

of Vasari had been conceived as interested in the depiction of nature rather than religious imagery. Vasari claimed that Giorgione never represented any object he had not copied from life,[97] an idea repeated in the nineteenth century by Stendhal, Arsène Houssaye, and Antoine Fleury, among others.[98] The German scholar Franz Kugler noted that, despite Giorgione's sensitive interpretations of the real world, his allegorical pictures were "not always understood," and "it is difficult, indeed, sometimes to decide whether Giorgione means to represent a real portrait, or an ideal, or a genre subject, so well did he understand to give his figures that which especially appealed to the comprehension and sympathies of his spectators."[99] Alfred Dumesnil, in an article on the artist in *L'Artiste* in 1853, recalled the Venetian's passion for music and the fair sex and described him as a painter "without brakes, without rules": "There are no compositions in his paintings. There is perhaps disorder in his art, but also the harmony of nature."[100]

In an unusually detailed analysis of Giorgione's life and work, Dr. M. J. Rigollot in 1852 reported the "remark made long ago that because the subjects of Giorgione's paintings were most often obscure and difficult to interpret, their merit is independent from the idea that directed the artist and consists entirely in the excellence of execution and the power of talent (or, as Reynolds said, the 'power of art alone')."[101] Rigollot cited the *Pastoral Concert* as proof of this idea and gave a description of the work that prefigures those of Manet's *Déjeuner:*

> A nude woman, seen from behind holding a flute, is seated on the grass facing two young men in Venetian costume toward whom she turns. One of them seems to play a lute or perhaps chat with his neighbor. On the other side of the painting, a woman whose drapery covers only the bottom of her torso in front of a fountain pours water with a crystal vase. The scene is set in the middle of a wooden landscape adorned with buildings [fabriques] and glowing with the gaiest colors. In the distance a shepherd advances with his troops. One can't see the face of the seated woman; that of one of the young men is covered with such strong shadows that it seems completely black and one can't make out anything; the other man's face is lit only partially. The body of the woman, of which we can only see the back, is thickly painted and bloated; her coloring is yellowish olive, which

may be the effect of the green of the grass and the leaves that reflect on her. The people's expressions are almost null, and in this insignificant scene, nothing seems to excite any interest.[102]

Nonetheless, he adds, this painting is precious for its powerful color and daring chiaroscuro: "The artist is inspired by nature and reproduces the objects that strike his view with a feeling of truth and rare power."[103]

Whether or not Manet consciously identified with the historically crafted image of Giorgione when he modeled his bathing scene after the Venetian's enigmatic composition cannot be known and is not really necessary for our argument. Given the topicality of the issue of the artist's responsibilities to contemporary nature and/or morally uplifting idealization, his painting must have been intended to challenge the conservative public that had fumed over Flaubert's *Madame Bovary* and even his friend Baudelaire's *Les Fleurs du Mal* (also tried in 1857 but convicted of obscenity).[104] Manet would have agreed with Feydeau that the artist has a right to express the world as he sees it, to be concerned with style without worrying about how low and ignorant minds interpret his subject. He certainly could not have been surprised that his painting, in both style and subject, provoked controversy and was rejected from the Salon.[105]

That Manet's painting was explicitly *about* the artist's privileged morality and haughty transcendance of the base thoughts that the masses felt when confronting the nude body is suggested by his inflections on Giorgione's celebrated composition. Giorgione's nude females, while not responding to the depicted gentlemen, also do not respond to the viewer; Manet's model, Victorine Meurent, pointedly does so through her gaze, but does not show the gestures of modesty that critics of Gérôme's *Phryne* had tagged as an appropriate response for a modern, chaste nude. Manet had dealt with just such a gesture in his earlier painting of Suzanna, in which the profile model crouches and covers her breasts while staring out at the viewer, who by implication becomes one of the voyeuristic elders not depicted within the painting. By rejecting both the biblical subject and the stereotypical signs of modesty, Manet in the *Déjeuner* leaves only two possible interpretations for his nude: that she is a shameless harlot or that she is an artist's model posing in an environment in which sexual desire is presumably left at the studio door.

In contrast to the many stories of painters' romantic involve-

ment with their models (from Vasari's tales of Raphael and the Fornarina to Mürger's *Scènes de la vie de Bohème*), a second discourse of equally long lineage emphasized the artist as the disinterested appraiser of female flesh. For our purposes, the best exposition of this stereotype can be found in the Goncourts' *Manette Salomon* of 1865, in which the authors recount the story of a nude female model posing before thirty students in Ingres's studio who suddenly started and grabbed up her clothes when she saw a roofer staring at her from a neighboring building. For both the model and the male student, the studio situation was supposed to act like a huge dose of saltpeter: "It's in the pose that the woman is no longer woman, and for her men are no longer men."[106] The artist at work is lost in the contemplation of lines and shadows and, like Paris judging his three goddesses, apparently deflects his libidinal instincts into his critical faculties. The experienced model similarly is supposed to shed her culturally imposed shame with her clothes and return to an Edenic innocence. As had been metaphorically represented in Ingres's painting of Raphael and the Fornarina, in which the Renaissance master admires his canvas while ignoring his flesh-and-blood model and mistress seated on his lap, art overcomes and surpasses the mundane reality of sexual desire.

By staging Victorine as an artist's model, neither modest nor enticing, Manet challenges the viewer's morality. In effect, he is saying, if you find this woman sexually desirable, you are not identifying with the painter who saw her as forms and colors. The artist's morality is asserted as different from and superior to that of men of the world, an argument that we today may challenge as yet another artifact of the enlightenment definition of the aesthetic, but one that Manet's contemporaries still touted in defense of their professional autonomy.[107]

We may, however, probe a bit deeper into Manet's construction of a confrontational and peculiarly unseductive female totally unlike those of Cabanel and Baudry. Victorine as depicted in the *Déjeuner* may metaphorically embody the situation of the model in the studio, but Manet's stripping off of coded signs of flirtation and his frank rejection of passive, curvaceous suppleness make her reminiscent of the fearful, physically repulsive woman that populates countless Realist novels. Emile Zola, who was soon to become Manet's friend and defender, in his autobiographical *Les Confessions*

de Claude introduces a livid, pallid prostitute who at once disgusts and then seduces and obsesses the young hero. The Goncourts similarly depict female characters who have secret sexual appetites (*Germinie Lacerteux*) and palpitating and devouring moist flesh (*La Fille Elisa*) and who destroy their lovers' careers (*Manette Salomon*). This misogyny and identification of the female as the source of social and physical contagion is replayed to a certain extent in the lives of the major Realist writers, which are marked by sexual (or castration) anxiety and a withdrawal from heterosexual attachments (the Goncourts, Flaubert, even Baudelaire).[108]

One could entertain the notion that the artistic depiction of a woman who bears none of the traditional symbols of desirability and "beauty" at an unacknowledged, repressed level perhaps reflects a painter's and writer's deep-seated ambivalence about (or even lack of desire for) women. Manet's extreme objectification of female flesh, introduced in the *Déjeuner* and continued in *Olympia*, may be more than a manifesto of the Realist's right to paint what and how he pleased; it could express Manet's own inability to reconcile sexual arousal with bourgeois love.[109] What lay at the heart of the Realist agenda and its negative representations of women during the 1850s and 1860s may have been the obsessive devotion to craft and artistic creativity in lieu of the formation of more significant physical romantic liaisons.

NOTES

1. Maxime Du Camp, "Le Salon de 1863," *La Revue des Deux Mondes* (June 15, 1863), pp. 892–3.

2. In addition to the *Déjeuner*, Manet exhibited *Mlle. V . . . in the Costume of an Espada* and *Young Man in the Costume of a Majo*, as well as three etchings.

3. For evidence of how this journalistic network operated during the Second Empire, see my *Industrial Madness: Commercial Photography in Paris, 1848–1871* (New Haven: 1994), pp. 80–5; also see the letters addressed to Théophile Gautier by artists and critics in his *Correspondance générale*, Claudine Lacoste-Veysseyre, ed. (Geneva: 1993), vols. 7–8.

4. Among the magazines not discussing individual works in the Salon des Refusés were *L'Illustration*, *La Semaine des familles*, *L'Univers illustré*, *Figaro programme*, *Gazette rose*, *Gazette des dames*, *Mémorial Catholique*, *Revue du Monde Catholique*, *Journal des arts, des sciences, et des lettres*, and *Revue du mois littéraire et artistique*.

5. Paul Mantz's failure to cite Manet in the *Gazette des Beaux-Arts* was not

an accident and represented a personal grudge against the artist. The magazine had actually been quite sympathetic to Manet: Léon Lagrange had praised his *Spanish Singer* in his review of the 1861 Salon (July 1, 1861, p. 52), and Philippe Burty had publicized the Société des Aquafortistes in the February 1, 1863 issue. Mantz came out violently against Manet in his April 1, 1863 review of the Martinet exhibition, claiming that in contrast to his earlier promise, the young painter was now on the "route of the impossible" and "we refuse to follow him" or plead his case before the Salon jury then meeting. Edouard Lockroy reviewed the Salon for both *L'Esprit publique* and *Le Courrier artistique;* he effusively praised Manet in the *Courrier,* but did not mention him by name in the other paper. The critic for *L'Opinion nationale,* Olivier Merson, was sympathetic to the Refusés and critical of the current system of state support for the arts but did not want to review individual works extensively. Louis Enault in *La Revue française* defended other Refusés artists such as Mlle. Duckett, Chintreuil, Fantin-Latour, and Rodolphe Julian.

6. Alan Krell, "Manet's *Déjeuner sur l'herbe* in the Salon des Refusés: A Re-Appraisal," *Art Bulletin* 65 (June 1983), 316–20.

7. On Astruc, see Sharon Flescher, *Zacharie Astruc: Critic, Artist and Japoniste* (New York: 1978). Astruc's letters and archives, largely postdating the 1860s, can be found in the Bibliothèque du Musée du Louvre, Paris, Ms. 420.

8. On this organization and its mandate to foster and sell etchings, see Janine Bailly-Herzberg, *L'Eau-forte de peintre au 19e siècle: La Société des Aquafortistes, 1862–1867* (Paris: 1972), 2 vols.; and Charles Baudelaire's celebrated promotional article, "L'Eau-forte est à la mode," which appeared in April 1862 in *La Revue anecdotique.*

9. Zacharie Astruc, *Le Salon* (May 20, 1863), p. 5.

10. On Lockroy, see his published autobiography, *Au hasard de la vie: Notes et souvenirs* (Paris: 1913). Lockroy did sketches and took photographs to assist Renan in his researches for *La Vie de Jésus,* published shortly after Renan's return to Paris; his entry into politics took place only after the fall of the Second Empire.

11. On the importance of Martinet's gallery for the development of alternative exhibition spaces in Paris, see Lorne Huston, "Le Salon et les expositions d'art: réflexions à partir de l'expérience de Louis Martinet (1861–1865)," *Gazette des Beaux-Arts* 116 (July–August 1990), 45–50.

12. Edouard Lockroy, "L'Exposition des Refusés," *Le Courrier artistique* (May 16, 1863), p. 93.

13. "Lettres particulières sur le Salon," *Le Petit Journal* (June 11, 1863), p. 2.

14. Michael Fried, in *Manet's Modernism* (Chicago: 1996), pp. 175–6, identifies Pompilius as Carle Desnoyers, Fernand's brother. Pompilius ended his review with a reference to a fuller article on the Salon that was going to be published by Fernand Desnoyers in the coming month. No further

article in *Le Petit Journal* appeared, but Fernand Desnoyers published a Salon review (not citing Manet) in *La Chronique illustrée* on July 5, 1863 and printed a separate brochure on *Le Salon des Refusés* (1863). Since critics often sold their work to two journals and published slightly different comments each time (Lockroy, identified as Edouard and Edmond, reviewed the 1863 Salon for *Le Courrier artistique* and *L'Esprit publique*), there is no reason to doubt that the *Petit Journal* piece was also by Fernand Desnoyers. Fernand Desnoyers (1828–69) wrote pantomime plays (two of which featured frontispieces by Courbet and Alphonse Legros and therefore place him in the circle around Manet) and edited *L'Almanach parisien* during the time that this Salon review was written. His brother Charles Henry Etienne Edmond Desnoyers de Biéville (1814–68) was a more successful writer of vaudeville plays who edited the drama feuilleton for *Le Siècle* from 1856 to his death. These men should not be confused with their contemporary, Louis Desnoyers, also an editor, theatre and music critic, vaudevillian, and president of the Société des Gens de Lettres.

15. Arthur Stevens and Arthur Louvet also commented on the "grand tapage autour du nom de M. Manet." Arthur Stevens, *Le Salon de 1863* (Paris: 1866), p. 195, originally published in *Le Figaro;* Arthur Louvet, "Exposition des Refusés," *Le Théâtre* (July 12, 1863), unpaginated. Much of this commotion must have been oral, because the only early press discussions of Manet were those of Astruc (May 20), Lockroy (May 16), Monselet (May 24), and Didier de Monchaux (May 21). Since most Salon reviewers followed the established hierarchy of artistic genres, beginning with history and mythological painting and ending with sculpture and the Refusés, most of the citations of Manet's paintings were published in July at the end of or after the Salon exhibition (which ran from May 1 to July 1).

16. Jules Castagnary, *Salons, 1857–1870* (Paris: 1892), vol. 1, pp. 173–4.

17. Stevens, as in note 15, pp. 196–7.

18. Théophile Thoré is well known as a socialist, champion of the Dutch school, and defender of Realism. His 1863 Salon criticism appeared in *Le Temps* and *L'Indépendance belge* and was reprinted as *Salons de W. Bürger, 1861 à 1868* (Paris: 1870); see vol. 1, p. 425. Adrien Paul was a playwright who contributed Salon reviews to the liberal and anticlerical *Le Siècle*. "Salon de 1863 – Les Refusés," *Le Siècle* (July 19, 1863), p. 2. Another playwright, Arthur Louvet, normally wrote theatre criticism. His aesthetic philosophy can be judged by his 1861 book, *Le Théâtre en 1861,* in which he defends freedom in art and those writers who copy nature. In his comments on Manet, Louvet referred to other critics who had exalted Manet as the painter of the future (no doubt Lockroy and Astruc) and lowered him to a transitional figure between pure "nullités" and works affirming respect for art. "Exposition des Refusés," *Le Théâtre* (July 12, 1863), unpaginated.

19. Louis Etienne, *Le Jury et les exposants – Salon des refusés* (Paris: 1863), p. 30.

20. Ibid.

21. Stevens, as in note 15, p. 197.

22. Adrien Paul, "Salon de 1863 – Les Refusés," *Le Siècle* (July 19, 1863), p. 2.

23. Didier de Monchaux, "Salon de 1863 – Les Refusés," *La Patrie* (May 21, 1863), p. 2.

24. Arthur Louvet, "Exposition des Refusés," *Le Théâtre* (July 12, 1863), unpaginated.

25. Thoré, as in note 18.

26. Philip Hamerton in his autobiography discusses his conversion to Ruskinian ideas, marriage to a French woman, and expatriate life in France. In 1863 Hamerton was living in Sens and traveling between France and England to review art exhibitions; his review of the 1863 Salon was his first for the *Fine Arts Quarterly Review*. He continued to dislike the crudeness and ugliness of works by Manet, Millet, and Courbet, which he expressed in his *Painting in France* (Boston: 1895). See *Philip Gilbert Hamerton: An Autobiography, 1834–1858, and a Memoir by His Wife, 1858–1894* (London: 1897).

27. Philip Hamerton, "The Salon of 1863," *Fine Arts Quarterly* 1 (October 1863), p. 261. In a subsequent review of "Modern Etching in France," Hamerton identified Manet as "the person who painted the indecent picture which I spoke of when reviewing the refused works at the Salon." *Fine Arts Quarterly* 2 (January 1864), p. 99.

28. Ernest Chesneau, *L'Art et les artistes modernes en France et en Angleterre* (Paris: 1864), p. 188.

29. Julian's other two works were *Portrait de M. J.* and *Portrait*.

30. Girard de Rialle, *A travers le Salon de 1863* (Paris: 1863), p. 65.

31. Arthur Louvet, "Exposition des Refusés," *Le Théâtre* (July 12, 1863), unpaginated.

32. Louis Enault, "Le Salon de 1863," *La Revue française* 5 (1863), 476.

33. Thoré, as in note 18.

34. Julian's letter demonstrates the ways young artists attempted to pull strings to achieve Salon success and also the ways the jury's deliberations were leaked back to artists: "Mme the Duchess of Hamilton had the extreme kindness to recommend me to you. A life-size painting, drawn from a poem of M. de Musset, has been refused from the Salon. I learn from a highly commended member of the jury of the painting section that it was not because of any consideration of art that my painting was refused, and that if I obtained from you the authorization to go to the Palais de l'Industrie to put a drapery on my painting, which would be submitted for the examination of the jury that has to meet one last time to judge a statue being repaired, it would have every chance of being admitted, the jury having found my work very acceptable from the point

of view of painting, and the permission to say so having been given by the person who engaged me to speak to you." Archives des Musées Nationaux, Paris, X. 1863.

35. The best discussion to date of the many canvases featuring nude "Venuses" in the 1863 Salon and the theories of female reproduction that underlay their representation and reception is Jennifer L. Shaw, "The Figure of Venus: Rhetoric of the Ideal and the Salon of 1863," *Art History* 14, no. 4 (December 1991), 540–70.

36. *La Chronique des arts et de la curiosité* (May 17, 1863), p. 229, cited this price. The actual prices were 20,000 francs for Baudry's *The Pearl and the Wave (Persian Fable)* and 15,000 francs for Cabanel's *Birth of Venus*. Archives des Musées Nationaux, Paris, X. 1863. The paintings may have already been sold to the state from the artists' studios. Cabanel's work was not submitted to the jury until April 10 (he received permission from Nieuwerkerke to do so; see Cabanel's letter dated March 24, 1863 in the Archives des Musées Nationaux, Paris, X. 1863); he had invited Théophile Gautier to view the picture in his studio on April 2 (Gautier, *Correspondance générale,* vol. 8, p. 113). Advance publicity for the two paintings appeared in *L'Univers illustré* on April 23 (Baudry's work was called "une toile destinée à faire sensation") and in J. J. Guiffrey," Correspondances particulières," *Le Journal des Beaux-Arts* (April 30, 1863), p. 59. *La Gazette de France* (May 2, 1863), p. 2, reported that the Emperor had bought the Baudry and the Empress the Cabanel. Baudry himself wrote to Gautier that the Emperor had bought his Venus "on the eve of the exhibition" (*Correspondance générale,* vol. 8, p. 128, letter dated May 7, 1863).

37. Hamerton, as in note 27, pp. 238–9.

38. Didier de Monchaux, "Salon de 1863," *La Patrie* (May 16, 1863), p. 3.

39. Théophile Gautier, "Salon de 1863," *Le Moniteur universel* (June 15, 1863), p. 1.

40. Astruc never mentioned Cabanel or any other painters of Venuses in the official Salon, presumably because his paper was censored so rapidly. *Le Salon* (May 20, 1863), p. 6, note.

41. Edouard Lockroy, *L'Esprit publique* (May 24, 1863), p. 3. This criticism was repeated in his "Dixième lettre d'un éclectique," *Le Courrier artistique* (July 5, 1863), p. 12, although his judgment of Cabanel in the June 28 issue had been more positive. He noted that Cabanel's Venus was proud of her nudity and had "perfect plastic beauty," yet the expression of her head was "totally modern and the smile, wandering on this partially opened mouth, seemed more that of a Boucher shepherdess than a goddess of Phidias." "Neuvième lettre d'un éclectique," *Le Courrier artistique* (June 28, 1863), p. 6.

42. The prevalence of comparisons of these figures to children suggests that a certain sublimation may have been occurring; these nudes have all the physical traits of adults except for pubic hair, which could not be por-

trayed and whose absence might have reinforced at some unstated level the figures' readings as prepubescent. The more slender and small-breasted body type was also more associated with youth than it is today. However, since most prostitutes were in their teens and twenties, as were models for pornographic photographs, there was certainly no justification for associating these less fleshy bodies with sexual innocence during the Second Empire. The fact that Cabanel and Baudry chose these body types itself suggests that younger girls represented ideal beauty and were the most sought after for sexual liaisons.

43. On the involvement of *La Revue de Paris* with Flaubert, see René Dumesnil, *La Publication de Madame Bovary* (Amiens: 1928).

44. On the *Revue's* Salon criticism, see Robert de la Sizeranne, "Les Salons," in *Cent ans de vie française à la Revue des Deux Mondes* (Paris: 1929), pp. 309–34. The journal was counted as part of the opposition and had received several warnings from the censors after becoming more overtly antiregime in the late 1850s. In 1861 *La Revue* began attacking the financial dealings of the Empire and in the spring of 1863 supported the liberal party during the legislative elections. For more information on the politics and aesthetic stances of the journal, see Thaddeus E. Du Val, *The Subject of Realism in the Revue des Deux Mondes (1831–1865)* (Philadelphia: 1936); and Gabriel de Broglie, *Histoire politique de la Revue des Deux Mondes de 1829 à 1979* (Paris: c. 1979).

45. Du Camp, as in note 1, p. 902.

46. Ibid., p. 904.

47. Ibid., p. 906.

48. Ibid., p. 908.

49. Stevens, as in note 15, pp. 17, 57.

50. Castagnary, as in note 16, p. 113.

51. Thoré, as in note 18, p. 374. The rue Bréda was notorious for its prostitutes.

52. P. J. Proudhon, "Du principe de l'art et de sa destination sociale," in C. Bouglé and H. Moysset, eds., *Oeuvres complètes* (Paris: 1939), vol. 11, p. 207.

53. Ibid., pp. 208–9. Henri de la Madelène also implicated broader social forces in the decline of contemporary art. He deplored "the narrowness of modern moeurs, the lowness and vulgarity growing greater each day, the insolent rule of lucre, and the daily triumph of speculation." *Salon de 1863* (Paris: 1863), p. 4.

54. Bathold Bouniol, "L'Amateur au Salon – Critique et Causerie," *La Revue du Monde catholique* (June 10, 1863), p. 384.

55. Bathild Bouniol, "L'Amateur au Salon (post-scriptum) – La Morale de ces messieurs," *La Revue du Monde Catholique* (July 10, 1863), p. 594.

56. Vignon wrote that the Cabanel was "ideal beauty incarnated in a woman" and ranked his inspiration next to that of Raphael and Correggio. The Baudry was described as more mortal, with a "plebeian" origin.

ignon [Naomie Constant], "Salon de 1863," *Le Correspondant* 863), p. 381; Bouniol, as in note 55, p. 595.

's aesthetic theories and life are summarized in Neil , *Dreams of Happiness: Social Art and the French Left, 1830–1850* 1993), pp. 235–8, 242–3, 246–51.

dant, "Littérature et Beaux-Arts – Esprit du Salon de 1863 – après dix-huit siècles d'évangélisation, 3ᵉ article," *Le Mémor-* October 1863), p. 395.

ant, "Littérature et Beaux-Arts – Esprit du Salon de 1863 – près dix-huit siècles d'évangélisation, 4ᵉ article," *Le Mémor-* lovember 1863), p. 429.

chaud said that drapery was tied to the Greek idea of 861 book on Phidias and in *Au Parthénon* (Paris: 1886), p.

istoire des religions de la Grèce antique (Paris: 1857), vol. 1,

'Littérature et Beaux-Arts – Esprit du Salon de 1863 – ès dix-huit siècles d'évangélisation," *Le Mémorial* 1863), pp. 312–15. The political motivations of Laver- k on nudity (he claimed that "nudity, except in chil- t" in the October issue) becomes apparent in the alon review. He notes that Cabanel's and Baudry's next to Yvon's battle pictures and then criticizes ram- ilitarism as yet another social ill.

that Gérôme used for this story is unknown. He could accounts in the Latin originals or, more likely, con- mmaries such as that found in Pierre Dufour [Paul de la prostitution *chez tous les peuples du monde depuis l'an- culée jusqu'à nos jours* (Paris: 1851); see vol. 1, pp. 140–4, ubject had already been treated by the sculptor James

as has correctly suggested that the figure of Phryne was in by a Nadar photograph. The gesture of covering the head tion of the legs, which were much criticized (see Delaborde, le 1861," *La Revue des Deux Mondes* (June 15, 1861), p. 877; and in note 18, p. 16), represent compositional changes from a pre- drawing and seem to quote from an extant Nadar image. As noted, a letter from Gérôme to Nadar alludes to such a photo- er a female model. Sylvie Aubenas, "Musette: modèle de peintre, de photographe," unpublished paper presented at the Musée y symposium, "Autour de Nadar: portrait et figure dans la pho- hie et les arts visuels," September 8, 1994. It is known that Gérôme

used Nadar portraits for his 1861 painting of *La Réception des amba*
de Siam à Fontainebleau par Napoléon III; for further informat
Gérôme and photography, see my "'The Most Beautiful of I
Works': Thomas Eakins's Photographic Nudes in Their Fren
American Contexts," in Susan Danly and Cheryl Leibold, eds.
and the Photograph: Works by Thomas Eakins and His Circle in the (
of the Pennsylvania Academy of the Fine Arts (Washington, D.C.: 1
31–2.

66. Léon Lagrange, "Salon de 1861," *Gazette des Beaux-Arts* (June 1,
264; Théophile Gautier, *Abécédaire du Salon de 1861* (Paris: 1861
Thoré, as in note 18, p. 16; Claude Vignon, "Une Visite au
1861," *Le Correspondant* (May 1861), p. 158.

67. A. J. Du Pays, "Salon de 1863 – La Mythologie et l'Allégorie,"
tion (May 30, 1863), p. 348.

68. Quatremère de Quincy, "Dissertation sur la statue antique
découverte dans l'île de Milo," read before the Académie F
Beaux-Arts on April 21, 1821 and reprinted in *Recueil de ¢*
archéologiques (Paris: 1836), p. 8.

69. Comte de Clarac, *Sur la statue antique de Vénus Victrix* (Paris: 18.

70. See Alain Pasquier, *La Vénus de Milo et les Aphrodites du Lo*
1985).

71. Thoré, as in note 18, p. 373.

72. Proudhon, as in note 50, p. 204.

73. Alphonse de Pontmartin, "Semaine littéraire," *La Gazette de*
28, 1863), p. 1.

74. Du Camp, as in note 1, p. 902; Thoré, as in note 18, p. 374
Montlaur, *L'Ecole française contemporaine – Salon de 1863* (Paris

75. See Lockroy, *Le Courrier artistique* (June 28, 1863), p. 6;
Gazette des Beaux-Arts (June 1, 1863), p. 484; Olivier Mers
nationale (June 1, 1863), pp. 1–2.

76. On the development of the market in nude photographs,
trial Madness, as in note 3, Chap. 4; on anti-photographic at
the Second Empire, see ibid., pp. 223–32.

77. Alain Corbin's study of nineteenth-century prostitutio
more specific problem of identifying unregistered ǀ
insoumises, among all working-class women in Paris. *Wome*
titution and Sexuality in France after 1850 (Cambridge, Mass.

78. Some of the most scandalous plays, which often were b
were Sardou's *Les Diables noirs* (premiered in 1863), Barrié
marbre (1853), Dumas fils's *Diane de Lys* (1851, first perf
Emile Augier and E. Foussier's *Les Lionnes pauvres* (18
classic *La Dame aux Camélias* (1848, first performed in
Demi-Monde (1855). Alexandre Comte de Walewski was

atrical censorship during his tenure as Ministre d'Etat et des Beaux-Arts (1860–3) and tried to stem the flood of *filles perdues* on stage. When the Ministère de la Maison de l'Empereur absorbed the Beaux-Arts on June 23, 1863, Maréchal J. B. P. Vaillant took over this responsibility, with Camille Doucet named director of the administration of theatres. Vaillant on January 6, 1864 declared the freedom of theaters as part of the general reforms of the Liberal Empire; he was also the minister responsible for the controversial reorganization of the Ecole des Beaux-Arts in November 1863. On theatrical censorship during the Second Empire, see Victor Hallays-Dabot, *La Censure dramatique de la théâtre: Histoire des vingt dernières années* (Paris: 1871). To date there has been no comprehensive study of the factors influencing these ministerial reorganizations and the changes in imperial cultural policies during this period; the Salon des Refusés, however, was merely the prefiguration of these liberalizations.

79. Edmond and Jules de Goncourt, *Journal des Goncourts: Mémoires de la vie littéraire* (Monaco: 1956), vol. 4, p. 51, entry for July 29, 1860. This musing was prompted by the appearance of *Ces Dames! Physionomies parisiennes, ornées de portraits photographiques par Petit et Trinquart* (August 1860), a book of biographical notices on famous entertainers accompanied by carte de visite portrait photographs.

80. On the effect of this style see Dominick LaCapra, *Madame Bovary on Trial* (Ithaca: 1982), Chap. 6.

81. Cuviller-Fleury, "Variétés – Revue littéraire," *Le Journal des Débats* (May 26, 1857), p. 3.

82. Cuvillier-Fleury wrote that "M. Flaubert fixed his daguerreotype camera on a village in Normandy, and the too faithful instrument gave him a certain number of gray resemblances, portraits, landscapes and small vignettes of an undeniable truth, of that wan, pale truth that seems to suppress, in its copies of the physical world, the very light that produced them." Ibid. J. Habans in *Le Figaro* (June 28, 1857) also predicted that the followers of Flaubert "would be the invasion in language of the daguerreotype, under the pretext of naturalism and exactitude." Cited in René Descharmes and René Dumesnil, *Autour de Flaubert* (Paris: 1912), vol. I, p. 72.

83. Sainte-Beuve, while defending Flaubert, used the analogy of the scalpel in the *Moniteur universel* (May 4, 1857). Granier de Cassagnac in *Le Réveil* (January 16, 1858) also spoke of dissection (Dumesnil, as in note 43, p. 109), and Gustave Merlet in a *Revue européenne* article on "Le Roman physiologique – Madame Bovary" (June 15, 1860, cited in Descharmes and Dumesnil, as in note 82, p. 87) described how Flaubert's "scalpel plunges deftly in the palpitating fibers."

84. Sainte-Beuve, *Causeries de lundi,* 3rd ed. (Paris: 1860), vol. 14, pp. 165, 167, June 15, 1858. Sainte-Beuve said that Feydeau "entered in a laboratory, in

an anatomy chamber; placed himself at the dissection table, and, under a lamp in the style of Rembrandt, armed with his scalpel, began to prepare his subject, studying it in depth and spreading the viscera of its heart before us without pity, in its hypertrophy or with its polyp."

85. "La Morale et l'Art," *Causeries de lundi,* vol. 15, pp. 347–52, February 20, 1860.

86. Emile Montégut, "La Littérature nouvelle – Des caractères du nouveau roman," *Revue des Deux Mondes* (April 15, 1861), pp. 1010–11.

87. Ibid., p. 1012.

88. Ibid. Montégut blamed in part the contemporary moral atmosphere for this decline in taste and also cited the influence of the writings of Hippolyte Taine, which tied artistic creation to material conditions. Taine's reputation in 1861 was based on his *Les Philosophes français du XIXe siècle* (1857), his recently published doctoral thesis on the fables of La Fontaine, and numerous essays published in *Le Journal des Débats* and elsewhere. His celebrated *Histoire de la littérature anglaise* appeared only in 1864, and his *Philosophie de l'art* (based on his 1864 lectures at the Ecole des Beaux-Arts) in 1865.

89. Gustave Merlet, "Les Moralistes de la fantasie – *Idées et sensations* par MM. de Goncourt," *Hommes et livres: Causeries morales et littéraires* (Paris: 1869), pp. 109–10.

90. Ernest Feydeau, *Un Début à l'opéra,* 3rd ed. (Paris: 1864), pp. xl–xli.

91. Ibid., p. xliv.

92. Ibid., p. lxxii. Feydeau continued his attack on press campaigns that decried immorality in his *Du Luxe, des femmes, des moeurs, de la littérature et de la vertu* (Paris: 1866). This publication documents the involvement of the French Senate in debates over morality and press censorship in 1865 in which prostitutes took much of the blame for social decay. One bone of contention was establishing which social class was responsible: liberals and the Bonapartist opposition such as Eugène Pelletan insisted that there was an "aristocracy of vice"; representatives of the government, of course, argued that contagion came from below. For more on this Senate debate, see my *Industrial Madness,* as in note 3, pp. 161–4.

93. The inherent danger of any nude women was in fact alluded to during the Flaubert trial, in which the prosecution charged that Flaubert had broken the rules of literature: "Art without rule is no longer art; it's like a woman who takes off all her clothes. To impose on art the sole role of public decency is not to subjugate it, but to honor it." Cited in Dumesnil, as in note 43, p. 86. This use of the female nude as a metaphor for unfettered art and, by inference, unfettered society differs somewhat from the observations of Lynda Nead. Nead has noted that the nude represents the border between art and obscenity and that art, or aesthetic contemplation as it was defined during the enlightenment, is a way of controlling the female body. See Lynda Nead, *The Female Nude: Art, Obscenity and Sexuality* (London: 1992).

94. Hamerton, as in note 27, p. 260; and Astruc, as in note 9.

95. Francis Haskell, *Past and Present in Art and Taste: Selected Essays* (New Haven: 1987), pp. 149–50.

96. Théophile Gautier, *Guide de l'amateur au Musée du Louvre* (Paris: 1882), pp. 50–1.

97. Giorgio Vasari, *Lives of the most eminent painters, sculptors, and architects*, Mrs. Jonathan Foster, trans. (London: 1851), vol. 2, p. 395.

98. Stendhal wrote that the Venetian school impressed the viewer with "the attentive contemplation of effects of nature and with the almost mechanical and unreasoned imitation of the scenes with which it enchants our eyes." *Histoire de la peinture en Italie* (Paris: 1860), p. 125. Fleury in *Etudes sur la génie des peintres italiens* (Lyon: 1845) said "the Venetians, like the Spanish and Flemish who imitated them, rarely raised themselves above the reality in front of their eyes" (p. 322). Houssaye in an 1863 article on Giorgione and Titian claimed writers had traditionally identified Titian as a naturalist but would today call him a realist. Arsène Houssaye, "Variétés – Giorgione et Titien," *La Presse* (May 12, 1863), p. 1.

99. Franz Kugler, *The Schools of Painting in Italy*, 2nd ed., Lady Eastlake, trans. (London: 1851), vol. 2, pp. 430, 432.

100. Alfred Dumesnil, "Le Giorgione," *L'Artiste* (1853), p. 81.

101. Dr. Marcel Jérôme Rigollot, *Essai sur le Giorgione* (Amiens: 1852), p. 16.

102. Ibid., p. 17.

103. Ibid., pp. 17–18. The similarities between Giorgione and Manet do not end with these two paintings. Rigollot constructs Giorgione's life in a way that anticipates Antonin Proust's, Tabarant's, Zola's, and Duret's fashioning of Manet's career. Giorgione is a child genius who had trouble in Bellini's studio because "the objects of nature appeared to him under such a striking and new aspect," just as Manet broke with his teacher, Couture. Giorgione substituted for his master's style "an ardor, a warmth of tone, an audacious use of chiaroscuro that seemed by far too strange and disorganized" (ibid., p. 3). Unlike Manet, however, Giorgione was reputed as a great romantic lover who died because of the loss of his mistress. See Dumesnil, as in note 100; Louis Viardot, *Wonders of Italian Art* (London: 1870), p. 193; Abate Luigi Lanzi, *The History of Painting in Italy*, Thomas Roscoe, trans. (London: 1828), vol. 2, p. 103, for variations on the story of Giorgione's death.

104. The Baudelaire volume provides a less fruitful comparison to Manet's painting despite the closer personal relationship of the poet and the painter. The offensive poems ultimately censored were more explicit sensual descriptions of sexuality and lesbianism rather unlike the asexual scene in Manet's painting. Baudelaire was ultimately fined 300 francs and his printer and publisher 100 francs each. See René Jouanne, *Baudelaire et Poulet-Malassis: Le Procès des Fleurs du Mal* (Alençon: 1952).

105. The usual evidence for Manet's purported astonishment at the negative reactions to his paintings is the exchange of letters between him and Baudelaire in 1865. Manet had written Baudelaire, "J'aurais voulu avoir votre jugement sur mes tableaux, car tous ces cris agacent, et il est évident qu'il y a quelqu'un qui se trompe." However, Baudelaire had already learned that bad publicity was the best friend an author could have. Regarding the publication and trial of *Les Fleurs du Mal*, he wrote his mother on February 19, 1858: "I don't want an honest and vulgar reputation; I want to crush minds, astonish them like Byron, Balzac, or Chateaubriand." An expanded version of the celebrated volume, printed in an edition of 1,500, was issued in 1861, and the poet signed a contract with the editor, Hetzel, in 1863 for a third edition (published by Michel Lévy frères only in 1868).

106. Edmond and Jules de Goncourt, *Manette Salomon* (Paris: 1894), pp. 181–2.

107. Baudelaire used the same argument in his defense of *Les Fleurs du Mal*. In his notes for his lawyer, he wrote: "il y a plusieurs morales. Il y a la morale positive et pratique à laquelle tout le monde doit obéir. Mais il y a la morale des arts. Celle-ci est tout autre, et depuis le commencement du monde, les Arts l'ont bien prouvé" (*Oeuvres complètes* [Paris: 1980], p. 139). This argument that two types of morality exist and that artists must be judged on their creative skills anticipates Feydeau's reasoning.

108. On misogynistic tendencies in Realist fiction, see Danielle Thaler, *La Clinique de l'amour selon les frères Goncourt: peuple, femme, hystérie* (Quebec: 1986); and Chantal Bertrand Jennings, *L'Eros et la femme chez Zola: de la chute au paradis retrouvé* (Paris: 1977).

109. Manet, of course, did marry, and from the evidence provided by his letters during the Franco-Prussian War, seems to have been devoted to his wife, Suzanne, who was older than he and rather matronly, according to portraits and the testimony of Berthe Morisot. Nevertheless, he had no children and continued to live with his mother until his death, probably from syphilis. Although we do not know if Manet's syphilis was congenital, we can speculate that the knowledge that he had this disease may have encouraged him to associate women with contagion and to have directed what may have been a sexual interest in attractive Parisiennes into his well-known pictorial interest in their dress and manners. For a good analysis of Manet's family life and its impact on his art, see Nancy Locke's essay in this volume. However, given the meager extant biographical information on Manet, posthumous speculations about his sexuality must remain cautious.

JOHN HOUSE

MANET AND THE
DE-MORALIZED VIEWER

My focus in this essay is on the original contexts of the *Déjeuner sur l'herbe:* on the contexts and frameworks of reception but also on the picture's production. I want to reclaim the possibility of talking about the artist's intention – not as the expression of a private, personal vision but in terms of a calculated intervention into a public forum and a set of public debates. I shall argue that the picture was a profoundly knowing work, made with a keen awareness of a wide range of artistic and social issues, and a deeply intentional and deliberately provocative statement, designed to be seen in a particular forum, the Paris Salon.

At the outset, I want to highlight two points that are central to the writing of a social history of art as I see it and to the analysis of Manet's picture.

First, the formal language of a work of art is inseparable from the social meanings it carries. The rhetorical devices it uses, and the ways in which these relate to contemporaneous artistic conventions, do not belong to a separate aesthetic sphere; rather, it is these forms, and the relations they set up with other works, that generate viewers' responses to the work. Specifically, in the context of the *Déjeuner,* paintings recently shown at the Salon highlight the frames of reference for Manet's picture – not only the frames within which the painting would have been viewed in 1863 but the framing debates in relation to which Manet well knew that his painting would be judged; these debates were fundamental to his strategy as he conceived and executed the *Déjeuner.*

Second, social histories of art in recent years have tended to look at broader patterns of social consciousness and anxiety and have too often ignored the relevance of specific, topical issues, whether in the arena of social debate or in the more explicitly political sphere.[1] I shall be arguing that some of the points of reference of Manet's painting were very immediate. Beyond broad anxieties about modern sexuality and the relation between city and country, I shall argue that a central element in viewers' responses to the picture was historically very specific, grounded in a debate that raged in Paris in 1860–1 about student morality.

FOR ITS ORIGINAL VIEWERS, *Le Bain* – to restore the *Déjeuner*'s original title – posed basic problems of classification. It refused to conform to accepted boundaries, both as a work of fine art and in its imagery. It could be viewed within a range of different categories, but it consistently flouted and travestied the defining characteristics of these categories. It was too big to be a genre painting, too contemporary to be a pastoral, too illegible to be a conversation piece. Its imagery invited comparison with popular prints, but it was intended for the Salon, and its composition invoked hallowed Old Master models. Moreover, both subject and composition engaged the viewer in ways that, in the specific context of its original appearance, were particularly disconcerting. Each of these issues must now be explored in turn, but the challenge that the *Déjeuner* posed derived from their combination.

The first question involves the settings of the picture. This must be understood in two senses: the setting in which the painting was intended to be seen – in the Salon, as fine art, and the setting in which the figures are placed – by a wooded river side and evidently in the present. These two types of settings gain their point only when taken together: what was a travesty was the depiction of this risqué modern scene as fine art and on a scale appropriate to significant, ideal art, not everyday genre painting.

Within the sphere of fine art painting, bathing scenes might – rarely – be very large. Alexandre Antigna's *After the Bath* from the 1849 Salon (Fig. 22) measures over 10 feet across. The forms here, unlike Manet's, are idealized, and the setting is evidently not contemporary; moreover, there is a narrative hint in the dog at the bottom right – perhaps a reference to the Diana and Actaeon story. Even this canvas, though, aroused much controversy when it was

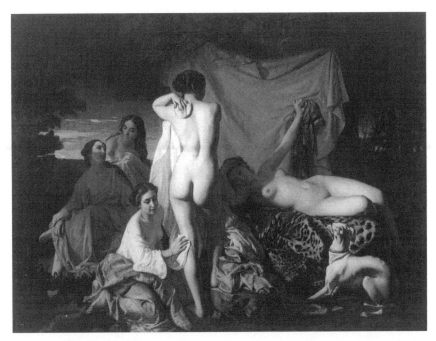

Figure 22. Alexandre Antigna, *After the Bath,* Salon of 1849. Musée des Beaux-Arts, Orléans.

exhibited in the Orléans museum during the 1850s, after its purchase by the State.[2] More obvious as a precedent for the scale and shock value of Manet's painting is Courbet's *Bathing Women* of 1853 (Musée Fabre, Montpellier); and, like the *Déjeuner,* Courbet's canvas lacks an intelligible narrative. Yet, as we shall see, the two pictures gain their impact by very different means.

The appropriate medium for a scene such as that shown in Manet's *Déjeuner* was not the exhibition picture but the mass-reproduced popular lithographs and engravings of the period. Particularly relevant to Manet's painting are prints such as Morlon's *Oarsmen of the Seine, Port of Call at Asnières*[3] and Eugène Guérard's *Long Live Wine, Long Live the Fruit Divine* (Fig. 23), both of 1860; Guérard's print is part of a series entitled *Les Vacances.* Such "permissive" imagery, when presented in modern dress, was acceptable in the semiprivate realm of prints designed for a gentleman's portfolio, but not in public fine art painting.[4]

This contrast between high and low is exacerbated by the overt

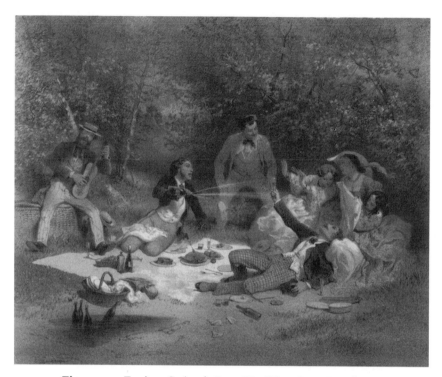

Figure 23. Eugène Guérard, *Long Live Wine, Long Live the Fruit Divine,* 1860, lithograph. British Museum, London.

references to past art in the *Déjeuner.* Even if the compositional derivation from Marcantonio Raimondi's engraving after Raphael's *Judgment of Paris* (Fig. 11) was not immediately noted,[5] the picture's subject bore obvious comparison to the Giorgione/Titian *Pastoral Concert* (Fig. 8) in the Louvre, and both subject and figure grouping carried generic similarities with the *fêtes champêtres* of Watteau.

What most disturbed the critic and art historian Théophile Thoré in reviewing the picture was the incompatibility between the subject, with its echoes of the *fête champêtre,* and the ugliness of the types; it could have been redeemed, Thoré said, by giving "elegance and charm" to the figures.[6] Other reviewers sensed the incongruities between the contemporaneity of the picture and its references to traditional imagery: the critic for *La France,* the Comte Horace de Viel-Castel, described the picture ironically as a "large *paysage historié*" and

the male figures as "philosophers," and Adrien Paul, writing in *Le Siè-cle*, characterized the female figure as a "shameless naiad."[7]

The presence of male figures was also very unusual in fine art genre paintings of contemporary life, even in the most innocent domestic scenes, and was quite unwonted in a context such as Manet's. Again, I emphasize the contrast with what was admissible in prints such as those by Morlon and Guérard. Within the sphere of fine art, the boundaries of permissibility were quite different in scenes in which the subject was distanced from the viewer. Male figures, often presented in overtly sexualized contexts, were commonplace provided they were removed in space or time by being located in the "Orient," in a historical or mythic past, or in a world of overt fantasy. In the Salon of 1861, Gérôme's *Socrates Seeking Alcibiades in Aspasia's House* (Robert A. Isaacson Collection, New York) and Cabanel's *Nymph Carried Off by a Faun* (Musée des Beaux-Arts, Lille) were both safely across this barrier.[8]

The *Déjeuner* flouted another boundary by placing overtly urban figures in a seemingly rural setting, thus undermining the stock image of the countryside as a self-contained, unchanging realm. Courbet's *Young Ladies on the Banks of the Seine (Summer)* (Fig. 12), shown at the Salon in 1857, was an obvious precedent. Though at first sight Courbet's canvas shows only two women, one in a state of semiundress, a male presence is hinted at by the presence of a third, male hat in the moored boat.[9]

The issues about the relation between city and country were remarkably exemplified by Auguste Glaize's canvas *Misery the Procuress* (Fig. 24), shown at the 1861 Salon, and by the response to it of the writer and critic Maxime Du Camp. In the Salon catalogue, the picture was accompanied by a brief text: "How many young girls, abandoning work, rush headlong into all the vices that debauchery brings with it, in order to escape from this specter that seems always to pursue them." Image and text together suggest that salvation lies in the country, in the modest image of the "wise virgins" on the right. It is the specter of misery or destitution that leads the other young women to go astray, rushing headlong and half-naked toward the burning city in a chariot driven by a satanic-looking and apparently "Oriental" male figure. The specter here is encountered in the country, but the chimera the young women are pursuing is a false image of fortune in the city. Thus, it is the influ-

Figure 24. Auguste Glaize, *Misery the Procuress,* 1860, Salon of 1861. Musée des Beaux-Arts, Rouen. (Photo Musée des Beaux-Arts de Rouen, Photographie, Didier Tragin/Catherine Lancien)

ence of the city, the influx of urban ideas, that disrupts the modest living and restricted horizons of rural life.

At first sight, the focus of the imagery seems rather different in Du Camp's review:

> It is the allegorical representation of what we see every day on our promenades and in our theatres, the increasing invasion of loose-living girls who are today a new element in our transitory society, and who, in the always active and intelligent hands of civilisation are perhaps only the instruments of equality, designed to make inheritance an illusion or at least to reduce it to a compulsory circulation. Seeing this uninterrupted procession of *lorettes* (one must call them by their name), who follow each other ceaselessly among us like the waves of the sea, I have often asked myself whether the lower classes of our society were not unknowingly perpetuating the conflict which began at the end of the last century, and whether they were not peacefully continuing the task of the most violent clubs of 1793, by producing these beautiful girls whose mission seemed to be to ruin and cretinise the *haute bourgeoisie* and the débris of the nobility.[10]

The focus here is explicitly political, on class relations in the city, with the extraordinary lurking biomedical fear of contagion, overtly by heredity but surely at another level through the ever-

present fear of venereal disease. As we shall see, these anxieties had a sharp topical focus in 1861.

By hitching his homily to Glaize's image, Du Camp located the source of the contagion in the countryside but attributed it to the effects of the Revolution, which disturbed the "natural order" through the notions of equality and self-advancement and to the invasion of urban ideas and politics, which in turn led the young women to seek their fortune in the city, turning a rural peasantry into an urban proletariat. Glaize's canvas, by treating misery as an allegorical figure, perhaps allowed it to be prised apart from politics and socioeconomic injustice, but in Du Camp's text the message was explicitly political: to preserve the equilibrium of society; the crucial thing was to keep the countryside free of "politics."

The *Déjeuner* can readily be interpreted in the terms suggested by Du Camp's homily. The young men may be seen as delinquent members of the bourgeoisie, and the women, by their conduct, are evidently presented as immoral – as temptresses or prostitutes, though we cannot tell whether they originate in city or country. The very casualness of their relationships shows how deep-seated the contagion is.

This seeming casualness is central to the uncertainties created by the *Déjeuner.* The viewer seeks a narrative explanation of the interchange between the figures, but the grouping denies any clear-cut reading. The gesture of the figure on the right is unequivocally one of communication, inviting us to interpret it, but his companions ignore him: the other man stares out past him, and the woman looks at us. Once again, the oddity is heightened by the combination of two seemingly incompatible things – the close proximity, intimacy even, implied by the placing of the figures and the interweaving of their legs and the scattered directions of their gazes.

In these terms, the illegibility is very different from that in Courbet's 1853 *Bathing Women*. The poses and gestures of Courbet's figures clearly suggest some direct and significant communication between them, but the problem lies in interpreting their interchange: there is nothing in the picture that enables us to make sense of it. Moreover, the exaggerated rhetoric of their gestures is quite at odds with the mundaneness of the figures and their situation.[11]

In the imagery of the period, there was a wide range of ways in which coherence might be suggested by the groupings and gestures

of figures, ranging from the unobtrusive focused gestures in a pic-
ture such as Alfred Stevens's *Morning in the Country* (Fig. 25) to the
exaggerated posturing in Guérard's *Long Live Wine, Long Live the
Fruit Divine* (Fig. 23). However, in both the Stevens and the
Guérard, there is a liaison between figure arrangement and narra-
tive. The criteria for such coherence were well defined by the
Republican critic Jules Castagnary, writing about Manet in 1869:
"Like the characters in a comedy, so in a painting every figure
should be in its place, play its part and so contribute to the expres-
sion of the general idea. Nothing arbitrary and nothing superflu-
ous, such is the law of every artistic composition."[12] The scattered
focuses of attention in the *Déjeuner* prevent the viewer from identi-
fying any "general idea" in the group.

The confusion is compounded by the still life, which by Casta-
gnary's standards is clearly both arbitrary and superfluous: a strange
jumble of clothing and picnic, with a bread roll casually cast on the
ground. But this is not presented in a way that suggests riotous
pleasures (contrast the broken plate and discarded bottle in
Guérard's print); indeed, the artfulness of this whole arrangement is
stressed by the juxtaposition of cherries and figs – fruit from quite
different seasons.[13] And nothing elsewhere in Manet's picture
speaks of actively disorderly conduct.

The disorder in the Manet lies in the inattention – in the refusal
to present a coherent interchange between the figures. This is com-
pounded by a play on authority and gender roles, since this blatant
inattention undermines a male would-be authority figure. The ges-
ture of the man on the right claims the attention of his companions;
both ignore him, and the woman's attention is actively distracted.

This distraction, of course, involves the viewer of the picture,
who is clearly implicated by the eye contact of the female figure.
This eye contact is a key element in the *Déjeuner;* it means that the
viewer can in no way posit his or her standpoint as outside, as an
overview. Since the figures are obviously contemporary and
Parisian, we cannot see the scene as remote in time or space; and
the woman's stare prevents us from seeing the picture as a hermeti-
cally sealed tableau that we can imagine ourselves as categorically
outside. If we engage with her gaze, we can no longer assume the
role of detached analyst or moral judge.

This is not simply because the woman turns toward us but

Figure 25. Alfred Stevens, *Morning in the Country,* c. 1865. Present whereabouts unknown.

because of the way in which she looks at us: not shocked or surprised, not shy or modest, not welcoming or enthusiastic. Our presence is seemingly taken for granted. The obvious contrast here is with standard images that posit the viewer as voyeur, like Manet's own 1861 *Surprised Nymph* (Museo Nacional de Bellas Artes, Buenos Aires), where our looking is unexpected and unwelcome.

Although most bather images do not include a peeping viewer, it was generally understood that the subject in a sense presupposed some such observer; the discussion of the bather theme in Pierre Larousse's *Dictionnaire* concludes:

> What image could be more graceful than that of a bathing woman, trembling at being surprised by a prying man, and trying to conceal the charms that she reveals in her haste. Many painters and sculptors have treated this theme without any historical concern.[14]

One reviewer of the *Déjeuner* imagined transforming Manet's bather into just such a victim, "stripped bare by robbers and seeking to hide amid the reeds," and lamented that instead she was just sitting there, seemingly ignoring the clothes that were lying beside her.[15]

The distinctiveness of Manet's treatment becomes clearer by comparison with another contemporary image of female display, Gérôme's *Phryne before the Tribunal* (Fig. 20), shown at the 1861 Salon. The story concerns the Athenean courtesan Phryne, who was accused of impiety for masquerading as Venus; her defense counsel exposed her body before her judges so as to convince them that her beauty was divine. In Gérôme's picture, her eyes are hidden, in order not to see the viewer/voyeurs looking, but her body is frontally displayed. The viewer of the picture is more directly implicated by this act of looking than appears at first sight; the cut-off foot at the lower right shows that the ring of judges continues around the chamber and embraces our viewpoint.

In two ways this treatment is quite unlike that in the *Déjeuner;* Manet's female figure is quite unashamed, but at the same time her body is presented in a way that rejects all the rhetoric of display so characteristic of the image of the female nude at the Salon. In these terms, she reveals little to the viewer/voyeur, but equally she is emphasized as naked, self-awarely but not self-consciously.

The distinctiveness of the woman's gaze in the *Déjeuner* is highlighted by comparison with Tissot's *Partie carrée* (private collection), exhibited at the Salon in 1870. The general idea of this canvas evidently derives from Manet's *Déjeuner,* but it offers just the sort of anecdotal narrative closures that the *Déjeuner* denies. This is openly a scene of sexual flirtation, and the woman on the left looks at us with an amused complicity. But we, the viewers of the *picture,* as opposed to the *scene,* are distanced through the scene being set in historical dress of the Directory period.[16]

The relevance of Tissot's theme to Manet's was emphasized by the fact that in 1871, when memories of the Tissot would have been fresh, Manet gave the *Déjeuner* the title *Partie carrée* in an inventory; by contemporary definition, as Alan Krell has recently noted, a *partie carrée* was "a four-way debauch, involving two men and two girls, who sleep together, go for walks together, eat together, and kiss."[17]

Manet set up a particularly problematic relationship between the picture and its original viewers in Paris in 1863 by denying the viewer any of the conventional means of establishing a categorical distance between viewing the picture and viewing the scene it depicts. This is partly through the direct glance of this figure but also because, in contemporary social terms, many of the points of reference of the subject were topical and controversial.

In a number of the reviews the figures in the *Déjeuner* are characterized. The woman in the foreground, not surprisingly, is called a *bréda* (by Louis Etienne) – a low prostitute. The men appear once as "philosophers" (Viel-Castel), presumably an ironic reference to bohemianism; once as *gandins* (Etienne) – young men of fashion but doubtful morals; but they also appear twice as *étudiants* (Ernest Chesneau, Paul); and, startlingly, once as *collégiens* (Etienne) – high school kids.[18]

These designations are not all simply stock epithets. The identification of the men as students, seemingly rather more surprising, is very specific in its reference. The context of this was a debate that broke out in 1860 about the morality of the student population (the male student population, of course) in the Quartier Latin. It was precipitated by an anonymous pamphlet, apparently by the journalist Noel Picard, in which he alleged, with salacious glee, that the well-brought-up, innocent sons of the bourgeoisie were being corrupted as soon as they reached Paris by the night life and the demimondaines of the left bank.[19] In a flurry of responses, again in anonymous or pseudonymous pamphlets, voices sprang up to insist that Picard's account was grossly exaggerated and that, in its prurient details, it acted as an advertisement for the prostitutes of the Quartier Latin. Most students, it was argued, were respectable and hardworking and a worthy focus for the country's hopes for the future. Not surprisingly, given the masculinist terms of the discourse, there was less defense of the women. All that was said on their behalf was that there were still a few good-hearted girls – survivals of the legendary *grisette* – who were interested in students for their charm, not their money.[20]

This debate attracted widespread attention in 1860–1, becoming a major focus for the litanies of moral fear that were part of the wider intellectual climate of the early 1860s – litanies of which Du Camp's responses to Glaize's *Misery the Procuress* were so clearly a

part. Picard's seeming case histories were seen as proof of the creeping degeneration attacking the upper classes in French society – as proof of the legitimacy of Du Camp's fears.[21]

Such anxieties, and arguably these specific debates, were central to the acute moral discomfort that greeted Manet's painting in 1863. The male viewer found himself plunged into the middle of one of Picard's scenarios, as a participant on equal terms with the men in the scene. For a female viewer, the implications would have been still more disturbing; a woman so readily accepted as she entered the glade could be no more respectable than the women she saw there.

But did these issues play a central part in the conception of Manet's painting? Were these references encoded in the ways in which he presented his subject? I would emphasize the topicality of the issues and Manet's obvious alertness to the complexities of debate about life in modern Paris. And there is one jokey detail in the picture that shows just how topical its references were and suggests that debates such as that about student morality were central to Manet's project. This is the frog in the lower left corner – small but unequivocal. It cannot simply be explained away as a colored accent, a *tache,* for it is clearly green and placed against green grass. It has been pointed out before that *grenouille* (frog) was Parisian slang for prostitute; but more specifically, one source tells us, it was student slang.[22] This solemn little attendant sits below the naked woman and can be seen in a sense as her attribute. Most viewers would have missed the detail, and many more would have missed the reference; but this is one of the signs in Manet's art that cannot be arbitrary.

THE TRANSGRESSIVENESS of Manet's *Déjeuner* is best understood in terms of the boundaries it flouted: between the genres in painting, between the forms of high art and the imagery of popular culture, between the normative notions of city and country, and between the world within the painting and the world of the viewer. But the force of these transgressions was best expressed by the oft-reported response of viewers to the Salon des Refusés and to Manet's painting in particular: laughter.

When the painting put in a scarcely veiled appearance in Zola's novel *L'Oeuvre* in 1886, this laughter was presented partly as a mark

of the artist's incomplete realization, partly as a reflection of the audience's philistinism. But it is better understood as a marker of the *Déjeuner*'s transgressions, for no response could have been less appropriate than laughter within the realm of fine art and high culture that the Salon represented. As Linda Nochlin has suggested, the painting demands to be viewed in terms of the notion of the *blague* – the sort of joke or parody that the Goncourt brothers in *Manette Salomon* described as a key symptom of the degeneracy of modern civilization:

> It has become the farcical *credo* of scepticism, the Parisian revolt of disillusion, . . . the great modern form, impious and carnivalesque. . . . The *Blague,* this terrifying laughter, enraged, feverish, evil, almost diabolical, that comes from spoiled children, from the rotten children of the dotage of a civilisation. . . .[23]

Whatever Manet's intention, the effect of his painting was to introduce the *blague* and the carnivalesque into the Salon; given his acute awareness of the politics and poetics of the art world, this can hardly have been accidental.[24]

NOTES

> For contemporary press criticism of the *Déjeuner sur l'herbe,* I am indebted to George Heard Hamilton, *Manet and His Critics* (New Haven: 1954); Alan Krell, "Manet's *Déjeuner sur l'herbe* in the *Salon des Refusés:* A Re-appraisal," *Art Bulletin* 65 (June 1983), 316–20; and Eric Darragon, *Manet* (Paris: 1989). Translations are by the author.

1. For analyses of Manet's work that do focus on specific political contexts, see, for example, John Hutton, "The Clown at the Ball: Manet's Masked Ball at the Opera and the Collapse of Monarchism in the Early Third Republic," *Oxford Art Journal* 10, no 2 (1987), 76–94; Jane Mayo Roos, "Within the 'Zone of Silence': Monet and Manet in 1878," *Art History* 11, no. 2 (September 1988), 374–409; Philip Nord, "Manet and Radical Politics," *Journal of Interdisciplinary History* 19, no. 3 (Winter 1989), 447–80.

2. See *Jean-Pierre Alexandre Antigna,* exhibition catalogue (Musée des Beaux-Arts d'Orléans, 1978–9), catalogue no. 5, n. p.

3. We are indebted to Beatrice Farwell's researches for our knowledge of this repertoire of imagery. Morlon's print is reproduced in *The Cult of Images: Baudelaire and the 19th-Century Media Explosion,* exhibition catalogue by Beatrice Farwell and others (UCSB Art Museum, University of California, Santa Barbara, 1977), p. 72.

4. For further discussion of these issues, see Anne McCauley's essay in this volume.

5. It was first cited in the book version of Chesneau's 1863 review, *L'Art et les artistes modernes en France et en Angleterre* (Paris: 1864), pp. 188–9; see Hamilton, as in note 1, p. 44.

6. Théophile Thoré, *Salons de W. Bürger, 1861 à 1868* (Paris: 1870), I, p. 425.

7. Horace de Viel-Castel, "Le Salon de 1863," *La France* (May 21, 1863), quoted in Darragon, as in unnumbered opening note, p. 87; Adrien Paul, "Salon de 1863: Les Refusés," *Le Siècle* (July 19, 1863), quoted in Krell, as in unnumbered opening note, p. 317.

8. For Gérôme's canvas, see Gerald M. Ackerman, *The Life and Work of Jean-Léon Gérôme* (London and New York: 1986), pp. 57, 210; for Cabanel's picture, bought by the Emperor Napoleon III, see *The Second Empire,* exhibition catalogue (Philadelphia Museum of Art, 1978), pp. 263–4.

9. On the critical response to Courbet's painting, see *Courbet Reconsidered,* exhibition catalogue by Sarah Faunce and Linda Nochlin (Brooklyn Museum, 1988), pp. 133–4.

10. Maxime Du Camp, *Le Salon de 1861* (Paris: 1861), pp. 136–7.

11. Delacroix provided the most perceptive response to the problems that Courbet's picture posed: "What a picture! what a subject! The vulgarity of the forms would not matter; it is the vulgarity and uselessness of the idea that are abominable; and . . . if only that idea, such as it is, was clear! What do these two figures mean? . . . [The standing woman] makes a gesture that expresses nothing. . . . There is some exchange of thought between the figures, but it is incomprehensible." (Eugène Delacroix, *Journal,* ed. A. Joubin [Paris: 1980], pp. 327–8, entry for April 15, 1853.)

12. Jules Castagnary, "Salon de 1869," reprinted in *Salons (1857–1879)* (Paris: 1892), vol. I, pp. 364–5.

13. See, e.g., *Manet,* exhibition catalogue (Metropolitan Museum of Art, New York: 1983), p. 169.

14. Pierre Larousse, *Grand dictionnaire universel du dix-neuvième siècle* (Paris: 1867), vol. II, p. 57.

15. Paul, as in note 7.

16. For Tissot's canvas, see Christopher Wood, *Tissot* (London: 1986), p. 47; for a recent discussion of the immoral reputation of the Directory, see Susan L. Siegfried, *The Art of Louis-Léopold Boilly: Modern Life in Napoleonic France* (New Haven and London: 1995), pp. 57ff.

17. See Alan Krell, *Manet* (London: 1996), pp. 32–3, who quotes the *Dictionnaire érotique moderne* of 1864.

18. Louis Etienne, *Le Jury et les exposants* (Paris: 1863), pp. 29–30, quoted in Darragon, as in unnumbered opening note, p. 86; de Viel-Castel, as in note 7; Ernest Chesneau, "Le Salon de 1863," *Le Constitutionnel* (May 19,

1863), quoted in Darragon, as in unnumbered opening note, p. 85; Paul, as in note 7.

19. *Les Etudiants et les femmes du Quartier Latin en 1860* (Paris: 1860); the author is identified as Noel Picard in another pamphlet by Picard, *Les Lions de Province* (Paris: 1861).

20. For responses that defended the morality of male students, see Anon., *Vive l'étudiant* (Paris: 1860); O. Mounpais, *Aux vrais étudiants: Guerre! Guerre! à la brochure Les Etudiants et les femmes du Quartier Latin en 1860* (Paris: 1860) (see pp. 40–2 on the *grisette*). More equivocal were two other responses to the original pamphlet: Anon., *Le Quartier Latin* (Paris: 1861); and Un Etudiant en droit, *Sus aux gandins! Sus aux biches! à propos de la brochure Les Etudiants et les femmes du Quartier Latin* (Paris: 1860). The whole debate coincided with the controversy aroused by the so-called *Mémoires* of the prostitute Rigolboche.

21. On these fears, viewed from two very different perspectives, see Jennifer L. Shaw, "The Figure of Venus: Rhetoric of the Ideal and the Salon of 1863," *Art History* 14, no. 4 (December 1991), 540–57; and Elizabeth Anne McCauley, *Industrial Madness: Commercial Photography in Paris, 1848–1871* (New Haven and London: 1994), Chap. 4.

22. "Murger's *grisettes,* abandoning their independence and their gaiety, have become, according to the term used by students, *grenouilles de brasseries*"; Macé, quoted in J. P. Colin and J. P. Mével, *Larousse, Dictionnaire de l'argot* (Paris: 1992), p. 317.

23. Edouard and Jules de Goncourt, *Manette Salomon*, first published 1867, new ed., Paris, 1979, pp. 42–3; see Linda Nochlin, "The Invention of the Avant-Garde," in *The Politics of Vision: Essays on Nineteenth-Century Art and Society* (New York: 1989), pp. 13–14.

24. This assessment is informed by P. Stallybrass and A. Wright, *The Politics and Poetics of Transgression* (London: 1986).

TO PAINT, TO POINT, TO POSE

MANET'S *LE DEJEUNER SUR L'HERBE*

We are in the painter's studio. A model is posing. The painter has asked her to replicate a pose from an old Venetian Renaissance painting in the Louvre. The model takes up the pose but alters it a little, at the painter's suggestion. She attempts to get comfortable, propping her elbow on her knee in an effort to stay still while the painter paints her. She looks out at him, and at us, the visitors to the studio — where else should she look while she holds her pose? She keeps one bit of cloth underneath her backside to soften the hard floor beneath her somewhat, but the rest of her clothes lie discarded next to her, along with an artfully disarranged painter's still life of basket, brioche, peaches, cherries, and oysters — this painter, she knows, likes to paint live models together with still lifes. He likes to have them both in front of him in the studio, so that he may judge them against each other while they are both, model and still life, under his gaze at once. Behind the model the painter has provisionally propped up some painted stage scenery in order to get the effect of the outdoors, indoors here in the studio. Everyone present — the model, the painter, and the visitors — shares in an open acknowledgment that this is a professional scene: a professional exchange between painter, model, and spectator.

Two of the visitors to the painter's studio are family: one is a brother of the painter; the other is the painter's soon-to-be brother-in-law, who also happens to be an artist — a young Dutch sculptor. Since they are there, the painter asks them to model too — they come cheap, after all; they can be expected to put up with their brother's foibles; and they, like the professional model, also know how much their brother the painter likes to have models under his gaze, how much he likes to turn everything under his gaze into models for painting. They, in contrast to the undressed figure next to them,

are not professional models, and they do not get undressed. The studio is not so warm, the bare floor is not so comfortable against naked flesh, and they have not been paid to take their clothes off – and, anyway, the men in the Renaissance painting they are asked to replicate have kept their clothes on.

The painter changes his mind a bit, unable to decide whether he wants to paint a modern fête champêtre or an updated judgment of Paris. He has a print after another Renaissance image lying around, and on a whim he asks his brother to replicate one of its poses – he likes it – why not combine two old images in one modern one? – he's done that sort of thing before. The brother's pose is a little more difficult than that of the professional model, but unlike the model, who has to stay put, he will come and go (the painter's other brother may even sit in for him now and then and act as a sort of place marker). In fact, not only does he remain in his street clothes, he will never actually put down his cane, which happens to serve equally well as a studio prop, something to curl his fingers around while he takes up his uncomfortable lounging, lifted-arm pose. The painter is happy with it – for he discovers that in taking up that pose his brother can be painted pointing at the model, keeping everyone's gaze directed at her and her professional look.

The model is posing. The brother is pointing. And the painter is painting. He works hard at the contrast between the model's naked white flesh and the black of the men's frock coats; he lays the paint on and smooths it over to get a stark, black-and-white contrast. He works hard on his brother's hovering arm and hand and on the stark effect of the model's gaze. He searches for just the right color for her hair, almost as dark as the men's coats, yet with a touch of warmth to match the live tints of her face and to catch a suggestion of Titian red. And he works hard on the background, brushing in some russet and green quickly so as to keep the feeling of painted theatrical sets to contrast with his harder rendering of the models' bodies, to keep the process of painting before his and our eyes, with just a touch of reminiscence of the open-air quality of the picnic along the Seine that he thinks first inspired him – not enough, however, to spoil the effect of the studio that he wishes to maintain.

Remembering some other rococo fêtes champêtres, the painter hits on the idea of sketching in a bent-over female figure in her shift in the middle ground, lifting her straight from Watteau and rendering her with an appropriately light-handed touch. Yes, that almost finishes it – she makes a nice contrast in every way to the harder, more finished look of his outwardly staring professional model. She's a nice demonstration of the different ways a

woman can look to the painter's gaze and of the different ways a painter can paint, catching different manners from the painting of the past, arriving at different painterly effects. And if he wants to, he can get his model to take up that other pose another time, just to check it against life. On the other hand, perhaps he won't: it might be enough merely to hint that it's the same woman seen twice, and leave it at that. It occurs to him that he just might want to keep the contrast he's got now between art and life, the quick sketch and the slow, vivid, compelling gaze, the unfinished rendition and the finished personal presence. If he goes back to the bent-over woman in the middle ground and works her over, if he checks her against the model, he just might lose that. He'll wait and see when he's done.

The painter turns to the still life in the foreground and labors at getting it right, brushing on some icy blue, some gray-green, some black and straw and peach and red, picking up the model's warm-cold effect, enhancing and framing her with that still life. The painter worries over the still life – it's the key to the whole, perhaps. He dabs the small patches of dark red that are becoming cherries with tiny white highlights to make them look real and yet still painted – to show how a painter paints an illusion. His glance returns to his brother's pointing index finger and then to his model's gaze and stays riveted there, commanded by it.

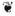

IN THIS IMAGINING of the scene of Manet's studio, what is true and what is false? Well, it is just that, an *imagining,* not a historical reconstruction – I rather doubt, for instance, that Manet actually set up some stage sets to make a background for his painting, even though the background has the look of painted flats. Nonetheless, I believe the foregoing is an imagining *solicited* by the *Déjeuner sur l'herbe,* which I want to describe as a not-very-veiled evocation of the painter's world of the studio,[1] replete with the model and her discarded clothes, a still-life arrangement, accouterments and props, and family visitors, together with a demonstration of painterly quotations and manners and of the workings of illusionism, as well as a deictic gesture pointing to it all – *rather* than an image of contemporary social mores and sexual practices associated with the banks of the Seine at Bougival, Argenteuil, or the Bois de Boulogne. It is also, I think, an imagining borne out by some of the facts.

And what are the salient facts? To start, they concern the players

in the painterly drama of 1863. First, there was Manet himself, who
we know had an inordinate liking – indeed, *need* – for the live
model, and who was wont to pair live model with still-life arrange-
ment, which he also needed to have in front of him as a means
both of color composition and of adjudication of illusionistic
effect. (I am thinking in particular here of Théodore Duret's anec-
dote concerning his own sitting of several years later, in which
Manet placed next to him at the last moment a book and a still-life
tray with a lemon, a spoon, a water carafe, and a glass on it, sud-
denly enabling him to finish his painting.[2]) Second, there was Vic-
torine Meurent, who was the model to whom I have been
referring – and whose features appear repeatedly and recognizably,
if also changeably, in painting after painting of Manet's between
1862 and 1866: in the sixties Manet painted her more often than
anyone else, including Léon Leenhoff, who was the illegitimate son
of one of the men in the Manet family,[3] and who as a model came
in a close second to Victorine. In all of those paintings, to which I
will return in a moment, Victorine's status as painter's model is dra-
matized over and over again by her overt adoption of poses, her
wearing of costumes, her enactment of scenes from the museum
with and without walls – her replication of scenes from paintings
from the past found in the Louvre and other collections, and in
reproduction, and her dead-pan model's stare.[4]

Then there was Ferdinand Leenhoff, the sculptor brother of
Manet's soon-to-be-wife Suzanne, who posed for the male figure
seated next to Victorine. And there was Eugène and Gustave Manet,
Manet's brothers, who, it is said, alternated as the model for the male
figure at the right, the one who points at Victorine. We know also
that Gustave Manet sat at least one other time for Manet that year,
posing in costume as a *majo* just as overtly as Victorine had posed as
an *espada* the year before. That painting of Gustave, which makes no
more pretense of being anything other than a pictorial performance
than *Mlle. V . . . in the Costume of an Espada* does, showed up at the
Salon des Refusés together with the *Déjeuner*, as if to draw a double
line under the presence of the posing brother and his connection to
the posing Mlle. V. in that open-air luncheon scene.

Then there is the date – 1863: not only was this the year Manet
married Suzanne Leenhoff, it was also the year he painted Vic-
torine as *Olympia* (Fig. 15), taking up the pose of Titian's *Venus of*

Urbino (Ufizzi, Florence), which he had copied earlier in Florence. The two paintings, though shown at different times, need to be considered together – for they belong to a series of pairs comparing and contrasting the features of Victorine in and out of art historical guise, more or less absorbed into her art-historical role, more or less overtly announcing her status as painter's model. Then there is the well-known array of sources for the *Déjeuner* – ranging from Giorgione/Titian to Raimondi/Raphael to Watteau, not to mention Achille Devéria and others, and making of this painting perhaps the most concentrated exercise in eclectic quotation since *The Old Musician* (National Gallery of Art, Washington, D.C.) of 1860,[5] and one whose prime art-historical reference was more recognizable to Manet's public than that of *Olympia* would be two years later – no doubt simply because it was located closer to home, in the Louvre.[6] This array of sources makes of the *Déjeuner* an even more sustained demonstration than Manet's other early work of what it means to paint in the age of the museum and the mechanical reproduction, with its privileging of the exhibition value of the art-historical image.[7] (Working from prints as he often did to produce his "original" works, and then reproducing those same "original" works in print form many times over, Manet was perhaps more involved in this demonstration – of the way the museum and the mechanical reproduction work hand-in-glove – than any other painter of his generation.)

Then, last but not least – it is what I have been speaking of all along – there is the painting itself. Surely the painting itself is *the* "primary text" with which we are confronted. Surely, if all the texts and events that surround it can serve as external evidence of its context and reception, the painting per se offers its own kind of internal evidence, not so much of the world around it but of *itself.* And that internal evidence consists of its outward-staring model, its framing of her gaze with an empty deictic gesture, its supplementation of her flatly naked body with its richly painted still life, the unconvincing plein-airism of its background, the nonsense it makes of its updating of a Venetian Renaissance idyll, and its comparison of two factural manners associated with two views of a woman – the hard, flat, harsh constrast and thingy quality of Victorine and her black-attired male companions versus the caressive, light, and brushy rococo rendering of the Watteau-inspired figure in her shift

amid the forest, the latter's retreating, folded-over, barely there body attached to the background's visible demonstration of the process of painting rather than to the painter's freshly finished products (as seen in the figures and objects of the foreground – particularly the rather unpleasurably rendered body of Victorine). That is the internal evidence of the *Déjeuner:* one of the things it speaks to is the fact that the painting is precisely not synonomous with the world around it – to the fact not of its autonomy but of its *difference* from the world it depicts.[8]

1862 and 1866: FOUR PICTURES OF VICTORINE

Always we come back, directed by that pointing index finger, to Victorine Meurent, as perhaps *the* salient fact of this painting and of the pair and the series to which it belongs. The year before, when Manet first began using her as his model, he painted her three times, first as herself, then as a street singer, and finally as an *espada.* The little portrait of 1862 (Fig. 26), with the stark, stripped-naked, strangely bleached look of its face, the unprecedented harshness of its black-and-white contrasts, and the peculiar, off-key mélange of its icy blues and warm russets stands as testimony of the fascination that Victorine's features appear to have held for the painter.

The other two paintings (Figs. 27 and 10), however, stand as a more complex pair. The puzzle of the pair is, what defines the identity, what constitutes the true "nature" of a woman who is a painter's model? Between one and the other, Victorine appears in costume that is alternately close to and far from her native attire. In the one she wears the street clothes of a demimondaine performer, wearing clothes that are appropriately feminine and French, and she is given the simple genre title of *The Street Singer.* In the other she wears the theatrical costume of another kind of performer, which is masculine and Spanish – as distant from who Victorine "really was" as the street clothes are proximate to it. And yet it is the other picture that has her own name in the title, yet at the same time announcing that she is appearing in guise and playing a role, that she is precisely *not* "herself": *Mlle. V . . . in the Costume of an Espada.* In the one Victorine's body is covered and indistinguishable under her bell-shaped dress; in the other it is revealed (as feminine) by her skin-tight (masculine) breeches. In the one she is shown

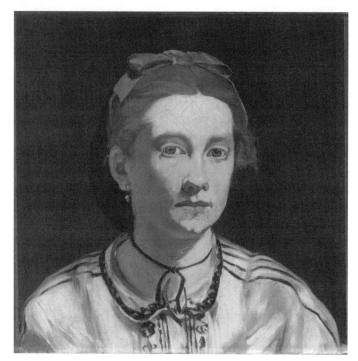

Figure 26. Edouard, Manet, *Victorine Meurent,* 1862. Museum of Fine Arts, Boston. Gift of Richard C. Paine in memory of his father, Robert Treat Paine II. Courtesy, Museum of Fine Arts, Boston.

against a more or less convincing contemporary background; in the other she appears pasted onto an overtly flattened, unconvincing ground, demonstrably lifted from mechanically reproduced images.

And in the one painting her features, which are half-concealed, appear slim and angular and Parisian, whereas in the other image they are fully revealed, yet they look quite different – plump, apple-like, and Rubensian. From one to the other, however, one thing is held in common, like a control on the experiment: while Victorine's features undergo changes, her outward gaze is somehow enough the same to be recognizable, and with it she frankly acknowledges what the title of the *Espada* acknowledges, namely, that when she is in a painting she is a model, that for that purpose she dons a costume, takes up accouterments, and strikes a pose; that the changeability of her model's identity *is* her identity; and that, at that moment, her native habitat is the studio and its images more

Figure 27. Edouard Manet, *The Street Singer,* 1862. Museum of Fine Arts, Boston. Bequest of Sarah Choate Sears in memory of her husband, Joshua Montgomery Sears. Courtesy, Museum of Fine Arts, Boston.

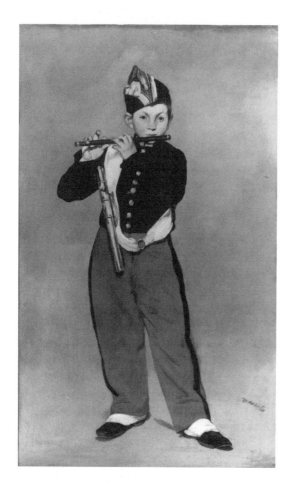

Figure 28. Edouard Manet, *The Fifer,* 1866. Musée d'Orsay, Paris. (Photo R.M.N.)

than the street or the stadium. Or, to put it differently, her gaze spells out the fact that within the world of painting both the quotidian street and the theatrical stadium are simply aspects of the *studio* – the studio in costume.

In 1866 Manet again painted Victorine twice in guise (Figs. 28 and 29). This time he painted her first as a little boy in trousers and then as an adult woman at home in a pink peignoir. *The Fifer* is thought to have had several models, among them another family member, Manet's illegitimate son or half-brother or half-nephew Léon Leenhoff, as well as Victorine: it is easily conceivable that Manet used Victorine as a placeholder for Léon when he was not

Figure 29. Edouard Manet, *Young Lady in 1866*, 1866. Metropolitan Museum of Art, New York. Gift of Erwin Davis, 1998. (89.21.3)

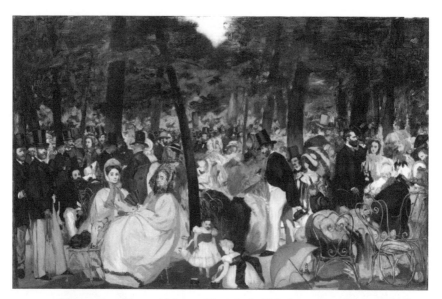

Figure 30. Edouard Manet, *Music in the Tuileries,* c. 1862. National Gallery of Art, London. Reproduced by courtesy of the Trustees of the National Gallery.

there and perhaps also vice versa, Léon as a placeholder for Victorine – and both as placeholders for the other young boy who, it is said, had been sent to Manet as a model for this picture.[9] In any event, however the modeling sessions actually happened, Victorine's bald-foreheaded stare is certainly discernible in *The Fifer,* whose winged eyebrows, small nose, and half-hidden mouth directly recall the similarly limned features of *The Street Singer,* in combination now with the projecting ears and childish width of Léon's face and his shorter boyish body. (Of all her parts, Victorine's body is the least recognizable here; it is her gaze that announces her presence. But then, throughout the pictures in which she makes an appearance, her body was always disappearing and changing shape – far more even than her face.)

In *The Fifer* Manet seems to have been rather fascinated with the notion of using the doubled figure of the female model and the family member – to stand in for himself perhaps? He had done something similar before, in the *Déjeuner.* Manet very rarely portrayed his own features per se: he seemed remarkably uninterested in depicting

himself *as himself.* When he did portray himself it was always as part
of an allusion to the history of painting – in the *Music in the Tuileries*
(Fig. 30), for example, painted the year before the *Déjeuner* (each
functions, I think, as a kind of antedote to the other: the first, which
depicts society as a world of, by, and for artists, nonetheless pretends
away the studio, whereas the second announces the studio's presence
in the picnic), he appears at the left margin, barely squeezed in, much
as Raphael appeared at the courtly, spectatorial edges of the *School of
Athens* (Vatican Museum, Rome); in his later 1879 self-portrait with
brush and palette, he adopts, reverses, and closes in on the stance of
Velázquez in *Las Meniñas* (Museo del Prado, Madrid), updating it
with modern clothes.

More often, Manet would use others to stand in for himself; by
the end of the sixties, it would be writers and critics like Duret,
Astruc, Zola, and then Antonin Proust (whose portrait Manet based
on his own persona as presented in an earlier portrait by Fantin-
Latour); in the earlier sixties, partly out of convenience to be sure, his
choice of stand-in was most often his brothers, his wife's son – and
Victorine. Kin on the one hand, familially close to him but not him,
adjacent to him but not identical to him; his studio "other" on the
other hand, his opposite number, the prime object of his painterly
gaze: his brothers, Léon, and Victorine seemed to frame him as fig-
ures at one and the same time of identity and alterity – as figures of
identity *as* alterity. With *The Fifer,* the defining of identity via adja-
cence, opposition, and alterity would be jumped up one notch, by
the fact that the figures of the familial and the feminine other are
collapsed into one (and by the fact that the familial relationship
between Manet and Léon was indeterminate to begin with).

The place of this framing of identity was, of course, the studio,
and Victorine was Manet's prime studio persona. As for *The Fifer's*
"companion," the *Young Lady in 1866* (Fig. 29), she is again Vic-
torine more or less as herself, presented somewhat as if she were
chez elle, and as if we, the spectators who might have sent her the
posy she sniffs, might presume to be on intimate terms with her, to
know her for who she really is, when she's at home and has, figura-
tively speaking, let down her hair – except that her home is still the
studio, and her hair, her clothes, all that she is belong to that domi-
cile; it is studio property. Dressed *en déshabille* in a bell-shaped piece
of feminine apparel similar in its shape to *The Street Singer's* street

dress, the *Young Lady in 1866* provides a similar contrast to the trousered figure in *The Fifer* as that found in the dynamics of the masculine and feminine, the body-revealing and body-concealing costuming of the *Espada* and *The Street Singer*. But where both pictures of the 1862 Victorine pair had contextualizing backgrounds brushed in, now both pictures of the 1866 Victorine pair have blank, grayed, Velázquez-inspired backgrounds, more overtly than ever stating that the proper context of these images is the theatrical space of the studio, with its poses, costumes, and accouterments, its theatrical conferring and changing of identities, its circulation and reproduction of depictions from the past, and its out-and-out performance of the exhibition value of the image.

In both pictures little illusionistic games are played, jokes about the paintedness of the paintings' illusionism: in *The Fifer* there is that famously ridiculous shadow cast by the "boy's" foot; in the *Young Lady in 1866* there is the parrot stand, with its overtly painted effects of glass, metal, and wood, with the peeled orange at its base referring to the Dutch and Spanish still-life tradition, with its handles turning illusionistically in space to mediate between the putatively projectile three-dimensionality and the literal two-dimensional flatness of the painting. In both pictures something is held up to the model's face, partly obscuring her features in the one, on the verge of doing so in the other, as if still questioning her recognizability and the role that the "beholder's share" of illusionism plays in it.[10] Thus, in these pictures as in those of 1862, Victorine's face and gaze are used to announce that painting is an illusionistic performance that takes place between painter, model, and history of art and that the studio, not the "real world," is the stage for that performance, the stage on which the play of identity – both the painter's and the model's – is enacted reciprocally, and for an audience.[11]

1863: ANOTHER READING OF *OLYMPIA*

Manet would paint Victorine Meurent one last time, in 1872, when she served as the model for the mother or governess in the *Gare Saint-Lazare* (Fig. 31). There, however, though her stare is still recognizable in spite of the less assertive domestic look about her, she disappears into her role much more than she had in Manet's earlier painted uses of her. But let us return to 1863. That year, Victorine's

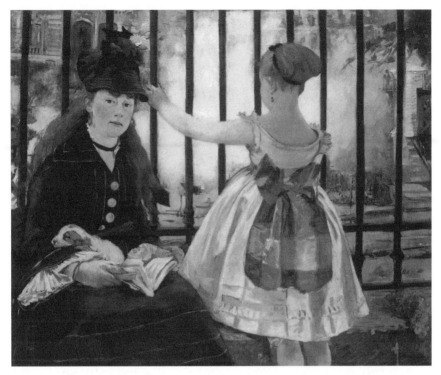

Figure 31. Edouard Manet, *Gare Saint-Lazare,* 1873. National Gallery of
Art, Washington, D.C. Gift of Horace Havemeyer in memory of his
mother, Louisine W. Havemeyer.

features appeared in the pair constituted by the *Déjeuner* and
Olympia (Fig. 15), the most dramatically quotational of all the pairs,
and marked by the fact that Victorine appears naked in both –
without clothes, but in the costuming of art-historical nudity.

Surrounded by a plethora of accouterments, grouped together
with other figures, with backgrounds that mediate between art-his-
torical past and sociosexual present, Victorine's face and body
undergo the same subtle changes from rounded to angular, large to
small as found in the other pairs, and her Titian hair and the quality
of her stare nevertheless continue to suggest that this is the "same"
woman – the same model. In this pair of pictures that sameness is
both asserted and questioned, this time by matching a certain inde-
terminacy in the rendering of Victorine to a mixing-up of differ-

ent factural manners. In the *Déjeuner,* on the one hand, we find those different manners assigned to two separate renderings of the female body, which look like nothing more than two views of the *same* woman (though my guess is that Victorine did not actually pose for both; the sketchy Watteau-derived figure seems clearly lifted from art rather than life). In *Olympia,* on the other hand, those two manners are, as Tim Clark has beautifully shown, collapsed into the single rendering of her face, distinguishable only when one moves back and forth in front of the painting, from the hard, slicked-back flatness of Olympia–Victorine's face from a medium distance to the softer, more yielding painterliness of her mouth, chin, and loosened hair up close:[12] she is a bit like the two women of the *Déjeuner* collapsed into one – one, however, who is also two.

The indeterminacy in the look of *Olympia* has been attached by Clark to the discourse on prostitution that ran rampant through the critical and caricatural reception of her when she was shown in 1865. But I wonder if that indeterminacy, reattached to the studio and its moment of production, might not be understood instead as an aspect of Manet's thematics of the model. For if we reconsider *Olympia* together with her alter ego(s) in the *Déjeuner,* and place her back in the context of the studio rather than that of the street or the boudoir, she begins to appear, again, as an image of Victorine *rather than* the woman the painting's title names her – as yet another *Mlle. V . . . in the Costume of* Seen together, the *Déjeuner* inflects *Olympia* with its more overt statement to this effect: that the woman it depicts is a character drawn from the history of art, that her real context can be only the studio, and that her audience can be only spectators at the studio's exhibition of itself. For if in his 1862 and 1866 Victorine pairs Manet consistently contrasted Victorine as more or less herself, the professional painter's model[13] – alternating between performing herself and performing someone-else from the history of painting, and showing, in effect, how she performs herself *whenever* she performs the painterly persona of someone-else (and vice versa, too) – he did so in 1863 as well, moving between two pictures in which Victorine more or less refuses to be absorbed into her pictorial role. In the *Déjeuner* the refusal is just a little more insistent; in *Olympia* it is just a little, but only a little, less insistent.

Clark has also argued that the subversiveness of the *Olympia*

resides largely in the naked rendering of her body and that the painting's refusal to fit that body to its accouterments and its art-historical references in large part accounts for the critics' reading of *Olympia* as a low-rung prostitute (rather than the courtesan that her adornment and surroundings suggest) and for their missing the reference to the *Venus of Urbino*.[14] Again, however, if we consider the *Olympia* and the *Déjeuner* as a pair and the world they refer to as that of the studio, the question of the rendering of the model's body, and of its discrepancy with its surroundings, might be slanted a little differently. For now the body, as well as the face of Victorine, takes part in Manet's play of identity-as-alterity, and in running the gamut between small and pert and challengingly passive, on the one hand, and large and heavy and inert, at once flattened and rounded, on the other, the two pictures, taken together, seem to tread the line between the body's essential anonymity and its particular possession of personality – or at least its taking part in a person's personality (in this case, multiple personalities).

Furthermore, that the locus of pictorial interest and painterly pleasure is *not* the female body, is everywhere *but* the female body, is observable in both paintings. In each a stark, unmodulated body – sensuous it is not – is framed by and contrasted to a deliciously and variously painted world and to a rich assortment of colored accessories. A studio reading of that twice-painted body, as another of Manet's studio properties, another of his painted flats, might serve to cover this observation better than an account according to class – better than discovering a proletarian corporeality in Victorine's painted body. A reading of Victorine's bluntly discrepant figure as a piece of painted discourse – *Manet's* discourse – on the "nature," or better, the culture, of femininity might shift the slant as well.

Taking the *Olympia* together with the *Déjeuner,* we might need to consider just how inadequate the critics' readings were to the former, and just how poorly their pot-boiler realism and their offhanded references to the discourse on prostitution served them in confronting Manet's work. It was not that there was no contemporary discourse that was a match for the *Olympia* – there was, and it was Baudelaire's writing on femininity: it was just that the majority of the critics writing about the Salon of 1865 were not up to Baudelaire's weight.[15] Baudelaire's writing is not identical to Manet's painting either, of course; the two men were friends and

contemporaries, but they were different people with different for-
mations working in different media. What Baudelaire's writing does
suggest, however, is something of what it was possible to articulate,
in this case about femininity, back in Paris in the 1860s:

> [I]n a word, for the artist woman is not only . . . the female of
> man. . . . She is not an animal, I say, whose limbs furnish . . . a
> perfect example of harmony; she is not even the type of pure
> beauty, such as the sculptor dreamt of. . . . Here we are not deal-
> ing with Winckelmann and Raphael. . . . Everything that adorns
> woman . . . is part of herself. . . . What poet would dare, in the
> painting of pleasure caused by the apparition of a beauty, to sep-
> arate woman from her costume?[16]

By now it hardly needs saying that Baudelaire was writing about
Constantin Guys, not Manet. However, the terms Baudelaire used
to describe the art value of the feminine are remarkably consonant
with Manet's painting of the sixties, particularly the scandalous pair
of Victorine pictures of 1863, roughly contemporaneous as they
were with Baudelaire's *The Painter of Modern Life*. For though in one
sense Manet has indeed "separat[ed] woman from her costume," in
another sense he has followed Baudelaire's dictum in both paintings,
demonstrating that femininity *is* costuming and that even the naked
body of his model, within the "painting of pleasure," is a costume.
And like Baudelaire, Manet has defined the feminine in terms of the
changeable and the supplemental rather than the essential: contrast-
ing his modern understanding of the feminine as changing fashion
to the godly beauty contests, courtly homages, and normative cor-
poreality of antiquity and the Renaissance by quoting from the
museum twice over, updating his quotes with modern apparel and
adornment, and locating painterly pleasure in everything that frames
the female body, rather than in that body "itself" – in its patent arti-
fice rather than its "nature," its fashionability rather than its animal
bodiliness, its lability rather than its stable essence.

In this instance Baudelaire used the figures of Raphael and
Winckelmann to stand for everything his feminine was not. Else-
where in *The Painter of Modern Life* he used the figures of Raphael
and Titian:

> There are in the world . . . artists, people who go to the Louvre
> Museum, who pass rapidly in front of a crowd of very interest-

ing pictures, although of *second order*, and who plant themselves
to meditate in front of a Titian or a Raphael, one of those which
have been popularized the most in prints; then they leave satis-
fied, more than one saying to himself: "I know my museum."[17]

In another passage, Baudelaire named Raphael and Titian once more:

> If a painter . . ., having to paint a courtesan of the present day, *is
> inspired* (that is the consecrated word) by a courtesan of Titian or
> Raphael, it is infinitely probable that he will paint a false, ambi-
> guous and obscure work. The study of a masterpiece of that time
> and that genre will teach him neither the attitude nor the gaze
> nor the grimace nor the vital aspect of one of those creatures
> which the dictionary of fashion has successively classed under
> the coarse or familiar titles of the *impure*, the *fille entretenue*, the
> *lorette* and the *biche*.[18]

Writing in the interests of "modern-life" and the physiog-
nomics specific to it, Baudelaire castigated painters who "knew
their museum," who relied on masterpieces in the Louvre for
"inspiration" (with typical sneering intelligence Baudelaire itali-
cized his skepticism regarding the common way of speaking about
the act of quoting from the history of art). He skewered those
same painters for neglecting the panorama of contemporary femi-
ninity and for thinking that their art-historical goddesses could
substitute for modern demimondaines. (The range of epithets
Baudelaire employed, again with a certain distancing, double-
edged curl of the lips at contemporary habits of locution, to indi-
cate women of ill repute – *impures, filles entretenues, lorettes*, and
biches – would seem to align with the then-current discourse on
prostitution. I think, however, that both he and Guys, the artist he
was writing about, were less socially specific on this score than
either the codifiers of nineteenth-century prostitutional sociology
or later realist novelists and image makers. The women they valued
as objects of representation were society's marginals, certainly, but
they were also marginals whose social place was defined, paradoxi-
cally, by a certain mobility not available to respectable women.
They were demimondaines, the female counterparts, not of the
male animal, as Baudelaire might have said, but of that most artifi-
cial of masculinities, the dandy.[19])

It might have seemed, when *The Painter of Modern Life* came out

in November and December 1863,[20] that Baudelaire was castigating his friend Manet too, swimming in on an opposing tide from that of the Salon critics two years later, questioning Manet's taste for aping the past masters of art rather than lampooning and exaggerating the iffy contemporaneity of his female model. Yet at the same time the oppositions between contemporaneity and art history found in Baudelaire's essay on Guys adequate the tensions built into Manet's 1863 Victorine pictures. Titian and Raphael versus the modern *impure,* the museum versus the chic *fille entretenue,* the old-master *gravure* versus the up-to-the-minute *lorette* and the state-of-the-art *biche:* these were exactly the oppositions mobilized by Manet in his two pictures of Victorine dating from 1863. Except that Manet collapsed the oppositions, pictorially demonstrating that the old masterpieces of Titian and Raphael were enacted by an *impure* whose modern job it was to do such acting and that the museum and the *gravure,* rather than the street and the forest, thereby became the proper habitat of his *fille entretenue,* his *lorette* and *biche.* And it was in that artificial habitat that the slippery Baudelairean femininity so attractive to Manet as well could best be performed: so went Manet's special, painting-specific claim. It was in that artificial habitat, with all its costume changes, that Manet could identify with that brand of femininity and its alterity; it was there that he could "be outside of himself, and yet feel himself everywhere at home," there that he could "enjoy his incognito everywhere," there that his "*moi insatiable du non-moi,*" his "cult of himself" could find itself "in the other, in woman."[21] It was there that he could stare, not so much at some prostituted female body but back at his feminine other, himself. It was there that he could return *her* gaze and make it his own. (One hack caricaturist got this right, at least: Bertall named *Olympia* "Manette" in his cartoon for *Le Journal Amusant* of May 27, 1865, no doubt meaning to signal her unfemininity but suggesting as well that she was a figure for the artist himself.[22])

BACK TO THE *DEJEUNER*

The *Déjeuner* disputes its own alibis in contemporary culture and plein-air nature more obviously than *Olympia* does; that is part of the comparative logic of the 1863 pair of Victorine pictures. Indeed, the *Déjeuner* is more about the world of the studio and the play of iden-

tity that happens in it than any of the other pictures of Victorine. It is much more about the world of the studio, its objects and its processes, its actors and its spectators, than anything else in the exterior world of its contemporary culture. In fact, with its reversal of the order of the usual relation between studio and represented world, such that representing a scene in the world becomes a way to represent the studio rather than the other way around, the *Déjeuner*, even more than Manet's other Victorine pictures, may be seen as a staging of that world *as against* the fictional "real world" it conjures up.

As in the other pictures of Victorine, the *Déjeuner's* turning against itself – its refutation of its own fiction in order to assert the manner of that fiction's production as well as its labile quality – seems to reside most of all in the obstinate opacity of Victorine's gaze. But to that gaze the *Déjeuner* also adds (not necessarily in this order) the seemingly deliberate illogic of its naked women and clothed men, the implausibility of the quickly brushed-in background, the unabashedly supplemental quality of the still life, the narrative emptiness of the one man's pointing gesture, and the plethora of art-historical images to which that gesture seems to refer, while also directing us to Victorine. The *Déjeuner*, in other words, supplements its meditation on the studio and the model with other interconnected thematics found here and there in other paintings and gathered together here in concert.

I know my museum:

Replication is at issue, for one thing. Added into the *Déjeuner's* equation is the fact of mechanical reproduction: most prominently found in the central gesture of Eugène-Gustave's arm, lifted, as we know, from Raimondi's engraving after Raphael's *Judgment of Paris* (Fig. 11), and underlined in Manet's habit of making his own series of reproductions after his paintings. In this case his reproductions include another, smaller painting and a watercolor after a photograph of the "original" oil. So that replicated index finger points us to the fact that Manet "knows his museum" – knows both the museum of the Louvre, in which he found the "original" *Pastoral Concert* (Fig. 8), and the "museum without walls," in which he found the rest of the references that make up the *Déjeuner*.

With that pointing finger Manet also gestures toward the mixing

up of the spaces of the studio, the museum, and the early mass media – the spaces of facture, exhibition, and dissemination – and shows how they are thoroughly interconnected. For in tandem with the indexing of the fact of replication, that pointing finger also directs us to the model's frank acknowledgment of the modeling session that is under way. In so doing it indicates not only the collapse of the modern *impure* and the art-historical *gravure* but also the spectatorial destiny of the scene of painting and the scopic value of the multiplied image – the way that, in the era of the museum, the auratic gesture of the painter is confirmed (rather than undermined) by its multiplication and dissemination and the way a painting like this one is *made* to be exhibited, to become a spectacle, the way it is *produced* (privately) to be optically consumed (in public). In short, the exhibitionism of Manet's *Déjeuner,* as indexed in his brother's gesturing arm and condensed in his model's bold gaze, directly connects the intimate self-referentiality of his studio to the multiplied exhibition value of modern painting.[23]

His other, woman:

In addition to muddying the waters at the boundary between auratic handmaking and mechanical reproduction, the *Déjeuner's* foregrounding of the world of the *gravure* ties one kind of replication to another: the replication, and reversal and variation, of the image to the replication, reversal, and variation of the model's identity. For Eugène-Gustave's replicated index finger points us, among other things, to the way Victorine Meurent and Ferdinand Leenhoff are as much replicas and alternates as they are each other's opposites. It also points us to some other things concerning men and women, the same and the other, *soi-même* and *autrui.*

Where later Manet would collapse his favorite female model together with a family member, in the *Déjeuner* he laid them out next to one another, folding them out, side to front to side, doubled three-quarter glance to *profil perdu,* feminine to masculine to feminine back to masculine again, so that female model and family member together form a closed, self-referential circle, reinforced by Eugène-Gustave's gesturing hand, broken only by Victorine's outward gaze and the loose facture of the bent-over figure in the middle distance. The masculine and the feminine have been twice

opposed – naked versus clothed, white versus black – but they are also twice twinned, to form a double Janus figure. And although the particular identity of each of the players in the picture is already in question, as a result of the musical chairs played by models substituting for each other and because of the many roles played by the principal model, the very "nature" of identity is put into question as well: by the intrusion of alterity into the family circle and of femininity into masculine society (not to mention the demimondaine into the bourgeois confines of patriarchal domesticity[24]). Thus, in the world of multiplied images in which they three or four exist, identity functions much like the *gravure:* by a series of varied replications and reversals, positive to negative, dark to light, left to right. And masculine to feminine as well: in that world gender is a matter of reversal and replication too, or so the *Déjeuner* proposes. Which brings us back to the model's stare once more, a stare that mirrors the "male gaze" of the spectator more than it answers to it.

Everything that adorns woman:

As she appears in the *Déjeuner* Victorine is not much of an object to solicit the gaze; instead, it is as if she *is* the gaze itself, in female form. It is hard to determine whether her look is challenging or accepting, whether she stares the spectator down, looks through or past him/us, or openly returns his/our gaze. (It is hard to tell that about her in all the pictures that Manet painted of her.) Instead, she offers a female image of what it looks like to look. Or better, she looks, rather impossibly, like two figures in one: a figure for the gaze itself and a figure for the gaze's object. As overtly as she is a painter's model, she must stand for the painter's (and hence the spectator's) object as well; but at the same time, again because she so overtly belongs to the studio, because she stands – or sits – for it, because she *figures* the scene of painting, she is a figuration of the painter too, and of what the painter does. In this way as well she untidies the neat old binarisms of gender and the gaze; collapsing them, she renders them together; she *alters* them.[25]

Together with everything that frames her, Victorine alters the pictorial place of Woman, shifting it, as I have tried to show, toward the Baudelairean conception of femininity. Surrounded by a world of nature that is patently not-nature, Victorine's place is in the

world of art. Compared as she is to a sketchy bit of rococo femininity, the point is redoubled: she is lifted from, and into, art. And then paired as she is with an elaborately spontaneous, an artificially "natural" still life, one that proclaims the means of illusionism, as Manet was wont to do, in such details as the white highlights upon the bunches of loose cherries, the point is redoubled again. Like those cherries, like the painted evidence of her discarded costume, like that old sign of abundance and delectation, the overflowing basket of fruit, Victorine is the product of the means of art; she is the sum of that which decorates and frames her, of everything that is next to her and around her, of all that supplements her. She, like painting itself, is all decor, all costume, all supplement.[26]

Victorine is, in short, a figment of art. At the edge of the *Déjeuner* and in the middle of it, she is the model who announces her studio context and her exhibition value. At once at the side and the center of the *Déjeuner,* she is a figuration of the studio's theater of unfixed identities, less a female body that is an object of consumption than the changeable feminine face of painting, defined by artifice rather than nature, as a multiple image rather than a single truth, as the supplemental rather than the essential, as at once the painter's Self and his Other. Installed at the forefront of the *Déjeuner,* she is the painter's Woman, with whose plural, feminine identity the painter complexly identifies – by posing her, pointing at her, and painting her in the painter's studio.

NOTES

1. Svetlana Alpers has remarked in *Rembrandt's Enterprise: The Studio and the Market* (Chicago: 1988), p. 56, on the similarity between Manet's staging of Victorine Meurent and Rembrandt's theatrical uses of the model. There are many other overlaps, too, between the practices of the two painters and between Alpers's and my treatment of them: in both the studio looms large. However, my approach to the studio is much less anthropological than Alpers's: I have not attempted to reconstruct the social structures embodied in Manet's studio or the conditions surrounding and informing it; rather, I have simply attempted to *read* the studio's presence in the paintings themselves.

2. Théodore Duret, *Histoire d'Edouard Manet et de son oeuvre* (Paris: 1926; 1st ed. 1902), pp. 88–9: "Mais lorsqu'il eut été paint, . . . je vis cependant que Manet n'en était pas satisfait. Il cherchait à y ajouter quelque chose. Un jour que je revins, il me fit remettre dans la pose où il m'avait tenu, et

plaça près de moi un tabouret, qu'il se mit à peindre, avec sa couverture d'étoffe grenat. Puis il eut l'idée de prendre un volume broché, qu'il jeta sous le tabouret, et peignit sa couleur vert clair. Il plaça encore sur le tabouret un plateau de laque avec une carafe, un verre et un couteau. . . . Enfin, il ajouta un objet encore, un citron, sur le verre du petit plateau. Je l'avais regardé faire ces additions successives, assez étonné, lorsque, me demandant quelle en pouvait être la cause, je compris que j'avais en exercice devant moi sa manière instinctive et comme organique de voir et de sentir." Cited in Françoise Cachin, *Manet 1832–1883* (Paris: 1983), p. 288.

3. On Ferdinand Leenhoff's relationship to the Manet family, see the essay by Nancy Locke in this volume. I agree that the evidence points to Ferdinand's being the son of Manet père, but there is enough uncertainty about it and enough mythmaking about his being the possible son of Edouard himself that my preference is to continue to register the ambiguity of his status in the family.

4. See Cachin, as in note 2, pp. 104–5. Also see Adolphe Tabarant, "La fin douloureuse de celle qui fut l'Olympia," *L'Oeuvre*, July 10, 1932; Margaret Seibert, *A Biography of Victorine-Louise Meurent and Her Role in the Art of Edouard Manet*, Ph.D. dissertation, Ohio State University, 1986; and Eunice Lipton, *Alias Olympia: A Woman's Search for Manet's Notorious Model and Her Own Desire* (New York: 1992).

5. I am indebted to Michael Fried's seminal "Manet's Sources: Aspects of His Art, 1859–1865," *Artforum* 7 (March 1969), 21–82, for any and all remarks about Manet's "sources" (and particularly for the observation about Manet's Watteau-borrowing in the *Déjeuner*), though I depart from Fried's stress on the overarching unity and Frenchness of Manet's art-historical quoting. See also Michael Fried, *Manet's Modernism or, The Face of Painting in the 1860s* (Chicago and London: 1996), for his updating of his original argument about Manet's "sources."

6. See T. J. Clark, *The Painting of Modern Life: Paris in the Art of Manet and His Followers* (New York: 1985), pp. 93–6, on the critics' unawareness of the *Olympia*'s reference to Titian's *Venus of Urbino*. See also T. J. Clark, "Preliminaries to a Possible Treatment of 'Olympia' in 1865," *Screen* (Spring 1980), pp. 18–41.

7. Most of what I have to say about Manet and "exhibition value" rests on Walter Benjamin's classic essay, "The Work of Art in the Age of Mechanical Reproduction," *Illuminations*, Hannah Arendt, ed., Harry Zohn, trans. (New York: 1969), pp. 217–51. See also Jean Clay, "Ointments, Makeup, Pollen," *October* 27 (Winter 1983), pp. 3–44, in particular for its discussion of Manet's engagement in the culture of the museum; and Michel Foucault, "Fantasia of the Library," in *Language, Counter-Memory, Practice*, Donald F. Bouchard, ed., Sherry Simon, trans. (Ithaca: 1977), pp. 92–3,

cited in Douglas Crimp, *On the Museum's Ruins* (Cambridge, Mass.: 1993), p. 50.

8. It should be noted that I mean this not as an intentionalist account of the work of art and its "internal evidence" but rather as a formalist argument, specifically as a reformulation of Clement Greenberg's formalist axioms about modernism in "Towards a Newer Laocöon," *Partisan Review* (July–August 1940); also in *Clement Greenberg, The Collected Essays and Criticism,* John O'Brian, ed. (Chicago: 1986), vol. 1, pp. 23–38. Further worked out in my "Facturing Femininity: Manet's *Before the Mirror,*" *October* 74 (Fall 1995); and "Counter, Mirror, Maid: Some Infra-thin Notes on the *Bar at the Folies-Bergères*" in *12 Views of Manet's Bar at the Folies-Bérgères,* Brad Collins, ed. (Princeton: 1995), pp. 25–46; the notion of "difference" that is at work here, though it is meant to retain its gender resonances, ultimately derives from another discourse entirely, namely, Roger De Piles's concept of color as the "difference" (rather than the "essence") of painting: *Dialogue sur le coloris* (Paris: 1673). See Jacqueline Lichtenstein, *La couleur éloquente: Rhétorique et peinture à l'âge classique* (Paris: 1989); and "Making Up Representation: The Risks of Femininity," *Representations* 20 (Fall 1987), 77–87.

9. See Cachin, as in note 2, p. 243. The hypothesis that Victorine modeled for *The Fifer* was first made by Paul Jamot, "Manet, 'Le fifre' et Victorine Meurend," *La Revue de l'art ancien et moderne* 51 (May 1927), 31–41; the suggestion that Léon Leenhoff also modeled was made by A. Tabarant, *Manet et ses Oeuvres* (Paris: 1947), p. 119. Supposedly, a young boy from the Imperial Guard was also sent to pose for Manet by commandant Lejosne.

10. See E. H. Gombrich, *Art and Illusion: A Study in the Psychology of Pictorial Representation* (Princeton: 1960), p. 39, for his coining and defining of the by-now classic term the "beholder's share."

11. The foregoing section is a condensation and variation on my discussion of the 1862 and 1866 Victorine pictures in "Manet/Manette: Encoloring the I/Eye," *Encoding the Eye, Stanford Humanities Review* 2, no. 2–3 (Spring 1992), 1–46.

12. See Clark, as in note 6, p. 137: "There are *two* faces, one produced by the hardness of the face's edge and the closed look of its mouth and eyes; the other less clearly demarcated, opening out into hair let down." This section on Manet's *Olympia* depends on Clark's reading of the painting at all points, but it shifts the slant away from the reception of *Olympia* and the question of class and changes the object of interpretation, from the battle of representations that constituted French culture in 1865 to the painting per se.

13. I have used the term "professional" a number of times. By that I do not mean to indicate either the business of modeling or the economic trans-

actions of the studio: that is for others to pursue. Instead, I simply mean to underline the vocational aspect of the model's self-referentiality and to distinguish between one kind of social physiognomics and another – between the physiognomic milieu of the prostitute and that of the model.

14. This is my understanding of Clark's argument: see Clark, as in note 6, p. 146, on *Olympia*'s nakedness as "a strong sign of class, a dangerous instance of it." My rereading of the *Olympia* is predicated, at least in part, on the principle of looking at the artist's larger "oeuvre" – not for its unified, developmental logic or for its expression of the psychology of Manet but rather for its particular series of pictorial fascinations and recurrences.

15. When *Olympia* was exhibited in the Salon of 1865, Baudelaire was in Brussels, and there was a brief exchange of letters between Manet and the poet regarding the scandalized public reaction to the painting. Otherwise, the only textual evidence that Manet might have been thinking along Baudelairean lines comes in the form of the vaguely Baudelairean poem by Zacharie Astruc, which Manet originally appended to the title of *Olympia* in the Salon catalogue: see Clark, as in note 6, pp. 80–3. See James Rubin, *Manet's Silence and the Poetics of Bouquets* (London: 1994), pp. 101–9, on the relationship between Manet's painting and Baudelaire's poetics (and, in general, on the performativity characteristic of Manet's art). It is, of course, by no means new to associate the practices of Baudelaire and Manet with one another.

16. "[L]a femme, en un mot, n'est pas seulement pour l'artiste . . . la femelle de l'homme. . . . Ce n'est pas, dis-je, un animal dont les membres . . . fournissent un parfait exemple de l'harmonie; ce n'est même pas le type de beauté pure, tel que peût le rêver le sculpteur. . . . Nous n'avons que faire ici de Winckelmann et de Raphaël. . . . Tout ce qui orne la femme . . . fait partie d'elle-même. . . . Quel poète oserait, dans la peinture du plaisir causé par l'apparition d'une beauté, séparer la femme de son costume?" – Charles Baudelaire, "Le peintre de la vie moderne," *Curiosités esthétiques, L'Art romantique et autres Oeuvres critiques de Baudelaire,* Henri Lemaitre, ed. (Paris: 1962), pp. 487–9.

17. "Il y a dans le monde . . . des artistes, des gens qui vont au musée du Louvre, passent rapidement devant un foule de tableaux très intéressants, quoique de *second ordre,* et se plantent rêveurs devant un Titien ou un Raphaël, un de ceux que la gravure a le plus popularisés; puis sortent satisfaits, plus d'un se disant: 'Je connais mon musée.'" – Ibid., p. 453. The italics are Baudelaire's.

18. "Si un peintre . . . , ayant à peindre une courtisane du temps présent, *s'inspire* (c'est le mot consacré) d'une courtisane de Titien ou de Raphaël, il est infiniment probable qu'il fera une oeuvre fausse, ambigüe et obscure. L'étude d'un chef-oeuvre de ce temps et de ce genre ne lui enseignera ni

l'attitude, ni le regard, ni la grimace, ni l'aspect vital d'une de ces créatures que le dictionnaire de la mode a successivement classées sous les titres grossiers ou badins d'*impures,* de *filles entretenues,* de *lorettes* et de *biches."* – Ibid., p. 468.

19. See Baudelaire, "Quelques Caricaturistes Français" (1857–8), ibid., p. 285: "Gavarni a crée la Lorette. Elle existait bien un peu avant lui, mail il l'a complétée. Je crois même que c'est lui qui a inventé le mot. La Lorette, on l'a déjà dit, n'est pas la fille entretenue, cette chose de l'Empire, condamnée à vivre en tête-à-tête funèbre avec le cadavre métallique dont elle vivait, général ou banquier. La Lorette est une personne libre. Elle va et elle vient. Elle tient maison ouverte. Elle n'a pas de maître; elle fréquente les artistes et les journalistes." The mobility of the demimondaine (or in Baudelaire's slightly earlier terms, the *Lorette*) is of a different order from the "ambiguities" of prostitutional physiognomics, as described, for example, by Hollis Clayson in *Painted Love: Prostitution in French Art of the Impressionist Era* (New Haven: 1991): quite apart from providing a cover for the ideological practice of misogyny – for firmly othering, defining the place of, and fixing blame upon the feminine – the demimondaine seems to have been a figurative alternative to the social and sexual fixity of the *femme honnête,* a form for figuring a kind of mobility within the feminine with which it was possible to identify. Which is not to say that Baudelaire's feminine is without its misogyny; it would be absurd to claim that, for the disparaging nastiness of the tone of his writing about women is one of its most apparent characteristics. But Baudelaire's is a misogyny that is typically double-edged, more superficial than deeply ideological and more strategic than anything else: a means of being anything but nice, and a ploy, not so much for objectifying women as for making them figurative – figurative of everything that departs from "Nature" and its norms and from "Man." For the best discussion of the psychic structure of Baudelaire's poetry, including his conflicted identification with the feminine, see Leo Bersani, *Baudelaire and Freud* (Berkeley: 1977).

20. *Le peintre de la vie moderne* was published in *Le Figaro* on November 26 and 29 and December 3, 1863. According to Baudelaire's correspondence, however, it was written between the end of 1859 and the beginning of 1860, just as Manet was beginning his painting career – editor's note, Baudelaire, as in note 16, p. 453.

21. "[E]tre hors de chez soi, et pourtant se sentir partout chez soi"; "jouit partout de son incognito"; "moi insatiable du non-moi"; "culte de soi-même"; "dans autrui, dans la femme" – Baudelaire, as in note 16, pp. 463–4, 483.

22. For more on this point, and on the relation between Manet's practice and the Goncourt brothers' *Manette Salomon,* published in 1855, see my "Manet/Manette," as in note 11.

23. One of the things that a work like Manet's *Déjeuner* helps to demon-
strate, I think, is that Benjamin's opposition between the auratic work of
art and the world of mechanical reproduction is too sweeping ("The
Work of Art in the Age of Mechanical Reproduction," as in note 7. In
fact, just as the "cult value" of "original" works of art in the modern age
depend upon their reproduction and dissemination, so, in the culture of
spectacle, are the spaces of auratic exhibition and mass media thoroughly
interpenetrated. This was already clearly the case in Paris in the 1860s.

24. If I were given to biographical speculation, I would wonder, here, about
Manet's painting of these pictures around the time he married Suzanne
Leenhoff (the marriage occurred in October 1863, after the couple had
lived together for some time – since 1860, when Manet, Suzanne, and
Léon moved into an apartment in the Batignolles together). I would also
be inclined to speculate about his use of Suzanne's brother as well as his
own next to a *fille entretenue,* and particularly about his use of Léon as a
model, over and over again. Obviously convenience was an issue – these
were the people most available to Manet and whose modeling came
cheap. But it seems likely that other considerations may have been at
work as well in his choice of models – that Manet may have been, albeit
elliptically, working out such things as the ordering of his domestic life, its
relation to his vocational life, the intrusion into the French high-bour-
geois home of those alien to it, the exact nature of paternity, and so on.

25. According to the Freudian logic followed in a lot of feminist writing,
such identification with the feminine would be possible on the part of a
male subject only in pre-Oedipal terms – only when the feminine is
equated with the maternal. I do not share the conviction that this is the
only possible scenario of masculine identification with the feminine. Nor
do I share the conviction that every scene from public life in nineteenth-
century Paris had to follow the same logic of gender difference (whereby
the feminine was irrevocably objectified), or that scenes from public and
private life divided along clear gender lines; see, for example, Griselda
Pollock, *Vision and Difference: Femininity, Feminism and Histories of Art*
(London: 1988).

One last remark needs to be made on the question of gender rela-
tions: I wish to forestall readers from thinking that I am attempting to
describe the real-life power relations between Manet and his model or
that I am ascribing either acts of coercion to Manet or, on the contrary,
any real freedoms to Victorine Meurent. The power relations of the stu-
dio are *not* my concern here; I am not particularly interested in whatever
structures of coercion and collusion, dominance and submission were
enacted within the studio. Neither am I aiming to do anything for Vic-
torine Meurent's reputation as either woman, painter (which she was as
well), or professional performer; I wish neither to reduce nor to expand

that reputation. Rather than as a real woman subject to real social and sexual pressures (which she certainly was), I have been at pains, instead, to describe Victorine Meurent as a piece of figuration, a figment of Manet's painterly imagination. Whatever freedoms or coercions are to be found lurking in my argument are meant to be confined, therefore, to the fictional space of painting: it is the defining of that space which is at stake.

26. See Jacques Lacan, "Dieu et la jouissance de la femme," *Le Seminaire XX Encore* (Paris: 1975), pp. 61–71, for his discussion of the feminine as the supplementary ("au-delà du phallus" – p. 69) rather than as the masculine's complementary term.

MANET'S *LE DEJEUNER SUR L'HERBE* AS A FAMILY ROMANCE

One of the challenges of approaching Manet's *Le Déjeuner sur l'herbe* is that of writing about any work of art on its own. Painters look to the work of other painters; paintings become what others – viewers and artists – make of them. However worthy of attention a single work might be, perhaps the very factor that makes the work noteworthy is, paradoxically, its connectedness to a history of visual precedents, critical literature, social praxis, and responses by artists who attempt to see it anew and to make it over again in some significant way.

In this essay I shall attempt to look at Manet's *Déjeuner* as a painting that declares its connectedness to its history. The history with which I am concerned here takes several forms. In one sense, it is the history of art: it is the problem first articulated by Michael Fried in 1969, which asks what to make of the "puzzling, almost riddling, *specificity* of [Manet's] references to previous art."[1] Another significant history consists of that which others made of the *Déjeuner:* Paul Cézanne, for instance, made the *Déjeuner* a reference point for several early fantastic landscapes with figures. I will also be concerned with the painting as it is connected to Manet's early work in general. The painting was exhibited at the Salon des Refusés of 1863 flanked by two other canvases: *Mlle. V . . . in the Costume of an Espada* (Fig. 10) and *Young Man in the Costume of a Majo* (Metropolitan Museum of Art, New York). These paintings feature his favored model, Victorine Meurent, and his brother Gustave Manet, both of whom also appear in the *Déjeuner,* and both of whom wear the

same Spanish costume.[2] A viewer in 1863 would have been struck by the repetition of costumes and faces; indeed, the group must have appeared as a côterie of sorts, as party to an "in" joke, as a meaningful cast of characters. Manet's use of familiar models, a repertoire of roles and stock costumes are all aspects of what I will argue is a "family romance" in Manet's art – a fantasy about the family that, on the one hand, has a biographical component and at the same time enacts its own history of art.

Originally entitled *Le Bain* and called *La Partie carrée* in Manet's inventory of 1871, the *Déjeuner* depicts neither a typical bathing scene nor a typical picnic; it is not a true landscape, genre scene, or history painting.[3] The bathing figure in the background is totally out of scale with the foreground figures; the gestures of the foreground figures do not cohere; the two men seemingly pay no attention to the nude woman, who looks out of the painting in a way that implies some knowing or collusive relationship with the beholder. The *Déjeuner* has been examined as a recasting of Old Master paintings, as an appropriation of pornographic photographs and popular lithographs, as a statement about the Parisian demimonde, as an allegory of studio painting, as a picture of bourgeois sociability with its attendant ambiguities, and – in the words of Meyer Schapiro – as "a dream image that [Cézanne] could elaborate in terms of his own desires."[4] In the early part of this essay, I would like to extend Schapiro's suggestion and to consider the possibility that in the 1860s Manet's painting could have been seen as a dream image. By looking at Cézanne's *Le Déjeuner sur l'herbe* of 1870–1 (Fig. 4), a painting that directly took Manet's painting as its model, I would argue that we might better understand the "sources" of Manet's *Déjeuner*. I would also argue that an historical investigation into nineteenth-century thinking about the dream image could yield more insight as to why Manet's painting was considered dangerous in 1863. In the later part of the essay, I will link the ideas about the dream image to the question of what to make of Manet's reference to Giorgione in the painting and to the repeated familiar (and familial) figures and motifs with which Manet was concerned at this point.

CEZANNE, in his *Le Déjeuner sur l'herbe*, engages in what we might call an imaginative reworking of Manet's canvas.[5] In Cézanne's

painting, the female figure at the right, though clothed, places her elbow on her knee and rests her chin in her hand in such a way as to recall Victorine Meurent in Manet's picture; she *becomes* Cézanne's Victorine here. The balding male figure with his back to us clearly resembles Cézanne himself; his fumbling two-fingered pointing gesture mirrors that of Manet's male figure at the right and of the "Victorine" figure in his own painting. His right hand echoes the somewhat mysterious hand that extends past Victorine on the left side of Manet's grouping. The male figure on the opposite side of the picnic blanket props himself up as if on a table; we see his knee off to the right and wonder how he can be reclining on the grass and under the blanket at once. Likewise, the "Cézanne" figure seems to have just emerged from under the blanket, although the women seem squarely above it. The blond man appears to be engaged in a staring contest with the intent dog. As in Manet's painting, the *déjeuner* is not pictured as a three-course meal: here it is oddly condensed, as in a dream, to a mere three orange fruits being placed almost ritualistically in the center of the vast blanket. A man and woman stride off toward the darkness of the glade at the left. The smoke coming out of the background figure's pipe wafts and curls its way up the edge of the glade and finds its echo in the distant clouds, as the smoker folds his arms and looks on.

Insofar as the picture stakes its claim to be a reworking of Manet's, it offers certain narrative possibilities that the earlier painting left unresolved. In a very real sense, Cézanne seems to be saying, "I was there" at the scene of Manet's *Déjeuner sur l'herbe:* "I was the reclining male figure gesticulating in the center of the picture." Or, looked at another way, he is saying "I was there — I was the other man in black jacket and white trousers; I was extending my hand past Victorine." Or, "I was there — but not part of the group; I was there looking on." Cézanne's picture appears to propose several "solutions" to its own narrative stalemate. The foreground figures, for instance, rather than remaining at odds with each other, could instead pair off like the background couple. One could look at the whole composition as a reversal of Manet's, with the woman (here safely clothed) on the right. If one were to look at the background figure as suggestive of Cézanne himself, then he would seem to be maintaining a safe distance from the others.

From the look of things, it would appear that Cézanne wanted

to retain certain figural and scenic aspects of Manet's painting. Cézanne's version keeps these elements in play only to restage them; it is an homage even while it remains largely a personal fantasy in which the artist himself watches and participates. The language typically used to describe the relation between an art object and a "source" is inadequate to describe the relation between Cézanne's and Manet's paintings. The earlier painting is not so much a "precedent" or a "source" as it is an entire scenario that signifies along several lines for Cézanne at this early point in his own work. Cézanne identifies with Manet and with the painting on several levels; he wants to be like Manet as a painter in certain ways, just as he may want to restage the *Déjeuner* in his own fashion.[6] This complex set of identifications and desires on Cézanne's part might involve factors as disparate as the desirability of Manet's notoriety (that is, Manet's own relationship to the academy and to the public); Manet's art as subject of Zola's interest (what *kind* of interest remains open to question); Manet's handling of paint; Manet's dramatic tableau and its narrative possibilities. Manet's *Déjeuner* becomes a fantasy for Cézanne, and as recent work on the subject has shown, fantasy often involves an entire scenario of desire, with the necessary inclusion of particular objects, possibilities, and constraints.[7] It may take an activity as its core element, as Freud suggested in "A Child Is Being Beaten": the activity was the parents' beating of a child, but the role of the subject changed from being that of the triumphant sibling to the position of the one punished to that of a spectator looking on.[8] As Constance Penley argues, one of the key elements in the process of identification with a fantasy narrative is the idea of multiple subject positions: the viewer or reader might move from a passive role to an active one or change gender or sexuality along the way.[9] What is significant for our purposes is that the "source" here, Manet's *Déjeuner sur l'herbe,* is not merely a theme for Cézanne but rather a concatenation of aspects of identity formation – public and private, social and psychological, artistic and somatic (in the Lacanian sense of the idealized *image du corps*) – which are not simply repeated but grappled with, assumed, refused, and remade in complex ways.[10]

There was no shortage of interest in dreams in midcentury Paris. Even before the efflorescence of *la psychologie nouvelle* in the 1880s and 1890s, the mid-nineteenth century witnessed a great increase in

the number of psychological studies with scientific pretensions.[11] There were evening lectures at the Faculté de Médicine on such topics as the nature of hallucinations, dreams, and what we would now call the unconscious;[12] one could also pick up the newspaper to read the latest *feuilleton* popularizations of these advances in psychological theory. Not only was Manet's close friend Baudelaire heavily involved with investigations into dreams and opium-induced hallucinations, but also the critic Edmond Duranty published articles on dreams in the early 1860s.[13] There was, in fact, a debate about the nature of dreams and other kinds of mental images in this period. The dream image occupied a liminal space between, as Cabanis called them, *le moral* and *le physique*. At the center of the debate was the existence of free will.[14] Advocates of positivism or materialism argued that there was no such thing as free will, that all aspects of human behavior and mental life could eventually be explained by physical laws.[15] On the other side, the spiritualists and the enemies of positivism argued that dreams would always escape the laws of science. They sought to preserve a notion of the mind as "a radically free entity," uncontrollable, unquantifiable, and distinct from the body.[16] This notion of the mind supported the existence of the moral choice, as nothing physical or innate would then govern ethical behavior. Both physiologists and spiritualists found support for their positions in the study of dreams and other kinds of mental images: such phenomena as retinal images and brain impulses were beginning to attract scientific interest in this period, and the possibility of retrieving hard-core physical data appealed to the physiologists. Conversely, spiritualists claimed that dreams were involuntary and pointed to them as evidence that the mind escaped the order the physiologists sought to impose.

Jules Baillarger, one of the founders of the Société Médico-Psychologique, initiated a kind of philosophical compromise between the two positions.[17] According to historian Jan Goldstein, he "postulated a split between the voluntary and directed use of the faculties of memory and imagination and their involuntary or unregulated use."[18] The human will functioned in the context of voluntary and conscious activities, but during periods of unconsciousness – sleep, somnambulism, rapture, intoxication, insanity, drug-induced hallucination, dreaming, or any other examples of *aliénation* – free will was in effect suspended. One was simply not reponsible for one's

actions. Baillarger's compromise built a bridge between the Catholic tradition, which absolved the individual of responsibility for actions committed in these states; an emerging liberal legal culture, which instituted the insanity plea in 1838; and the growing scientific interest in the physiological study of human behavior.[19]

One book that received much critical notice and was probably familiar to the artists and writers around Manet was Alfred Maury's *Le Sommeil et les rêves: Etudes psychologiques sur ces phénomènes,* which appeared in Paris in 1861.[20] Maury viewed dreams as having an indisputable physiological reality of their own. This physical aspect, however, was not a manifestation of the will; nor was it a conscious activity. In what was perhaps part of an attempt to avoid alienating those readers fearful that the physiologists were reducing human beings to the level of animals, Maury theorized about the involuntary but physical reality of dreams:

> It is neither attention nor will which conjures these images for our intellectual notice, these images which in dreams we take to be realities; they produce themselves, following a certain law due to the unconscious movement of the brain, and are a matter of discovery; thus they dominate our attention and will, and in this way appear to us as objective creations, as products which do not emanate from us and which we would contemplate in the same way we would exterior objects. These are not only ideas, but images, and this character of exteriority gives us reason to believe in their reality.[21]

The ideas I take to be important here center on the notion of the dream as able to produce images even while conscious control is suspended. This way of bracketing off the human will allowed Maury and others to come to grips with the moral question of the dream's content while recognizing the connectedness of the dream image to the everyday life of the dreamer. One can postulate, then, a position that would have been appealing to the Realists, which took from positivism and materialism the interest in the physical reality of the dream but that could also support a notion of the dream's involuntary production.

To speak of the interest in dreams in this period is not to delve into the kind of material appropriate only for an artist such as Redon or Grandville.[22] Courbet's interest in theories of the

unconscious has already been documented.[23] It was, in fact, highly appropriate for a Realist painter in the middle of the century to be interested in such phenomena. After all, if Courbet would not paint an angel unless he saw one, he would refuse to paint anything metaphysical or intangible, and he would have been interested in asserting the physical or physiological aspect of the dreamer. Consider Courbet's *Young Ladies on the Banks of the Seine (Summer)* of 1856–7 (Fig. 12). I would suggest that Courbet's voracious appetite for the physical aspects of the scene – the women's droopy eyelids, their splayed legs, their lace *mitaines* with jewelry overlaid, their casual postures – would suggest a Realist interest in *automatisme,* in a physiological state in which the women, as well as the viewer, could not have been in control of their actions. The picture suggests that the languorous women, the man who has left his hat in the boat, and the viewer all have access to a state in which conscious control of the mind had been suspended, in which libertine behavior would be fully absolvable.

Manet's *Déjeuner sur l'herbe* was most noteworthy in its depiction of a nude woman staring out at the viewer and all but ignored by her clothed male companions. Like Courbet's painting, there is a breach of decorum in and around a landscape with figures, a body of water, and a boat. There is an absence of conscience here on the part of the woman, the men, and the viewer; the viewer in particular has no pretext for being there and is definitively implicated in the woman's knowing look. Critics at the time complained not that there was a nude in Manet's picture but that there was no pretext for a nude woman to be lounging near two fully clothed men; they suggested that Manet's picture was offensive not because it was immoral but because it was amoral and sanctioned its own moral omissions in its abrupt physicality.[24] Conscience was exactly the aspect of the conscious that was threatened in the age of Darwin. If the physiologists triumphed, human beings would be reduced, in the eyes of the spiritualists, to animals functioning automatically, on instinct. Art, which was traditionally viewed as something to elevate the human spirit, was not a place to assert the animalistic nature of the human being. The act of viewing Manet's *Déjeuner* both evokes an unthinkable social situation and suggests the figures' submission to involuntary desires. This was one of the most dangerous things about the picture's subject.

Manet, of course, was not trying to paint a picture about uncon-

scious wishes or desires. It is well known that Manet posed the model Victorine Meurent, his future brother-in-law Ferdinand Leenhoff, and one or both of his own brothers after the figures in Raphael's *Judgment of Paris,* a work he knew through a print by Marcantonio Raimondi (Fig. 11). As has previously been pointed out, it was not unimaginable for an artist in Manet's time to think of posing contemporary models in tableaux after the great works of the past – it was a parlor game as well as an aspect of contemporary art practice – but it was novel for Manet to recast the tone of the piece so radically and to alter the gender of the characters, the circumstances of the scene, and the presence or absence of clothing.[25] Antonin Proust, Manet's friend in their teacher Couture's studio, recalled that Manet spoke of having copied "the women of Giorgione, the women with the musicians," and of wanting "to redo it in the transparency of the open atmosphere."[26] Thus the famous *Pastoral Concert* (Fig. 8), at the time attributed solely to Giorgione but now usually considered to have been finished by Titian, is displayed alongside Manet's *Déjeuner* in every introductory survey of art history as an example of the modern artist's taking a subject out of the past and making it contemporary in dress, manners, and painting style. One of the starkest formal differences has to do with the aura of golden light on the female figures in the *Pastoral Concert* and the lack of chiaroscuro on the nude figure of Victorine Meurent. The extremely high value contrasts set off the figures in Manet's large canvas in a way which would guarantee that the painting delivered a powerful punch from whatever badly illuminated, skied position the Salon jury might have chosen for it.[27]

The notoriety of Manet's interest in the Louvre *Concert* notwithstanding, a link between the *Déjeuner* and Giorgione's *Tempesta* (Fig. 32) has often been sensed, but until now has never been substantiated.[28] Manet and his brother Eugène traveled to Venice in the fall of 1853.[29] Until recently, it has not been known whether Manet could have seen the *Tempesta,* rarely discussed before the publication of Burckhardt's *Cicerone* in 1855.[30] However, William Hauptman has recently published a sketch made by Charles Gleyre on his trip to Venice in 1845.[31] Other travel accounts from the period have mentioned the picture.[32] And a guidebook by the German art historian Ernst Förster places the painting on view at the Palazzo Manfrin at least as early as 1840.[33] The guidebook, hav-

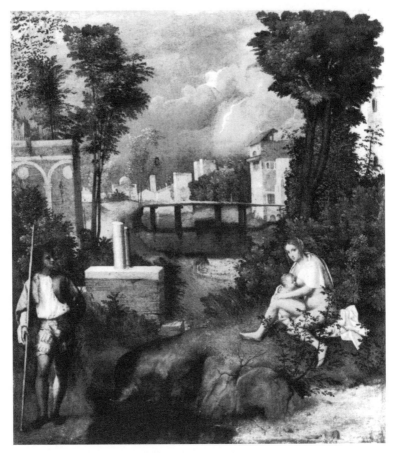

Figure 32. Giorgione, *Tempesta,* c. 1506. Accademia, Venice.

ing gone through several German editions in the 1840s, appeared in French in 1850 and was in its day a remarkably extensive guide to paintings and monuments in Italy.[34] There is, then, an excellent chance Manet had the opportunity to view the Giorgione and might even have had access to a printed French source to call it to his attention.[35] Given Manet's enthusiasm for the Louvre painting and the comments about it he made to Proust, it is safe to assume that while in Venice Manet would have deliberately sought an opportunity to view the *Tempesta* and that he would have been highly receptive to its suggestions.

Looking at the *Tempesta* as Manet might have, we see that certain characteristics emerge at once. Manet would surely have admired the sensuousness of the landscape and the painterliness of Giorgione's handling of the medium. The pose and ample figure of Manet's model, Victorine Meurent, recall the figure in the Giorgione.[36] Both works depict landscapes with figures just large enough so that the pictures cannot be easily categorized as either pure landscape or figure paintings. Giorgione's painting, often called *The Family of Giorgione* in the nineteenth century – a fact to which we will return – positions a man, possibly a sentinel, at left; on the opposite side of the embankment is a woman – nude except for a shawl – who is nursing a baby.[37] Vasari mentions no family of Giorgione that corresponds to the figures we see in the painting. The Giorgione appears to have been dubbed *The Family of Giorgione* based on some verses out of Byron's *Beppo* of 1817 ("'Tis but a portrait of his wife, and son/And self, but such a woman! love in life!"), although there are conflicting opinions about whether Byron was describing the *Tempesta* or a painting now ascribed to a follower of Titian, the *Triple Portrait* (Collection of the Duke of Northumberland, Alnwick Castle, Alnwick).[38] We should bear in mind that if Byron's verses were spun around the *Tempesta,* he would have been responding to some existing legend about it or some set of formal characteristics of the painting itself. The scene's intimacy and casualness, as well as its lack of a clear narrative program or of any obvious iconographic scheme, could give rise to the notion that the painting is some sort of family scene or even an allegory of Giorgione's illegitimacy or illegitimate child.[39] In the painting, some question of certainty with regard to the child's parentage is perhaps intimated in the way the woman and the man appear to be unconnected and in the atmosphere of furtiveness that surrounds the mostly nude woman nursing a baby out in the woods in a stormy setting. Manet, whose lack of narrative clarity in the *Déjeuner* is exceeded only by that of Giorgione's painting, would surely have been drawn to this scene, which simultaneously encourages interpretation and thwarts traditional narrative readings.

The *Tempesta* exemplifies Giorgione's embrace of an indeterminate subject within the pastoral mode of painting.[40] The figures in the painting are pictured with particular attributes; it would appear that a woman with a child, a man who carries a weighty staff, and a

stormy landscape with a distant town (among other details) could all be clues to some myth or story. At the same time, we must pay heed to the fact that fewer than thirty years after it was painted, an inventory of the private collection to which it belonged referred to the painting simply as a landscape with a soldier, a gypsy, and a child – a fact which suggests at the very least that its subject was originally elusive or perhaps iconographically obscure or insignificant.[41] What encourages narrative readings of this painting – and Manet's – is the way the man looks in the direction of the woman but does not clearly represent someone who is guarding or caring for her, whereas the woman, already in a vulnerable position, looks out of the painting directly at the viewer. The visual force of her gaze and the impression it makes on the beholder are singularly and powerfully imitated in Manet's painting.

Another striking characteristic of the Giorgione painting is the treatment of the female figure. Although she wears a cape half draped over her shoulder, she is basically nude. Despite the ingenuity of scholars who have ascribed roles to her that range from Astarte and Eve to the Virgin Mary and beyond, a quality of unidealized earthiness remains a notable aspect of the painting.[42] The woman is often identified as a gypsy, and this can be supported by the fact that she is nursing her child out in the landscape and she appears possessionless.[43] One can imagine the reaction of the nineteenth-century upper-class viewer on seeing the baby at the woman's breast in the context of the woman's relative nudity and her gaze out of the picture. These attributes are also highly unusual in the Renaissance. The intimacy of the situation in which the viewer finds the woman must also be reconciled with her relative lack of connection with the male figure on the other embankment. This enigma might well have been a powerful draw to Manet, who would later paint many pictures in which figures fail to connect.

In Manet's time, Venetian painting was beginning to receive more attention; aspects of Venetian painting were admired and emulated by artists as disparate as Dante Gabriel Rossetti and Cézanne.[44] As Anne Hanson has suggested, Venetian art was considered "realistic" in the mid-nineteenth century insofar as it was not linked with an intellectual interpretation of nature.[45] One looked at Venetian painting to admire what Förster saw: "the luminosity in the colors [Glanz in der Farbe]."[46] Yet in addition to the obvious

properties of sensuous paint handling and rich colorism, there is another aspect to what Venetian art stood for in mid-century France that I think has particular relevance here. Stendhal summarized the differences between Venetian and Florentine art:

> The school of Venice appears to have been born quite simply of the attentive contemplation of the effects of nature and of an almost mechanical and unreasoned [*non raisonnée*] imitation of the scenes with which it enchants our eyes.
>
> By contrast, the two luminaries of the school of Florence, Leonardo and Michelangelo, would have preferred to search for the causes of those effects that they were transporting on canvas.[47]

Whereas Florentine painters emphasized reason and constructed pictures according to scientific principles, the Venetians, according to Stendhal, created enchanting tableaux by contemplating nature and imitating it mechanically and without reason. The word *mécanique* here, I think, is not meant to invoke the explicitly machine-like but rather the automatic – in the sense of *l'automatisme* – something done reflexively, somatically, without the exercise of intelligence and moral choice. A dictionary example quotes Zola in *Pot-Bouille,* 1882: "Duveyrier raised his feet in the mechanical fashion of the somnambulist."[48] Stendhal, then, is making a kind of equation between Venetian painting and a method of copying nature that was at some level unconscious. Stendhal's book of 1817, incidentally, was reprinted as a definitive edition in 1860 and was a work Cézanne mentions having read no fewer than three times.[49] One can therefore assume that it had some currency for French painters in the 1860s.

The physical and the unconscious also make their way into Charles Blanc's introduction of the Venetian School in his *Histoire des peintres de toutes les écoles:*

> One never sees it [Venetian painting] managed by wisdom, by cold reason; never held back by respect for history or for proprieties which, in another School – in ours, for example – would not be violated without scandal. All proceeds from fantasy: history is recounted like a novel; the most superstitious beliefs take physical shape, and it seems that the Venetians are more concerned with figuring the imaginary than with representing the

real – impossible things being those which come most easily to their way of thinking.[50]

In one introductory paragraph, Blanc speaks of "fantasy," "the imaginary," and "a child-like naïvety," exclaiming "what abundance of imagination! what freedom of comportment!" and "all the scenes take place in the land of dreams."[51] Blanc even appears to have been influenced by Manet's appropriation of Giorgione when he writes: "Giorgione transports us to the fabulous lands of a Venetian Decameron, where one sees nude women dreaming *sur l'herbe* or lending an ear to amorous musicians."[52] Venetian painting was, for Blanc, a novelistic dream world in which the inexplicable multiplied, in which "the strange dominates, the bizarre triumphs; painting is no longer anything more than a matter of tours de force of improvisation, or stage-management behind which there is nothing but a void."[53] In the same volume, Paul Mantz's essay on Giorgione praises the Louvre *Pastoral Concert* with the phrase "what absence of subject-matter!"[54] Mantz too seems to be thinking of Manet's painting and not the Louvre *Pastoral Concert* that he is ostensibly describing. He overstates the way Giorgione's second clothed man is "inattentive" to the first and claims: "How these persons have come to be there, and why they appear so indifferent to that which they seem to be doing, one does not know and one does not need to know, for Giorgione is not a doctor in search of nebulous subtleties, but a painter."[55] Compare these texts with Rigollot's 1852 essay on Giorgione, which states more accurately that in the Louvre picture, one male figure "appeared to play the lute or rather to chat with his neighbor."[56] I think it is possible to assert that by the late 1860s Mantz misreads Giorgione and Blanc revises his view of Giorgione based on an experience of Manet's painting.

Manet's interest in Venetian painting in general can be thought of as an involvement with a sensuous art, an art that possessed "a strange promiscuity of times and of personages,"[57] an art in which "the subject is nothing."[58] If Giorgione's painting contained elements of myth and allegory, it in effect resituated them in a pictorial world that was primarily sensual.[59] It was this embeddedness in sensuality that made some viewers in the mid-nineteenth century somewhat uncomfortable. After a long day of sightseeing in Venice with Edouard and Eugène Manet acting as guides, Emile Ollivier bemoaned the earthiness of Venetian painting. On the one hand, he

was pleased by a certain freshness about the paintings that made them look as if they had been painted yesterday. On the other hand, Ollivier despaired: "what an absence of the Ideal! what materialism!" One can imagine Manet seeking out precisely these qualities.

At this juncture, we can begin to make more precise postulations about the connections between Manet's painting and Giorgione's. We have seen the way Venetian painting in the 1860s was linked with an amoral emphasis on physicality, with the imaginary or unconscious, and with a dream world in which there was neither logic nor narrative order. This is not far from the kind of discourse on the dream world itself that we have seen in commentators such as Maury. The world conjured by Giorgione was one in which involuntary desires took on physical reality, a world like the dream world in which the inadmissible was permissible and no one – certainly not the artist – could really be held accountable. Just as Mantz proclaimed that there is no reason why Giorgione's figures should be doing what they are doing, critics in 1863 complained about the way Manet, in the *Déjeuner*, depicted persons as objects or automatons. "He treats human beings and objects in the same fashion," wrote Adrien Paul; and Ernest Chesneau: "Manet's figures make us automatically think of the marionettes on the Champs-Elysées: a solid head and flaccid garments."[60] Manet's picture suggested that persons were like puppets. This absence of conscious control was embodied by the nude woman whose breach of decorum was exacerbated by the indifference of the men. It was precisely such an utter absence of moral volition that the French critics saw animating the paintings of Giorgione. To the nineteenth-century viewer, the bizarre intimacy of the Giorgione scene would have been unthinkable outside a familial setting – hence the notion that the *Tempesta* depicted the family of the painter. Manet's gesture of unclothing Victorine must be understood in the context of a period that emblematized its own prudery, as Philippe Perrot has pointed out, by covering piano feet in little shoes and by counseling women to wrap themselves in peignoirs after the bath.[61] Compare the image of the naked Victorine with a nineteenth-century etiquette manual: during the bath itself, "if necessary, close your eyes until you have finished the procedure."[62]

In addition to trying, however briefly, to reconstruct a context for viewing Venetian painting in the 1860s, we should also, as Fried

urges, take into account the extraordinary specificity of Manet's sources. It seems to me that what Manet ultimately made of the *Tempesta* in the *Déjeuner* was quite different from what he made of the *Pastoral Concert,* and, in turn, far from what he saw in Marcantonio's *Judgment of Paris.* We should keep in mind, for instance, that the *Tempesta* was known in only a limited capacity, and then considered an ambiguous scene of a nude mother and child, or as *The Family of Giorgone* – perhaps even as a secret or illegitimate family of a handsome, robust sixteenth-century painter whose life and early death remained mysterious.[63] Manet's *Déjeuner,* I will argue, is not only a positivist picture of a dream world and not only an homage to Marcantonio and to Giorgione. The relation between Manet's picture and Giorgione's should, in fact, be seen along the lines of the reflections on Manet's picture made in Cézanne's *Le Déjeuner sur l'herbe:* an imaginative reworking that has the makings of a fantasy. As such, it becomes a picture of T*he Family of Manet,* or what I will call a family romance in Manet's art. Freud's idea of the family romance centers on the child's invention of a mythology of the family, often one that promises a certain freedom or set of social possibilities unavailable in the real family.[64] Ferenczi, too, considers within the rubric of the family romance such imaginings as "affairs between countesses and coachmen or chauffeurs, or between princesses and gypsies" or the legends of animals as helpful underlings.[65] The family romance includes the fantasies of the imagined illegitimacy of a sibling or the celebrity of the parents (or, alternatively, that instead of being the child of socially prominent parents, one belongs to a family of nomads or gypsies).

The idea that Manet's *Déjeuner* has elements of a familial scene has always been part of what was known and said about the picture. The painting depicted such family members and intimates as his brother(s), future brother-in-law, and favorite model. The landscape was based on sketches of the Manet family property north of Paris near Gennevilliers, property that had been a family home or retreat for generations.[66] Several commentators have linked the painting with a reminiscence of a childhood idyll and with the circumstances surrounding Manet's father's death.[67]

It might be useful here to review certain facts of the Manet family biography. Manet's father, Auguste, a judge in one of the civil chambers of the Tribunal de la première instance in Paris,

came from a long line of aristocratic *gens de robe* and men of the law, including juridical councilors to the king of France.[68] Manet's mother, born Eugénie-Désirée Fournier, grew up in Sweden, the daughter of a Frenchman who had helped the Napoleonic maréchal Charles Bernadotte win the Swedish throne.[69] She was the goddaughter of the king of Sweden and also had French aristocratic ancestors.

During the years 1850–1, the eighteen-year-old Edouard Manet, having already rejected law as a profession, failed his naval exams twice and announced he wanted to be a painter. At the same time, Auguste had a falling-out with Eugénie's brother Edmond Fournier, who had encouraged Manet's artistic leanings since childhood. Eugénie's mother died in 1851, an event that no doubt preoccupied her and at this point may have further contributed to the distance between the Fourniers and the Manets. And to top it off, Auguste was once again passed over for promotion to a higher court. The Dutch musician Suzanne Leenhoff had only recently appeared on the scene; she was ostensibly the piano teacher to the Manet sons, now fifteen to eighteen years old. In January 1852, Suzanne gave birth to a son, Léon. On his birth certificate, the fictitious name Koëlla appears as his father's name, and the child was passed off in society by the Manets as Suzanne's youngest brother.[70] Art historians had long assumed that the boy was Edouard's son, but circumstantial evidence supports the allegation published in 1981 that, in fact, Manet's father Auguste was the father of the boy.[71] The Manets kept the paternity tightly under wraps. Several years later, in late 1857, Manet's father became paralyzed after a stroke, which compounded the symptoms of tertiary syphilis. He died in September 1862, never having regained his ability to speak.

Manet painted the *Déjeuner* in late 1862 and/or early 1863. At that time there were at least two pressing issues for the family which I will argue have relevance for the subject matter of the painting. After the death of Manet's father, Manet and his brothers decided to sell a portion of the Gennevilliers property and divide the proceeds. Insofar as the land must have been a repository of memories of the father, one would surmise that the estate would have become both an emotional and a financial issue for the family in late 1862. At the same time, the Manets would also have found themselves in a bit of a quandary over what to do about Suzanne

and her son. The only way to protect her and the family name, it must have seemed, would have been for one of the Manet sons to marry her; the eldest, Edouard, fulfilled that responsibility by wedding her in October 1863, a year after his father's death. Although most art historians have long assumed that Edouard Manet and Suzanne Leenhoff had enjoyed a clandestine liaison for a long time, we should take note of the fact that the marriage came as a surprise to Manet's close friend Baudelaire.[72] Perhaps it was not Manet and Suzanne's relationship that had to be hidden. Another curious fact is that although Léon was well cared for by the Manets, he was never legitimized, even after Suzanne's marriage to Edouard, when legitimation would have been automatic had Edouard been the father. Such was the case with many of Manet's artist friends, including Monet, Cézanne, Pissarro, and Renoir.[73] In fact, in French law of the time, whereas nothing stood in the way of legitimation of children born out of wedlock upon the marriage of the parents, children born to individuals *who were already married to others* at the time of conception could *never* be legitimized under any circumstances.[74] This fact alone supports the allegation that Edouard Manet was not the father of Léon but, rather, that his father was an individual who was married to someone else at the time. It was certainly the career and reputation of the civil judge that had to be protected, and after his death, his memory and the family name. It is not only the case that the Manets' social prominence may have motivated such a decision: it was a fact that Manet's father, the civil judge, had been called upon to rule on just such things as paternity disputes. Léon's paternity, then, would have had to remain a family secret. It is, in my view, no accident that Manet's large painting of 1862–3 pictures family members and intimates on the family property, and with an air of côterie about them: theme and biographical fact can hardly be separated here. At the same time, I think the notion of the "family romance" in Manet's early work can best be supported by looking at his figural and compositional choices in several early works.

Looking at Manet's subject matter in the early 1860s, one is struck by his interest in gypsies, ragpickers, street singers, and beggar boys. It is noteworthy that he does not paint just any street types but by contrast paints recognizable individuals over and over again. *The Old Musician* (National Gallery of Art, Washington, D.C.) features a

known gypsy violinist, Jean Lagrène, as well as Manet's own *Absinthe Drinker* (Fig. 9), the boy who posed in *Boy with Dog* (private collection, Paris), and the very young girl with a baby, who also appears in an etching after the painting.[75] At least one of the rag-picker-philosophers from the 1865 series had appeared in the crowd in *Music in the Tuileries* (Fig. 30).[76] Victorine Meurent, his model in many of the key early paintings, is the recognizable *Street Singer* (Fig. 27). It remained a family tradition that Eugène Manet posed for the *Philosopher* (Art Institute, Chicago), the one who appears most upright and aloof. As was mentioned earlier, Manet paired Victorine and his other brother, Gustave, as the *Espada* and *Majo* who flanked the *Déjeuner sur l'herbe* in the 1863 Salon des Refusés, making the trio of pictures a family grouping. And Ewa Lajer-Burcharth has convincingly argued that we could look at Manet's *Absinthe Drinker,* rejected from the Salon of 1859, as a kind of self-portrait of the artist at the margins of society.[77] In her view, Manet was deliberately courting a certain kind of marginality by making the *Absinthe Drinker* his first Salon submission and, as it were, a personal artistic manifesto. A case can be made that not only does Manet picture members of his own family as gypsies or street types but the so-called gypsy or street types recur in his work like a loose-knit but discernible family – one utterly at odds with the social sphere of the Manets – a veritable *negation* in the Freudian sense.

Manet not only invented a family of street singers and gypsies in his early work: he also pictured the social world of his own family. Consider *Fishing* (Fig. 14) and *Music in the Tuileries* (Fig. 30), two small pictures that can be seen as pendants. They are the same size and were probably painted within a year of one another, 1861–2, just around the time of Manet's father's death.[78] They are the only multifigure paintings in which Manet includes a self-portrait; in each case, he appears at the margins of the picture. *Fishing* is a fantasy reworking of a Rubens and Carracci landscape, with Manet himself and Suzanne Leenhoff as the Rubenesque couple in the front of the picture. Léon Leenhoff is shown angling in the middle ground; as in the *Déjeuner,* the site is the family property near Gennevilliers.[79] In *Music in the Tuileries,* recognizable members of the Parisian artistic beau monde – Baudelaire, Eugène Brunet, Jacques Offenbach, Zacharie Astruc – have congregated for a public concert in the Tuileries Gardens. *Music* has long been seen as one of Manet's first great

modern-life paintings. I would point out – and Manet's preparatory drawing (private collection) specifically accentuates this – that a family grouping forms the core of this dense picture of Parisian sociability. Julie Manet identified the figure of her father, Manet's brother Eugène, as the top-hatted figure seen near the center of the painting, bowing.[80] Just to the left of Manet's brother Eugène is the figure of a widow, who probably represents Manet's mother, Eugénie.[81] Further to the left of Eugénie is the towheaded boy in the recognizable costume of the *Boy with a Sword* – Léon Leenhoff; he is leaning toward Eugénie and has perhaps climbed on a chair to do so. Eugène is probably conversing with Léon's mother, Suzanne, veiled but not in high mourning; she points an umbrella in his direction. Inscribed in this picture of public sociability, then, is a private familial grouping. *Fishing* and *Music in the Tuileries* represent the two halves of the social world Auguste Manet was leaving behind: on the one hand, the weekend retreat with its quotidian fishermen and the idyllic landscape (including the adult son, the mistress, and the illegitimate boy) and on the other, the fashionable Parisian men and women of letters who regularly came to the Manet household – the widow in her social circle. I would suggest that insofar as Manet has pictured himself in these paintings – stepping into these roles of the imaginary escort to Suzanne and of the Parisian artist-dandy – the intended spectator of the paintings is in a very real sense Manet's departed father, Auguste.[82]

Manet's realization of his own version of the "painting of modern life" in the early 1860s repeatedly featured a familiar milieu and a familial cast of characters. Victorine Meurent, of course, figures prominently in this dramatis personae; she appears as herself, as a street singer, as a model in male bullfighter's costume, in a dressing gown, conspicuously nude at a picnic, and, notably, as a courtesan.[83] She becomes in effect a member of the family insofar as she reappears in so many early works; the viewer at the Salon des Refusés is encouraged to recognize her with the brothers and again in Spanish costume.

As we have seen, even paintings of a public social world such as *Music in the Tuileries* are in a sense circumscribed by a private familial group. In some ways, the pictures' authenticity as Realist paintings depends for its effect on a degree of spectator recognition of these characters: the repetitions make the viewer aware of Manet's

presence as painter and observer. As Derrida writes of Freud's *Beyond the Pleasure Principle,* Freud's references to living "under the same roof" as the subjects he observes – his daughter and grandson – "guarantee the observation only by making of the observer a participant."[84] I think it is safe to say that Manet's familial references not only remind the spectator of his own role but also make the spectator of the painting a participant. It has long been central to many accounts of Manet's art that the spectator and the experience of the spectator play a prominent role in the framing of Manet's great figure paintings.[85] I am arguing, then, that not only does a "family romance" structure Manet's early works but that it also frames the experience of the spectator. It is the spectator at the Salon des Refusés, after all, who is confronted not only with the brazenness of the *Déjeuner* but with the doubling of its figures in the costume pieces that frame it. On one side, the swarthy self-assured brother; on the other, the female model in the same bolero; on one side, the *majo* cult of male beauty; on the other, a travesty – a woman in culottes, not a bullfighter. The costume pieces come across as posed, and they in turn open up the *Déjeuner*'s posed-ness, its status as a reenactment.

The reader may be wondering whether the notion of an unconscious "family romance" emerging in Manet's *Déjeuner* might ultimately contradict a thesis about a "painting of modern life" or Manet's attention to contemporary life and a recognizable social world that was part of a set of explicitly Realist commitments. I do not think this is a contradiction. Just as it is acceptable in the field of literary studies to think about a text as interweaving a set of conscious intentions and commitments with another set of unconscious misreadings and figurations on which the text's construction depends, I think it critical that we not confine ourselves either to Manet's explicit agenda or to a reading that brackets Manet's intentions as irrelevant, unrecoverable, or as a false consciousness. Manet's *Déjeuner* is at once a picture of a dream world, an homage to Giorgione and Raphael in which the earlier paintings are restaged, and a family drama that is best understood with some historical distance, with the benefit of Freud and Lacan. But Manet's flirtations with a dreamlike recasting of Old Master paintings – starring his family members and intimates – need further explication.

The spectator of Manet's painting in many ways can apprehend

the painting's drama and its mode of depicting a world only by experiencing several distinct spectatorial positions within the painting. Perhaps first and foremost, the gaze of Victorine invites the spectator to identify with her and to attempt to reconcile his or her own feelings of shock and embarrassment with the model's lack of them, with her presence among the clothed males. It is an experience of what could be called an inhibition of exhibitionism; it is the experience of the dream of being naked in a social situation and being frozen in place.[86] It is in this sense that the painting replicates the experience of the *Tempesta,* in which the woman's nudity and enigmatic gaze are inexplicable, in which there is a dreamlike lack of logic when we are led to expect a narrative. On another level, the painting reworks the Louvre *Pastoral Concert* and is a reflection on the subject of a reminiscence of four figures in nature. The *Pastoral Concert* depicts a harmonious eclogue and suggests a relation among the figures, the town, and the landscape that was perhaps meant to have the character of a reminiscence of something that never was. Manet's painting substitutes the setting of a childhood retreat, now irrevocably altered by circumstance. If this is a picture of a paradise, as several commentators have claimed,[87] it is in my view one that has already been lost and is recognized as never to be regained. The viewer's experience of the stark presence of Victorine Meurent, the way her creamy white figure stands out harshly against the dark greens of the landscape, makes it impossible to see the relation between the figures and nature as a harmonious one. There is yet another experience of the spectator that is key to the picture's effect. The entire foreground trio seems to be in on something – I suggest something like a family secret – with which the spectator is expected to collude. In this scenario, the figures occupy the position of the river gods in Raphael's *Judgment of Paris* and are watching as something else takes place; in the original story, a choice is made, and a woman given in marriage. In many ways, the themes and effects of the painting hover around the acts of desire, protectiveness, reminiscence, and secrecy that characterize an actual "family romance" of Manet. These themes can also be seen to animate the Renaissance paintings Manet admired – aspects of which he sought to replicate in his painting of 1862–3. The *Tempesta,* in particular, insofar as it appeared to represent an allegory of T*he Family of Giorgone,* could have provided Manet with a complex model for sug-

gesting relationships among the figures without resolving them, for emphasizing the sensuousness and materialism of the landscape, and for in some way picturing a family and entrusting its secret to the gaze of a nude woman out of the painting. I see these themes and histories not in terms of a set of unconscious motivations and biographical facts somehow taking precedence over the more public, professional ones: I see them as profoundly connected to Manet's project as a painter of modern life.

MANET'S 1871 INVENTORY was a private document, drawn up late in the year, when Manet was not able to paint in the wake of his grim experience during the Siege of Paris and the Franco-Prussian War. It is significant that in the inventory he noted the painting as *La Partie carrée* (*Le Déjeuner sur l'herbe*) and valued it at 25,000 francs, higher even than the *Olympia*. The inventory may provide us with a clue into the way Manet himself thought of and referred to the painting. The title is possibly a reference to Watteau's *La Partie quarrée* (Fine Arts Museum, San Francisco), an image Manet may have known, as Ingres did, from a Boucher print after it.[88] But the phrase, then as now, refers to a foursome with the implicit connotation of sexual partner swapping.

Michael Fried has argued forcefully that Manet's art of the early 1860s should be seen as participating in a Watteau revival of sorts.[89] Certainly, it seems plausible to consider the eighteenth-century painter as the key predecessor for the complex exchange of glances in the *Déjeuner,* for its leftover picnic and discarded clothing, and for its dreamlike mixture of activities (bathing, picnicking, and more). In place of Watteau's recurrent dogs and sculptures of Venus and Cupid, Manet adds a bright green frog in the lower left corner. It would indeed be fruitful to look at Manet's *Déjeuner* as Thomas Crow has argued we should regard Watteau's *fêtes galantes,* namely, as a "frankly artificial" genre that added "another, necessary layer of fiction over the life-as-fiction it portrays."[90] Ultimately, I would like the reader to look upon my adaptation of Freud's idea of the "family romance" not as a biographical reality painted faithfully by Manet but as a biographical *fiction* painted as such. If Manet called the painting – even in passing – *La Partie carrée,* it seems he meant the *Déjeuner* to be a loose adaptation of several visual narratives with the express possibility that the actors might switch partners as

well as roles. And as long as the gaze of Victorine Meurent draws
the spectator into the tangle of legs, feet, and hands at the painting's
core, she or he is offered a similar chance.

NOTES

The research for this essay was facilitated by a grant from the Humanities
Center at Wayne State University, Detroit, Michigan. I wish to thank
Christopher Campbell, Lucy Locke, Alexander Nagel, César Trasobares,
and Paul H. Tucker for their assistance and suggestions.

1. "Manet's Sources: Aspects of His Art, 1859–1865," *Artforum* 7, no. 7
 (March 1969), 29; see also *Manet's Modernism, or, The Face of Painting in the
 1860s* (Chicago: University of Chicago Press, 1996), p. 27.
2. There is some disagreement among Manet scholars concerning which of
 Manet's two brothers posed for the *Déjeuner*. Tabarant claimed it was
 Gustave; Moreau-Nélaton that it was Eugène; Proust that they posed in
 turn. Proust may be correct; the figure has Eugène's finer features and
 Gustave's dark hair. The important point is that the repetition of cos-
 tumes and features among the three paintings at the Salon des Refusés
 was noticeable. See Adolphe Tabarant, *Manet et ses oeuvres* (Paris: 1947), p.
 61; Etienne Moreau-Nélaton, *Manet raconté par lui-même* (Paris: 1926), vol.
 1, p. 49; Antonin Proust, "Edouard Manet inédit," *La Revue Blanche* 12,
 no. 85 (February 15, 1897), 172.
3. The 1871 inventory is reproduced in Paul Jamot and Georges Wilden-
 stein, *Manet* (Paris: Beaux-Arts, 1932), vol. 1, p. 89. The catalogue entry by
 Françoise Cachin in *Manet 1832–1883* (New York: Metropolitan Museum
 of Art, 1983), p. 172, gives a complete provenance for the painting.
4. Meyer Schapiro, "The Apples of Cézanne: An Essay on the Psychoana-
 lytic Meaning of Still-Life" (1968), reprinted in Schapiro, *Modern Art,
 Nineteenth and Twentieth Centuries: Selected Papers* (New York: Braziller,
 1986), p. 9. See also Judith Wechsler, "An Aperitif to Manet's 'Déjeuner
 sur l'herbe'," *Gazette des Beaux-Arts* 6 pér., 90/1308 (January 1978), 32–4;
 Beatrice Farwell, *Manet and the Nude* (New York: Garland, 1973), pp. 149,
 250–6; Anne Coffin Hanson, *Manet and the Modern Tradition* (New Haven:
 Yale, 1977), pp. 92–5; Wayne Andersen, "Manet and the Judgment of
 Paris," *Art News* 72, no. 2 (February 1973), 63–9; T. J. Clark, *The Painting of
 Modern Life: Paris in the Art of Manet and His Followers* (New York: Knopf,
 1984), pp. 4–5; and the essay by Carol Armstrong in this volume. In addi-
 tion, Hubert Damisch reflects on the relations between Manet's painting
 and the myth of the Judgment of Paris, as well as on the philosophical
 foundations of a notion of the judgment of beauty, in *The Judgment of
 Paris*, J. Goodman, trans. (Chicago: University of Chicago Press, 1996).

5. A bibliography on the painting can be found in Lawrence Gowing, *Cézanne: The Early Years,* Exhibition catalogue (Washington, D.C.: National Gallery of Art and Abrams, 1988), p. 172; see also the catalogue essay by Mary Louise Krumrine, "Parisian Writers and the Early Work of Cézanne," pp. 25–7.

6. Richard Wollheim, in *Painting as an Art* (The A. W. Mellon Lectures in the Fine Arts, 1984; Bollingen Series 35, no. 33; Princeton: Princeton University Press, 1987), pp. 231–46, considers Harold Bloom's notion of the "anxiety of influence" and brings it to bear on Manet's "identifications" with earlier masters, as well as with Picasso's phantasmagoric reworkings of Manet's *Le Déjeuner sur l'herbe.*

7. See the entry on "fantasy" by Victor Burgin in *Feminism and Psychoanalysis,* E. Wright, ed. (Cambridge: Blackwell, 1992), pp. 84–8; Constance Penley, "Feminism, Psychoanalysis, and the Study of Popular Culture," *Visual Culture,* N. Bryson, M. A. Holly, and K. Moxey, eds. (Hanover, N.H.: Wesleyan University Press and University Press of New England, 1994), pp. 302–24; and the classic essay by Jean Laplanche and Jean-Bertrand Pontalis, "Fantasy and the origins of sexuality," reprinted in *Formations of Fantasy,* V. Burgin, J. Donald, and C. Kaplan, eds. (New York: Routledge, 1986), pp. 5–34.

8. Sigmund Freud, "'A Child Is Being Beaten': A Contribution to the Study of the Origin of Sexual Perversions," *The Standard Edition of the Complete Psychological Works of Sigmund Freud,* J. Strachey, ed./trans. (London: Hogarth Press, 1958), vol. 17, pp. 179–204 (hereafter abbreviated S. E.).

9. See her "Introduction – The Lady Doesn't Vanish: Feminism and Film Theory," *Feminism and Film Theory,* C. Penley, ed. (New York: Routledge, 1988), pp. 22–3.

10. Here I have in mind both Lacan's 1949 essay, "The mirror stage as formative of the function of the I," *Écrits,* A. Sheridan, trans. (New York: Norton, 1977), pp. 1–7, and his remarks in *Le Séminaire IV: Les relations d'objet, 1956–57,* J.-A. Miller, ed. (Paris: Seuil, 1994), pp. 173–8, in which he discusses his concept of "l'image du corps" and its status as imaginary. One could make an analogy between Cézanne's way of viewing and appropriating the image of Manet's *Déjeuner* and the Lacanian subject's view of the idealized reflection in the mirror: the subject recognizes the image with elation but remains irrevocably estranged from it. One treatment of these early Cézanne paintings that attempts to bring together personal fantasy and professional ambition is that of Meyer Schapiro, *Paul Cézanne,* 3rd ed. (New York: Abrams, 1965 [1952]), pp. 24–6. In his introductory essay, Schapiro analyzes the violence of Cézanne's early fantasy pictures, which Schapiro considers to be modern-life images and which he opposes to Delacroix's settings in a remote place or time. The author views these images as inextricably connected, both in style and iconography, with the artist's early emulation of Manet and his friendship with Pissarro.

11. See Debora L. Silverman, *Art Nouveau in Fin-de-Siècle France: Politics, Psychology and Style* (Berkeley: University of California, 1989), pp. 75–106.

12. Jan Goldstein notes that these lectures "were open to interested medical students and to physicians" and discusses a suspension of these talks as a result of a controversy in 1865 over Alexandre Axenfeld's lectures on the innocence of witches tried for sorcery in the sixteenth century. See *Console and Classify: The French psychiatric profession in the nineteenth century* (New York: Cambridge University Press, 1987), pp. 355–6; see also Aristide Verneuil et al., *Conférences historiques faites pendant l'année 1865* (Paris: Ballière, 1866). Sartre also refers to the 1865 debates of the Société Médico-Psychologique in *L'imagination* (Paris: PUF, 1989 [1936]), p. 21.

13. Edmond Duranty, "Notes sur la vie nocturne," *Nouvelle Revue de Paris* 6 (November 1, 1864), 534–58; "Le Sommeil et les rêves," *Musée Universel* 2 (1873), 218–20.

14. Here I am indebted to the arguments put forth in Goldstein, as in note 12.

15. Goldstein, as in note 12, p. 245. She explains the history of terms such as "positive philosophy" in philosophical and psychological circles of the period and wishes to distance herself from the overuse of the term "materialist" (pp. 242–4); I use the term here for its familiarity to art historians.

16. Goldstein, as in note 12, p. 243.

17. Baillarger's "Théorie de l'automatisme," published in 1845, was reprinted in *Recherches sur les maladies mentales* (Paris: Masson, 1890), vol. 1, pp. 494–500.

18. Goldstein, as in note 12, p. 263, discusses the significance of Baillarger's argument for the psychiatric field of the time.

19. The insanity plea was, of course, based on the idea that one was not responsible for one's actions at the moment the crime was committed; it was thought that one was literally *aliéné,* alienated from the self. A fascinating discussion of these developments can be found in Goldstein, as in note 12, pp. 276–321.

20. Published by Didier. Edmond Duranty, for instance, praises the book in his 1864 article, as in note 13, p. 558.

21. Maury, as in note 20, p. 38: "Ce n'est ni l'attention ni la volonté qui amènent devant le regard intellectuel ces images que nous prenons en rêve pour des réalités; elles se produisent d'elles-mêmes, suivant une certaine loi due au mouvement inconscient du cerveau et qu'il s'agit de découvrir; elles dominent ainsi l'attention et la volonté, et par ce motif nous apparaissent comme des créations objectives, comme des produits qui n'émanent point de nous et que nous contemplons de la même façon que des choses extérieures. Ce sont, non pas seulement des idées, mais des images, et ce caractère d'extériorité est précisément la cause qui nous fait croire à leur réalité."

22. On this aspect of the work of Redon, Grandville, and Victor Hugo, see Stefanie Heraeus, *Traumvorstellung und Bildidee: Surreale Strategien in der französischen Graphik des 19. Jahr hunderts* (Berlin: Reimer, 1998).

23. See Aaron Sheon, "Courbet, French Realism, and the Discovery of the Unconscious" *Arts* 55, no. 6 (February 1981), 114–28; Michael Fried offers a fascinating discussion of Courbet's involvement with automatism in *Courbet's Realism* (Chicago: University of Chicago Press, 1990); for example, Fried discusses the notion of "habit" propounded in Félix Ravaisson's *De l'Habitude* of 1838 as something located between the will and nature (pp. 182–4); Fried expresses certain reservations about labeling Courbet an out-an-out materialist or positivist in light of the literature on *l'automatisme;* he borrows Ravaisson's phrase "spiritualist realism or positivism" for this purpose (p. 184). Fried also discusses Courbet's involvement with photography as evidenced in *The Quarry* (Museum of Fine Arts, Boston) as "a fantasy of the act of painting as wholly automatistic and therefore very close to the taking (or shooting) of a photograph" (p. 280).

24. Théophile Thoré, for instance, criticized "ce contraste d'un animal si antipathique [he means "le monsieur étendu près d'elle"] au caractère d'une scène champêtre, avec cette baigneuse sans voiles, qui est choquant," *L'Indépendance belge* (June 11, 1863); also cited in Alan Krell, "Manet's 'Déjeuner sur l'herbe' in the 'Salon des Refusés': A Reappraisal," *Art Bulletin* 65, no. 2 (June 1983), 318.

25. Hans Tietze, "Manet and a So-Called Velazquez," *Burlington Magazine* 69, no. 401 (August 1936), 85; Wechsler, as in note 4, 32–4. The parlor game of tableaux vivants in which women, usually demimondaines, shed their crinolines in favor of flesh-colored leotards and posed to re-create mythological scenes is discussed in Octave Uzanne, *Fashions in Paris: The Various Phases of Feminine Taste and Aesthetics from 1797 to 1897* (New York: Scribner's, 1898), p. 139. The Judgment of Paris, incidentally, was a favorite subject.

26. "'Il paraît, me dit-il, qu'il faut que je fasse un nu. Eh bien, je vais leur en faire, un. Quand nous étions à l'atelier, j'ai copié les femmes de Giorgione, les femmes avec les musiciens. Il est noir, ce tableau. Les fonds ont repoussé. Je veux refaire cela et le faire dans la transparence de l'atmosphère, avec des personnes comme celles que nous voyons là-bas." Antonin Proust, *Edouard Manet: Souvenirs* (Paris: 1913), p. 43.

27. Thomas Crow writes of a similar strategy in Jacques-Louis David's *Oath of the Horatii* (Salon of 1785); see Stephen Eisenman et al., *Nineteenth-Century Art: A Critical History* (New York: Thames and Hudson, 1994), p. 19.

28. One mention of a link is Christian Hornig, *Giorgiones Spätwerk* (Munich: 1987), p. 153.

29. A colorful account of the Manet brothers' Venetian voyage can be found

in Charles Limet, *Un vétéran du barreau parisien: quatre-vingts ans de souvenirs, 1827–1907* (Paris: Lemerre, 1908), pp. 200–8. See also Emile Ollivier, *Journal, 1846–1869,* T. Zeldin, ed. (Paris: Julliard, 1961), vol. 1, p. 168.

30. Francis Haskell, *Rediscoveries in Art: Some aspects of taste, fashion and collecting in England and France* (Ithaca: Cornell University Press, 1976), pp. 15–16.

31. William Hauptman, "Some new nineteenth-century references to Giorgione's 'Tempesta'," *Burlington Magazine* 36, no. 1091 (February 1994), 78–82.

32. See ibid. and a follow-up letter by Jaynie Anderson, *Burlington Magazine* 36, no. 1094 (May 1994), 316.

33. Ernst Förster, *Handbuch für Reisende in Italien* (Munich: 1840), p. 770. See my letter, "More on Giorgione's 'Tempesta' in the Nineteenth Century," *Burlington Magazine* 38, no. 1120 (July 1996), 464.

34. *Manuel du voyageur en Italie,* 4th ed., rev. (Munich: 1850), p. 571: "Scène [restée inexplicable] entre un vieillard, une femme et un enfant, en plein air" (brackets original).

35. Manet and his brother did act as knowledgable guides to the artistic monuments of Venice for the benefit of Emile Ollivier; see Zeldin, as in note 29, vol. 1, p. 168.

36. Farwell, as in note 4, p. 224, remarks on the ample figure of Victorine Meurent in the *Déjeuner* as uncharacteristic of Manet's representations of her in other paintings. As for whether the figure in the *Déjeuner* registered as ample with the viewers of the time, consider the fact that Alexandre de Pontmartin, in his review of Zola's *L'Oeuvre,* reads Claude Lantier's painting called *Plein air* in the novel as *Le Déjeuner sur l'herbe* and complains about the overuse of the words *ventre* (he stops counting at 45 instances) and *cuisses* (48). See *Souvenirs d'un vieux critique* (Paris: Calmann Lévy, 1886), vol. 7, p. 385.

37. Jacob Burckhardt's reference reads: "Das Bild im Pal. Manfrin, als 'Familie G's' bezeichnet, ist ein eigentliches und zwar frühes Genrebild in reicher Landschaft." *Der Cicerone. Eine Anleitung zum Genuβ der Kunstwerke Italiens* (Basel: Schweighauser'sche Verlagsbuchhandlung, 1855), p. 963.

38. This was a matter of dispute in the nineteenth century as well as today. Marcel Jérôme Rigollot, *Essai sur le Giorgion* (Amiens: Duval et Herment, 1852), for instance, discusses the *Triple portrait* as the picture Byron celebrated, but refers to Byron's letters and professed ignorance of painting, not to the *Beppo* (p. 27).

39. This appears to have been one of the anecdotes in circulation in the nineteenth century, and it is repeated by Antonio Morassi, *Giorgione* (Milan: 1942), p. 87. See Salvatore Settis, *La "Tempesta" interpretata: Giorgione, i committenti, il soggetto* (Torino: Einaudi Editore, 1978), p. 59, or the English edition: *Giorgione's Tempest: Interpreting the Hidden Subject,* E. Bianchini, trans. (Chicago: University of Chicago Press, 1990), p. 59. Settis also

discusses an 1894 reading by Angelo Conti, who held that the lightning represented "the tragedy of paternity" (pp. 50, 56).

40. I have in mind here some recent work by Alexander Nagel, such as "Lotto's Washington Allegory," a paper presented at the 1994 College Art Association Conference. I am indebted to Alex for sharing his views on Venetian art with me. See also Christopher S. Wood, *Albrecht Altdorfer and the Origins of Landscape* (Chicago: University of Chicago Press and Reaktion Books, 1993), pp. 50–3.

41. This is a very delicate point, as there have been many interpretations suggested for the *Tempesta* that have some merit. One could argue, for instance, that the painting depicts the legend of Saint Theodore, an interpretation suggested by Nancy De Grummond (see her "Giorgione's Tempest: The Legend of St. Theodore," *L'Arte* 18–20 [1972], 5–53), and that the iconography was significant to certain viewers of the time but not so striking that it made its way into the 1530 inventory. "El Paesetto in tela con la tempesta, con la cingana et soldato fu de man de Zorzi da Castelfranco" – so reads Marcantonio Michiel's inventory of the Vendramin collection in 1530. Reprinted in *Notizia d'opere di disegno . . . scritta da un Anonimo Morelliano,* Iacopo Morelli, pub. (Bassano: 1800), p. 80. See also *The Anonimo: Notes on Pictures and Works of Art in Italy Made by an Anonymous Writer in the Sixteenth Century,* P. Mussi, trans., George C. Williamson, ed. (London: George Bell and Sons, 1903), p. 123. Williamson's introduction explains the circumstances of the discovery of the "anonymous" manuscript by the Abate Don Jacopo Morelli in 1800 and its attribution to Marcantonio Michiel.

42. A comparative table of interpretations appears in Settis, as in note 39, pp. 78–9.

43. Paul Holberton, in "Giorgione's 'Tempest' or 'little landscape with the storm with the gypsy': more on the gypsy, and a reassessment," *Art History* 18, no. 3 (September 1995), 383–403, presents convincing evidence that the woman in the painting would have been read as a gypsy in the sixteenth century.

44. See Erik Forssman, *Venedig in der Kunst und im Kunsturteil des 19. Jahrhunderts* (Stockholm: Studies in History of Art 22, 1971); Dianne Sachko Macleod, "Dante Gabriel Rossetti and Titian," *Apollo* 121 (January 1985), 36–9; Michel Florisoone, "Manet inspiré par Venise," *L'Amour de l'Art* 17 (January 1937), 26–7. A period-by-period survey of critical attitudes can be found in Charles Dédéyan, "Giorgione dans les lettres françaises," *Giorgione e l'umanesimo veneziano,* R. Pallucchini, ed., 2 vols. (Florence: Leo S. Olschki, 1981), vol. 2, pp. 659–746. Cézanne speaks frequently about his emulation of Titian and Veronese in *Conversations avec Cézanne,* P.-M. Doran, ed. (Paris: Macula, 1978).

45. Anne Coffin Hanson, *Manet and the Modern Tradition* (New Haven: Yale University Press, 1977), p. 75; see also pp. 8–9, 145.

46. *Briefe über Malerei in Bezug auf die königlichen Gemäldesammlungen zu Berlin, Dresden und München* (Stuttgart and Tübingen: 1838), p. 59. Subsequent editions of Förster's Italian travel guide actually contained brief phrases meant to guide the visitor toward an appreciation of the particular strengths and salient characteristics of each artist.

47. Stendhal [Marie Henri Beyle], *Histoire de la peinture en Italie*, rev. ed. (Paris: Michel Lévy Frères, 1860 [1817]), p. 125: "L'école de Venise paraît être née tout simplement de la contemplation attentive des effets de la nature et de l'imitation presque mécanique et non raisonnée des tableaux dont elle enchante nos yeux. . . . Au contraire, les deux lumières de l'école de Florence, Léonard de Vinci et Michel-Ange, aimèrent à chercher les causes des effets qu'ils transportaient sur la toile."

48. *Trésor de la langue française,* Paul Imbs, ed. (Paris: Gallimard, 1985), vol. 11, p. 542: "Duveyrier levait les pieds dans un mouvement mécanique de somnambule."

49. Cézanne refers to having read the volume, first in 1869, then for a third time in 1878, in a letter to Zola of November 20, 1878. See Paul Cézanne, *Correspondance,* John Rewald, ed. (Paris: Grasset, 1978), p. 176.

50. See Charles Blanc, *Ecole Vénitienne, Ecole Espagnole* (Paris: Vve. Jule Renouard, 1868), p. 4: "On ne la voit jamais dirigée par la sage et froide raison, jamais retenue par le respect de l'histoire ou de ces convenances qui, dans une autre Ecole, dans la nôtre, par exemple, ne seraient pas violées sans scandale. Tout y procède de la fantaisie: l'histoire y est racontée comme un roman; les croyances les plus superstitieuses y prennent un corps, et il semble que les Vénitiens soient plus propres à se figurer l'imaginaire qu'à se représenter le réel, les choses impossibles étant celles qui leur viennent le plus facilement à la pensée."

51. Ibid.: "fantaisie," "l'imaginaire," "une naïveté enfantine," "quelle abondance d'imagination! quelle liberté d'allure!" and "toutes les scènes se passent dans le pays des rêves."

52. Ibid., p. 5: "Giorgione nous transporte dans les contrées fabuleuses d'un Décaméron vénitien, où l'on voit des femmes nues rêver sur l'herbe ou prêter l'oreille à des musiciens amoureux."

53. Ibid., p. 6: "L'étrange domine, le bizarre triomphe; la peinture n'est plus qu'une matière aux tours de force de l'improvisation, ou un machinisme derrière lequel il n'y a que du vide."

54. "Le Giorgione," in ibid., p. 4: "quelle absence de sujet!" As Theodore Reff has pointed out, the essays that make up the *Histoire des peintres* were published serially as fascicles well before they were collected into the large volumes. See "Manet and Blanc's 'Histoire des peintres'," *Burlington Magazine* 112, no. 808 (July 1970), 456–8.

55. Mantz, "Le Giorgione," in Blanc, as in note 50, p. 5: "Comment ces personnages sont là, pourquoi ils paraisssent si indifférents à ce qu'ils semblent

faire, on ne le sait pas et l'on n'a pas besoin de le savoir, car Giorgione n'est point un docteur en quête de subtilités nuageuses, il est peintre [. . .]."

56. Rigollot, as in note 38, p. 17.

57. Blanc, as in note 50, 5: "une étrange promiscuité de temps et de person-nages" was said apropos of Veronese.

58. Paul Mantz, *Les chefs d'oeuvre de la peinture italienne* (Paris: Firmin-Didot, 1870), p. 205: "le sujet n'est rien" was said apropos of the *Pastoral Concert*.

59. Admittedly, in the nineteenth century, these were often seen as mutually exclusive. As Léon Lagrange wrote of a picture in the Uffizi, which he compared with the Louvre *Pastoral Concert,* he asked, "Is it an allegory, or must we see it as one of the caprices of the painter, the analogue of the one who inspired the inexplicable picture in the Louvre, the *Pastoral Concert?* Giorgione had invented the fantasy before the fantasists of our time."("Est-ce là une allégorie, ou ne faut-il y voir qu'un de ces caprices du peintre, analogues à celui qui a inspiré l'inexplicable tableau du Lou-vre, le *Concert champêtre?* Giorgione avait inventé la fantaisie avant les fan-taisistes de notre temps.") See his "Catalogue des dessins de maîtres exposés dans la Galerie des Uffizi, à Florence," *Gazette des Beaux-Arts* 13 (September 1, 1862), 283–4.

60. Paul, *Le Siècle,* July 19, 1863: "Il traite de la même façon les êtres et les choses"; Chesneau, *Le Constitutionnel,* May 19, 1863: "Les figures de M. Manet font involontairement songer aux marionettes des Champs-Elysées: une tête solide et un vêtement flasque." Both cited in Krell, as in note 24, p. 317.

61. Philippe Perrot, *Les dessus et les dessous de la bourgeoisie: Une histoire du vêtement au XIXe siècle* (Paris: Fayard, 1981), p. 22; *Le Travail des apparences, ou les Transformations du corps féminin, XVIIIe–XIXe siècle* (Paris: Seuil, 1984), p. 117. Perrot (1981) has appeared in English as *Fashioning the Bour-geoisie,* R. Bienvenu, trans. (Princeton: Princeton University Press, 1994).

62. Perrot, as in note 61, p. 117, quotes Mme. Celnart, *Manuel des dames ou l'art de l'élégance* (Paris: 1833): "s'il le faut, fermez les yeux jusqu'à ce que vous ayez terminé l'opération"; the custom is also discussed in Guy Thuillier, *L'Imaginaire quotidien au XIXe siècle* (Paris: Flammarion, 1985), p. 6.

63. A typical period reference to Giorgione's life is that of Alfred Dumesnil in *L'art italien* (Paris: Girard, 1854), p. 287: "Pauvre et de basse extraction, il a d'instinct les manières les plus élégantes et les plus distingués. [. . .] C'est un beau et bon géant; la largeur de sa poitrine est colossale, mais son regard a une douceur qui enchante." This comes straight out of Vasari, as do notions such as those of Rigollot (1852), that he sang and played the lute so beautifully that he was called in to preside over concerts of all the patrician families, and that "il [. . .] vécut [. . .] en galant homme" (p. 6). There was, then, a nineteenth-century family romance of Giorgione: an idea that he rose from low roots but moved in elegant circles.

64. Sigmund Freud, *The Standard Edition of the Complete Psychological Works*, James Strachey, trans. (London: Hogarth Press, 1959), vol. 9, p. 237; *The Complete Letters of Sigmund Freud to Wilhelm Fliess, 1887–1904*, J. M. Masson, ed./trans. (Cambridge, Mass.: Belknap Harvard, 1985), p. 317.

65. Sandor Ferenczi, "Social considerations in some analyses," *International Journal of Psycho-Analysis* 4 (1923), p. 477.

66. Tabarant, as in note 2, p. 60. The family held about 150 acres of prime residential property. Manet's grandfather Clément and great-grandfather Clément Jean-Baptiste had both been mayors of Gennevilliers; Clément Jean-Baptiste started the practice, carried on by Auguste, of living in Paris and using the Gennevilliers property as a retreat. See Robert Quinot, *Gennevilliers: Evocation historique* (Ville de Gennevilliers: 1966), vol. 1, pp. 165–8, 297. Quinot also reproduces a photograph (p. 306) of the Manet family farmhouse, rue de Saint–Denis and rue des Petits-Pères.

67. See, for instance, Tabarant, as in note 2, p. 60; Farwell, as in note 4, p. 50; Cachin, as in note 3, p. 167; Eric Darragon, "Recherches sur la conception du sujet dans l'oeuvre d'Edouard Manet (1832–1883)," Université de Paris-Sorbonne/Paris 4, 1987, mentions childhood vacations apropos of the "idyllic tone" of *La Pêche* (vol. I, p. 119, n. 63).

68. A synopsis of Auguste's career, as well as references to archival documents, can be found in my "New Documentary Information on Manet's 'Portrait of the Artist's Parents'," *Burlington Magazine* 38, no. 1057 (April 1991), 249–52.

69. Information about Eugénie's birth, siblings, and parents can be found in Emile Taillefer, "Contribution d'un Grenoblois à l'histoire de la Suède," *Bulletin du Musée Bernadotte* 17 (December 1972), 13–21.

70. His birth certificate is in the Tabarant Archives, Pierpont Morgan Library, New York.

71. Mina Curtiss published a claim that "a highly distinguished and reliable writer" who had married into the Manet family confided the paternity to a close friend. See "Letters of Edouard Manet to his wife during the Siege of Paris: 1870–71," *Apollo* 113, no. 232 (June 1981), 378–89.

72. Theodore Reff, for instance, points out Baudelaire's surprise while supporting the notion that Manet had been hiding his relationship with Suzanne. See "The Symbolism of Manet's Frontispiece Etchings," *Burlington Magazine* 104, no. 710 (May 1962), 186.

73. Anne Higonnet points this out in *Berthe Morisot* (New York: Viking, 1990), pp. 45–6.

74. According to the Napoleonic Code, Article 331, children who were the offspring of adulterous or incestuous unions could *not* be legitimized, even upon the subsequent marriage of the parents. If one of the parents was lawfully married to someone besides the child's other parent, at least three hundred days prior to the birth of the illegitimate child, the child

was classified as an *enfant adultérin,* whose existence was seen in the eyes
of the law as "a violation of the moral laws on which societies rest" and
"a ceaseless protest against the sanctity of marriage"; as such, he was
denied many of the rights of the legitimate. See Dalloz, *Répertoire de légis-
lation, de doctrine et de jurisprudence* (Paris: 1855), vol. 35, pp. 289–309,
"Paternité et filiation," Tit. 2, Chap. 1.391.

75. See Theodore Reff, *Manet and Modern Paris* (Washington, D.C.: National
Gallery, 1982), pp. 174–91. I disagree with Reff that Manet's occasional
studio assistant, the "poor deranged boy" Alexandre, who appears in *Boy
with Cherries* and is the subject of Baudelaire's "La Corde," appears in the
picture. The dark-haired boy on the right resembles the model for *Boy
with Dog.*

76. Timothy Clark pointed out in a lecture course given at Harvard Univer-
sity that the *Philosophe à la main tendue* (Art Institute of Chicago)
appeared in *La Musique.* For more on the series, see Anne Coffin Han-
son, "Manet's Subject Matter and a Source of Popular Imagery," *Museum
Studies, Art Institute of Chicago* 3 (1969), 63–80.

77. Ewa Lajer-Burcharth, "Modernity and the Condition of Disguise:
Manet's 'Absinthe Drinker'," *Art Journal* (Spring 1985), 18–26. Lajer-Bur-
charth recast her central argument in light of Lacanian notions of self-
formation and feminist theory – principally that of Joan Rivière and
Mary Ann Doane – on the concept of masquerade in a talk, "Masculinity
and Masquerade: Manet's 'Absinthe Drinker' Revisited," given April 1,
1992 at Harvard University.

78. One cannot, I think, overstate the case for the father's death as an immi-
nent reality in Manet's imagination when the length and extent of the
father's illness and paralysis are taken into account.

79. Tabarant, as in note 2, p. 34.

80. Ibid., 38; Julie Manet, *Journal (1893–1899): Sa jeunesse parmi les peintres
impressionnistes et les hommes de lettres* (Paris: Klincksieck, 1979), p. 153.

81. This new identification was proposed by Juliet Bareau in a talk at the
Courtauld Institute, Spring 1991. She added the provision, however, that
the figure might also represent Suzanne Leenhoff's mother. The biogra-
phy of Manet by Brombert points out that the relative who had come to
Paris to help the unmarried Suzanne care for Léon was undoubtedly
Suzanne's widowed grandmother, not her mother. See Beth Archer
Brombert, *Edouard Manet: Rebel in a Frock Coat* (Boston: Little, Brown,
1996), pp. 136–7.

82. Tabarant, as in note 2, p. 34, working from the assumption that Manet
was hiding his relationship to Suzanne prior to the marriage, speculates
that the Gennevilliers landscape hardly seemed an ideal place for the
couple to promenade, since they could easily have run into people they

knew. One might ask instead just who or what was really being hidden in these pictured retreats to the country.

83. My argument here, that Victorine becomes in effect a member of the family, contrasts with that of Carol Armstrong, who sees Victorine as "a figure of the outsider and the other" next to Manet's relatives in the *Déjeuner.* See "Manet/Manette: Encoloring the I/Eye," *Stanford Humanities Review* 2, nos. 2–3 (Spring 1992), 39.

84. *The Post Card: From Socrates to Freud and Beyond,* A. Bass, trans. (Chicago: University of Chicago Press, 1990), p. 299.

85. Michael Fried, *Three American Painters: Kenneth Noland, Jules Olitski, Frank Stella* (Cambridge, Mass.: Harvard University, Fogg Art Museum, 1965), pp. 4–10; Wollheim, as in note 6, pp. 141–50.

86. Schapiro, as in note 4, p. 11, reproduces an 1867 frontispiece to a book on dreams by Hervey de Saint-Denis, which illustrates the anxiety dream of nakedness; on the phenomenon of inhibition of exhibitionism, see Gérard Bonnet, *Voir – être vu,* 2 vols. (Paris: PUF, 1981).

87. Notably Werner Hofmann, *Das Irdische Paradies: Kunst im neunzehnten Jahrhundert* (Munich: Prestel-Verlag, 1960), p. 348; Farwell, as in note 4, pp. 240–54, discusses the picture as a "paradise regained."

88. Pierre Rosenberg, in *Watteau 1684–1721* (Washington, D.C.: National Gallery of Art, 1984), notes that Manet apparently borrowed Watteau's title in his inventory (p. 279). Rosenberg reproduces the Boucher print and the Ingres drawing.

89. Fried, as in note 1, pp. 40–3; see also Fried, as in note 1, pp. 56–8. This is an understatement of the case Fried makes for Manet's dependence on Watteau.

90. Thomas Crow, *Painters and Public Life in Eighteenth-Century Paris* (New Haven: Yale University Press, 1985), p. 57.

THE FASCINATION WITH
THIS RENDEZVOUS DOES
NOT DIMINISH . . .[1]

Innumerable ways of playing and foiling the others' game
(*jouer, déjouer le jeu de l'autre*), that is, the space instituted by
others, characterize the subtle, stubborn resistant activity
of groups which, since they lack their own space, have to
get along in a network of already established forces and
representations.[2]

In the early autumn of 1994, workers waiting at bus stops,
children on their way to school, flaneurs for pleasure and flaneurs
from necessity, businesspersons hurrying to meetings, and lovers
setting out on assignations in cities the length and breadth of
Britain found themselves gazing at billboards situated at busy cross-
ings and overlooking abandoned urban wastelands from which
leered down the head of a popular comedian, Alexei Sayle, super-
imposed upon the body of Victorine Meurent (Fig. 33). To be
more precise, this leering, bearded head, wearing a knitted beret,
burst through a blown-up reproduced detail of Manet's *Le Déjeuner
sur l'herbe* at precisely the point where Victorine's head, familiar
from Manet's painting, would normally be found. The lettering –
typeface courtesy of Toulouse-Lautrec posters[3] – announced
"Alexei Sayle in Paris. A new Sitcom. Fridays 3.30 PM. 4."[4]

How should we regard this phenomenon? Is it simply yet
another example of the penchant of advertisers with their scant art-
school education to arrest public attention by parodying an inter-
nationally celebrated high-art image? Is it a clever, if tasteless,
strategy for encapsulating (and then marketing) Frenchness – a kind

Figure 33. Advertisement for Alexei Sayle's comedy series on British Channel 4 TV, billboard, autumn 1994. (Photo: Peter Burton)

of populist version of the assumption found among some academics working on post-Renaissance culture that Paris is the location of all that is significant, a phenomenon that a colleague once labeled "Paris envy"?[5] Is it yet one more demonstration of a now well-established pattern in which this particular painting has been targeted in a widespread practice of appropriation in popular graphics? Typical of this pattern are the record sleeve of *Go Wild in the Country*, released by BowWowWow circa 1981–2 and representing a tableau vivant of the *Déjeuner* formed by the members of this rock group (Fig. 34); Posy Simmonds's 1980 *Guardian* cartoon featuring the imaginary Jocasta Wright as an art student outmaneuvering her politically correct and priggish male tutors (Fig. 35); Sally Swain's reversal image *Mrs Manet Entertains in the Garden* (1988) (Fig. 36); and a variety of picture postcards including one in which the naked woman has spent six years getting her M.B.A. but still finds herself having to use her body to make a business deal and one in which the woman invites the second man to undress in an attempt to get rid of an after-dinner bore who drones on about motor cars.[6]

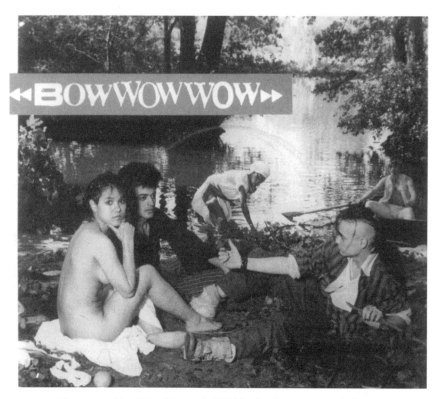

Figure 34. BowWowWow, *Go Wild in the Country,* record sleeve, 1981–2.

All this might tell us something about a poverty of imagination among a generation of graphic designers, or something about the taste for parody in Western culture in the second half of the twentieth century. It might be regarded as an interesting example of the ways in which the margins subvert the center and how popular culture annexes and transforms dominant discourses, thereby undermining them. In short, it might be regarded as offering a fine case of cultural hybridity. Should art historians, however, pay any attention to such manifestations? Do they have an impact upon Manet's painting as it hangs in distinguished and distinctive surroundings in the Museé d'Orsay in Paris, and does it provide any meaningful and productive entreé into a discussion of a painting that has been as intractable for art historians as it has apparently been malleable for cartoonists and graphic designers? Indeed, so

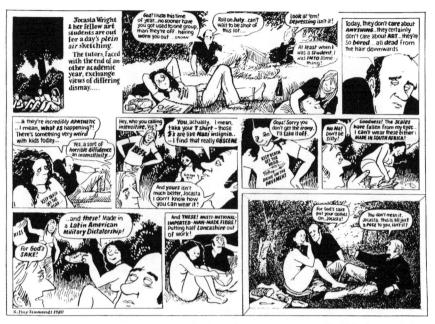

Figure 35. Posy Simmonds, *Guardian* cartoon, 1980. By kind permission of Posy Simmonds.

intractable is the *Déjeuner* that it has tended to be passed by in favor of *Olympia* (Fig. 15): that was the place where adversarial art historians made their mark.[7] The pace was set by Georges Bataille in 1955, who could scarcely contain his impatience to move from the *Déjeuner* to the *Olympia* of two years later, stating:

> The nude of *Le Déjeuner* would be a woman – a real woman, like those bathing in the Seine. But the stridency of the finished picture, with its inevitable effects of incongruity, left him dissatisfied; he felt that there was something arbitrary about the systematic elaboration of the *Déjeuner*. Though he said nothing, he now deepened his enquiry into the effects to be drawn from the transposition of one world into another. He abandoned the men in frock coats, clearing the stage of everything except the nude herself and a maidservant, as he had seen them in the *Urbino Venus*. . . . In the intimacy and silence of her room, Olympia stands out starkly, violently, the shock of her body's acid vivid-

Figure 36. *Mrs. Manet Entertains in the Garden,* from Sally
Swain, *Great Housewives of Art* (London: 1988).

ness softened by nothing, intensified, on the contrary, by the
white sheets.[8]

Nearly thirty years later, in naming the *Déjeuner* one of those paint-
ings that exemplify the city as a "free field of signs and exhibits,"
typifying the combination of display and equivocation that he takes
to be the chief new characterization of modern life, T. J. Clark
takes us into a semiotic era. But the focus of his attention is, like
that of Bataille, effectively *Olympia* rather than the *Déjeuner,* which

he considers exclusively (and briefly) as a contrast with the *Olympia* before which the critics failed, it is argued, to notice the quotations and revisions they had laughed at in the *Déjeuner.*[9]

In historiographic terms, what *Olympia* has offered the art historian is the opportunity to access the topic of prostitution and thereby open up discourses of class to which those of gender were subordinate – the project of progressive marxian art history of the 1970s. Race, which should also have been part of this discussion (given the presence of the black servant), tended to be occluded. The status of this servant and the plein-air setting apart, the chief difference between the *Déjeuner* and *Olympia* is that the former contains – in equal numbers – male and female subjects, whereas the latter contains only two women. It is these *apparent* binaries of male/female and clothed/unclothed upon which the parodists have conducted their experiments. Any attempt to extrapolate from the imagery of the *Déjeuner* as part of an agenda for the social history of art is fraught with difficulty; it is contemporary and yet incredible (it literally cannot be believed – it is, as Bataille expressed it, incongruous); it contains portraits (the painter's brother Gustave, the Dutch sculptor Ferdinand Leenhof, and the model Victorine Meurent). But its formal affiliations link it to the tradition of historical painting; the figures recline with patrician authority in a distinctly nonurban environment that is neither aristocratic park nor productive agricultural terrain; it refuses any obvious distribution of power of the sort that comes so easily in a discussion of *Olympia*. Above all, it produces a dialectic in which gender is deeply unsettled and in which the binaries identified above disintegrate, leaving a semantic void.

For the parodists, two facets of the painting are above all a focus of attention. First, the possibility of inverting gender identities (as with Sally Swain, who does it peacefully and in a genteel manner, and Alexei Sayle, who violently tears the canvas to achieve his end) and second, the relation between nakedness and speech (as with Posy Simmonds and the two postcard parodies). I shall suggest that parody does indeed instruct us about the "matrix" image. Although parody works with subversive mimicry and is often deflationary, its chief characteristic is analytic; it seeks out weaknesses or inconsistencies in its original and displays them self-consciously to a knowing audience. Thus, the audience assumed by Alexei Sayle's poster is "in the

know." This is a sure sign not only of the canonical status of the *Déjeuner* but also of the widespread (if unacknowledged) recognition of its "incongruity." Parody does not travesty; it establishes a creative and ironic relationship with its original. Unlike caricature, parody is essentially about art, not about life; it foregrounds stylistics and through subversion does not destroy but reinforces dominant modes.

I shall take these parodies as critically instructive and use them as a way of discussing the painting's narrative structure. That the narrative structure of this particular French painting is especially powerful is evinced, I suggest, by the evident desire of anglophone viewers to insert themselves as enunciative subjects in the image's silent spaces. Just as popular culture diverts resources and reuses them, so it may also serve as guide to the divisible components of the image field once it is separated from aura and from its history. Let us, then, ask what we have here once the image is detached from its high-art tradition and (in the imagination at least) removed from the walls of its Parisian art gallery? The components of this narrative are food and drink, convivial company and leisure pursuits (boating and bathing), sex, and speech – all elements calculated to contribute to a good story. Add a frog and a goldfinch and an apparently sunny day and we appear to have the ingredients of a typically mellow Impressionist narrative of bourgeois pleasure. In fact, as virtually everyone agrees, the components of this narrative do not add up as they should; they do not produce that kind of story; they are (to cite Bataille again) strident.

The most immediate impediment to an accommodation of the *Déjeuner* into the poetics and politics of the contemporary and quotidian as analyzed by scholars of Impressionism is the disjuncture between contemporary masculine dress and a female nude. But this alone would not be sufficient to attract claims of incongruity at the time of its exhibition and ever since. That disjuncture is, after all, a time-honored one, and the very referencing of Giorgione should have permitted recognition, however disapproving. Nor does the nude, I suggest, put Manet "in Courbet's camp as a realist out to shock the conservatives."[10] Visual realist polemic of that kind would have been all too obvious and therefore all too easy to categorize and thus to dismiss. What is disconcerting – and consequently destabilizing – about the *Déjeuner* is the fact that it does not merely borrow from the great Renaissance masters – it

parodies them. It is to all intents and purposes a history painting, albeit one with an ironic relation with tradition. Arguably, it is the propensity to pastiche in the technical sense[11] (a propensity well explored by writers as diverse as Mauner and Sandblad[12]) that produces, in turn, such a fertile field for the parodists.

The question of history was a challenging one to the generation of the 1860s. Baudelaire in 1859 saw the age as inimical to history painting and extolled the religious painting of Delacroix as works of an artist "as great as the old masters, in a country and century in which the old masters would not have been able to survive."[13] Odilon Redon also identified the period as unsympathetic to the nonnaturalist and remembered the first half of the decade of the 1860s as a time when "we were in the midst of Avant-Garde naturalism" and it was peculiarly difficult for an artist attracted by "the uncertain at the boundary of thought," a quality he found epitomized in the protoallegorical figure of Dürer's *Melancholia*.[14] Most symptomatic of the contestation over history painting were the government reforms of 1863, which wrested control of the Ecole des Beaux-Arts from the Academy and which provoked an intense debate about the definition of artistic originality and the educational system most likely to foster high art.[15]

The rhetoric of the real dominated the avant-garde of the 1850s and 1860s. Courbet declared in his letter to a group of students in 1861: "I also believe that painting is an essentially CONCRETE art and can only consist of the representation of REAL AND EXISTING objects. It is a completely physical language that has as words all visible objects, and an ABSTRACT object, invisible and non-existent, is not part of painting's domain."[16] By situating, to use Paul Jamot's words, the real in the unreal[17] (contemporary dress in combination with a classically inspired female nude), Manet's painting transgresses the imperatives of the avant-garde to which, at this time, the historical is inimical. By deploying the mechanism of history painting, the genre and the practice that a modernist historiographic trajectory tends to define as oppressive, Manet's image ruptures the polemics of the avant-garde. But since history in the sense of *istoria,* the grandest and most venerated of genres, has to coexist with such signs of modernism as cravats and *petit pain* as well as freely handled paint in the *Déjeuner,* the idea of history is deployed also, as we shall see, to critique the very traditions upon which history painting

depends. In Courbet, for instance, it is popular art forms and the lower genres that penetrate and threaten the plentitude of *la grande peinture*. But with Manet it is *la grande peinture* that becomes the instrument through which a critique is produced both of the limitations of contemporary subject matter and of the easy and bombastic narrative mode of academic history painting.

The parodies with which I opened serve to explain how the incongruities of Manet's painting work to critique the idea of the real, and with what effects history painting is deployed in parodic mode. The act of anarchic occupation of high art by popular culture that we notice in the advertisement for Alexei Sayle's sitcom consists in grafting a particular and unequivocally male head onto the body of the female nude. As is the way with creative parody, this does not startle by its impropriety or threaten the masculinity of Alexei Sayle but rather serves to draw attention to the sturdiness of Victorine Meurent's body as represented in the *Déjeuner*.[18] It reminds us that her gaze is utterly unlike that of the female figure in the central fragment of Monet's *Le Déjeuner sur l'herbe* of 1865–6 (Museé d'Orsay, Paris), that Manet's female nude has a thick neck and stocky shoulders, and that above all she has muscular thighs at evident variance with both the "pneumatic" academic paradigm of Cabanel, the buxom fleshliness of Courbet, or the exposed female body as depicted by Degas or Renoir. Nor is the body of this female model depicted with the seductive tension apparent in *Olympia*. In short, this female body does not fit into the typology of the female nude for reasons other than those that have been frequently rehearsed with regard to *Olympia*. An explanation is, of course, simply that the masculine characteristics of this figure got carried over from the well-known source of Manet's pastiche in the engraving by Raimondi after Raphael's *Judgment of Paris* (Fig. 11). To accept this at face value would be, however, to suggest that Manet was an unsophisticated plagiarist rather than a highly inventive pasticheur. The question remains as to why, in presenting a female nude so prominently, should Manet leave space for doubt about sexual characteristics when rhetorical strategies for ensuring difference are readily available?

Sally Swain also plays on the ambiguities of Manet's female nude; she wholly appropriates the figure and turns it into an unequivocally male figure by removing the breasts and adding

facial and body hair. The transformation of female into male nude
has as one of its consequences a reassessment of the clothed male
figures. Parody, by its critical mode, destabilizes. Manet's male fig-
ures were defined in their masculinity by contrast with the female
nude; now that masculinity is nude there is no place for clothed
male figures. By revealing the woman to be a man, the status of the
depicted men is raised into question with the outcome that they, in
turn, become women. As is the way with parody, the process leads
us to wonder whether in fact we ever understood them in Manet's
painting to be fixed in their manhood, whether those softly draped
clothes, delicate hands, and limply arranged thighs belonged to
female bodies all along. We think of Georges Sand, Rosa Bonheur,
Romaine Brooks, and other famous female cross-dressers and won-
der if the incongruities with which Bataille and others have felt so
uncomfortable are calculated contradictions. In social terms both
parodies iron out the uncertainties in the power relations that
Manet's painting produces; in the first, woman is excluded, and the
picnic becomes an all-male affair; in the second, the confederacy of
women puts the men in the shade.

 The chief point of intervention for the parodist is, then, the
masculinization of the represented body of Victorine Meurent.
The element that provoked this is, I suggest, less the stylistic charac-
teristics derived from Raphael (muscular thighs) than the peculiar
narrative structure of the *Déjeuner* and, in particular, the formation
through which a female subject is effectively detached through
nudity and through handling from the group and addresses the
viewer. If we take ourselves, for a moment, outside the exigencies
produced by the notion that this painting concerns the contempo-
rary, if we forget Baudelaire and his waxed boots, we might find
that Manet's image sits comfortably in a tradition defined by the
expectation that there be unity of action, that imagery should func-
tion dialectically insofar as gesture and expression may be read. This
allows us to invoke the parodists as commentators in the manner of
Le Brun's commentary on Poussin's *The Gathering of the Manna* of
1639 (Louvre, Paris). Just as Poussin's academic commentators saw
no difficulty in detaching a main group from the composition as a
whole in order to consider its special effects, so the parodist may
legitimately ignore the second female figure, the boat, and other

elements (signs of a time prior to the moment represented) and concentrate on the discursivity of the central group.

The central group stages – though it cannot reproduce – an act of enunciation. Manet depicts the physical accompaniments of a speech act made before an audience.[19] The gesture of the left-hand male figure (he who is situated to the female nude's right) is that of speech, and since the expressive hand is on the same plane as the nude we should understand that it is to her that the speech is addressed. Although the ostended right hand gestures for emphasis, the weight is on the left arm and the body is tilted back in Etruscan or Roman dining mode. This formation produces a powerful effect of distancing, which suggests ritualized relations at odds with the social and the contemporary. Put quite crudely, men do not speak to women in this way in paintings of this period either by academic artists or by artists associated with Impressionism. Men commonly lean over the backs of garden benches, they stand upright on terraces, they prop themselves against trees, they discourse endlessly, but even in moments of apparent alienation they are unremittingly seductive, inclining their bodies, bending their ears, insinuating themselves into the magic circle of female company, commanding attention by their proximity and their carefully controlled and frequently hatted heads.[20]

Manet's nude does not respond, does not even acknowledge this act of speech. The semantic change, strengthened by the *ad locutio* gesture of the man's right hand, meets the blank wall of female nudity.[21] The ineffable mobility, the condition of discursivity to which history painting aspires and which is pastiched in this speaking figure (solemn in its enunciating as Alexander at the tent of Darius or Anthony before Cleopatra), is bounced off the unyielding nude figure whose extraordinarily erect posture establishes a stern vertical resistance to the disorderly manifestations of nature and culture that spill within and around this group. The deliberate and harsh line of this figure's back offers no possibility for permeation or engagement of any kind.

The masculine attributes of the nude in Manet's painting that are picked up in parody are necessary for the decorum of this procedure – the act of speech. Equally, it is imperative that the figure is female. The social narratives of the following decade seem often to clearly posit a male speaker and a female listener or listeners.

Manet's *Boating* of 1874 (Metropolitan Museum of Art, New York) and *Argenteuil* of 1874 (Museé des Beaux Arts, Tournai) fall into this category. The quintessential painting for this gender division is Renoir's *Bal au Moulin de la Galette* of 1876 (Museé d'Orsay, Paris) where the faces of the two women in the foreground reflect back to the viewer the quality of enunciation delivered by the young man whose back is toward us but whose eager forward-leaning posture and raised left hand indicate an act of speech. But Manet's speaker addresses his female companion with the gesture not of a lover but of a rhetorician. The appropriate recipient of such an address would have been male. But equally had the auditor been male he would have had right of reply. By making the figure female – and by making her naked – Manet provides a listener who is addressed in a proper manner but for whom any response would be improper. Her averted gaze does not absorb his discourse but deflects it. Nudity, femininity, and the stern posture all combine to act as prism to this act of speech, bouncing the imagined words out of the controlled image field and into the viewer's space. The second man and the second woman, in their absorptive states, are evasive and make clear to the viewer that there is no escaping this trajectory, no evading the acute prismatic effect of the central female figure.

Figures that gaze out of images are normally subordinate and work to draw the attention of the viewer into the picture space that is occupied by a dominant group. One thinks, for example, of Titian's *Vendramin Family* of 1543–7 (National Gallery, London), or figures in paintings by Poussin or Le Brun. With Manet it is the dominant central figure that gazes out. The defining characteristic of narrative is, as Hayden White has so amply demonstrated, closure.[22] That which differentiates chronicles or inventories or other kinds of writing from narration is the structure that ends in closure. Manet's painting with its titillating suggestions both of the contemporary and of epic history painting offers a narrative about enunciation but a narrative that is structured in such a way as to refuse closure. The prismatic effect throws out any possibility we might entertain that these individuals are engaged in conversation. If we were able to believe that they discoursed with one another in a free play of social intercourse, that would suffice; our need as readers to have an episode, to be rewarded with unity of action, however

desultory that action, would be satisfied. What Manet does, instead, is to stage precisely the conditions associated with the most highly developed forms of narrative painting but to deny the necessary closing of the circle. The parodists, by turning the woman into a man or by rendering her vocal (typically, by giving her a balloon containing commentary on the situation) restores to the image the symmetry of the group. And I say restore because parody works on the occluded and the implicit. In restoring the painting's unity – in ironing out its incongruity – the parody also robs it of its tension. That tension is the creation of an artist intent upon interrogating the condition of discursivity; in laying open the terms of history painting's pact with the viewer. The *Déjeuner sur l'herbe* invites us to contemplate the story of how stories get told.

NOTES

1. This essay is a further development of ideas about Manet's *Le Déjeuner sur l'herbe,* which I first put forward in Chapter 6 of my book *Naked Authority: The Body in Western Painting 1830–1906* (Cambridge: 1990). I am grateful to Paul Hayes Tucker for enabling me to rethink my position with regard to this complex image and to all those friends who have continued to draw my attention to parodic expositions of Manet's theme. I am also grateful to Peter Burton for willingly dashing out with camera to capture Alexei Sayle before he disappeared from the hoardings.
2. Michel de Certeau, *The Practice of Everyday Life* (1984), S. Rendall, trans. (Berkeley, Los Angeles, and London: 1988), p. 18.
3. A second poster, simultaneously launched, showed Alexei Sayle bursting through a Toulouse-Lautrec image and being kissed on the cheek by a woman.
4. "4." stands for BBC television Channel 4.
5. I have to thank Thomas Crow for this witty observation.
6. The first of these is printed in the American Postcard, Inc., New York, "Misguided Masterpieces"; the second was produced in England by Ian Daniels, c. 1990. One might also mention that Picasso's 1960s series of drawings after the *Déjeuner sur l'herbe,* which seem in their "mastery" so secure from what Rosalind Krauss identifies as the rhythmic beat of an alternative and subconscious modernism, have been recently compared to that staple of popular culture, the flip book; Rosalind Krauss, *The Optical Unconscious* (Cambridge, Mass.: 1993), ch. 5.
7. The debates over *Olympia* have gone on since the painting's first exhibition, but they were lent particular impetus by the attention of T. J. Clark in a series of accounts initiated with "Preliminaries to a possible treat-

ment of 'Olympia' in 1865," *Screen* 21 (Spring 1980) and by the continu-
ation of this discussion in *The New York Review of Books* in the form of a
discussion with Françoise Cachin.

8. Georges Bataille, *Manet*, A. Wainhouse and J. Emmons, trans. (New York:
 1955), p. 74.

9. T. J. Clark, *The Painting of Modern Life. Paris in the Art of Manet and His
 Followers* (London: 1984), pp. 48, 95.

10. Robert L. Herbert, *Impressionism: Art, Leisure, and Parisian Society* (New
 Haven and London: 1988), p. 172.

11. I use the term not in the derogatory sense of mindless borrowing (that
 runs close to plagiarism) but in the sense of a practice that does not iron
 out ambiguities but exposes them. It differs from parody in that it
 involves a mixture of styles and motifs from different sources forming a
 patchwork. It has the element of a game in common with parody.

12. Nils Sandblad, *Manet. Three Studies in Artistic Conception* (Lund: 1954);
 George Mauner, *Manet, Peintre-Philosophe: A Study of the Painter's Themes*
 (University Park: 1975), ch. 2.

13. Charles Baudelaire, "Salon of 1859," in *Art in Paris 1845–62. Salons and
 Other Exhibitions Reviewed by Charles Baudelaire*, J. Mayne, ed./trans.
 (Oxford: 1981), p. 168.

14. Odilon Redon, *A Soi Même*, journal (1867–1915), Elizabeth G. Holt,
 trans., in *From the Classicists to the Impressionists: Art and Architecture in the
 Nineteenth Century. A Documentary History of Art* (New York: 1966), vol. 3,
 pp. 493–4.

15. The *locus classicus* on this conflict remains Albert Boime, *The Academy and
 French Painting in the Nineteenth Century* (London: 1971), but the topic
 remains one that is very much alive. *Art History* 20, no. 1 (March 1977),
 which is devoted to academies and art schools in late-nineteenth- and
 early-twentieth-century Europe, will further the debate.

16. Gustave Courbet, Letter to a group of students, first published in *Le
 Courrier du Dimanche* (December 29, 1861), reprinted in translation in
 Holt, as in note 14, pp. 351–3.

17. Jamot described Manet as "grand artiste qui situe la realité dans l'irréel";
 Paul Jamot, "Extraits de l'Introduction au catalogue de l'exposition
 Manet," Museé de l'Orangerie, 1932, in Pierre Cailler, ed., *Manet raconté
 par lui même et par ses amis* (Paris: 1953), p. 198.

18. It is interesting to note that the revised and extended edition of Hugh
 Honour and John Fleming's *A World History of Art* published in 1991 fea-
 tures a reproduction of the head of Manet's nude female from the *Déjeu-
 ner* on the front of the dust jacket. It serves in a revisionist way to make a
 point about Manet as protomodernist in his handling of paint surfaces. It
 is, however, tempting to conclude that it was necessary to omit the trou-
 blesome body in order to make this point.

19. I take my definition of enunciation from Michel de Certeau's summary, as in note 2, p. 33, in which he points out that enunciation presupposes, first, a realization of the linguistic system through a speech act that actualizes some of its potential (language is real only in the act of speaking); second, an appropriation of language by the speaker who uses it; third, the postulation of an interlocutor (real or imagined) and thus the constitution of a relational contract or allocation (one speaks to someone); fourth, the establishment of a present through the act of the "I" who speaks and conjointly the existence of a "now," which is the presence to the world.

20. I am thinking here particularly of Manet's *In the Conservatory* of 1879 (Nationalgalerie, Berlin).

21. In her discussion of Picasso's series of drawings after Manet, Krauss draws attention to the migration of genitalia around the company. It is also true to say, however, that Picasso pays a great deal of attention to the speaking male figure, increasing its dimensions, changing its position in relation to the other three figures and particularly in relation to the female nude, and lengthening the right arm.

22. Hayden White, "The Value of Narrativity in the Representation of Reality," *Critical Inquiry* 7, no. 1 (Autumn 1980), 5–29.

BIBLIOGRAPHY

MANET MONOGRAPHS, EXHIBITION CATALOGUES, AND IMPORTANT STUDIES OF THE PERIOD

Adler, Kathleen. *Manet.* Oxford: Phaidon, 1986.

Baudelaire, Charles. *Le Peintre de la vie moderne,* in *Oeuvres complètes,* Y.-G. Dantec and Charles Pichois, eds. Paris: Bibliothèque de la Pléiade, 1961.

Bernheimer, Charles. *Figures of Ill Repute: Representing Prostitution in Nineteenth-Century France.* Cambridge, Mass.: Harvard University Press, 1989.

Cachin, Françoise, and Charles S. Moffett. *Manet 1832–1883,* exhibition catalogue. New York: Metropolitan Museum of Art, 1983.

Clark, T. J. *The Painting of Modern Life. Paris in the Art of Manet and His Followers.* New York: Knopf, 1985.

Clayson, Hollis. *Painted Love: Prostitution in French Art of the Impressionist Era.* New Haven: Yale University Press, 1991.

Corbin, Alain. *Women for Hire: Prostitution and Sexuality in France after 1850.* Cambridge, Mass.: Harvard University Press, 1990.

Darragon, Eric. *Manet.* Paris: Editions Citadelles, 1991.

Duret, Théodore. *Histoire d'Edouard Manet et de son oeuvre.* Paris: H. Floury, 1902.

Faison, S. Lane. *Edouard Manet (1832–1883).* Amsterdam: Collins, 1955.

Farwell, Beatrice. *Manet and the Nude: A Study in the Iconology of the Second Empire.* New York: Garland Press, 1981.

Fried, Michael. *Manet's Modernism or, The Face of Painting in the 1860s.* Chicago: University of Chicago Press, 1996.

Hamilton, George Heard. *Manet and His Critics.* New Haven: Yale University Press, 1954.

Hanson, Anne Coffin. *Manet and the Modern Tradition*. New Haven: Yale University Press, 1977.

Herbert, Robert L. *Impressionism. Art, Leisure, and Parisian Society.* London: Yale University Press, 1988.

Hofmann, Werner. *Edouard Manet, Das Frühstück in Atelier: Augenblicke des Nachdenkens.* Frankfurt: Fischer Taschenbuch Verlag, 1985.

Krell, Alain. *Manet and the Painters of Contemporary Life.* London: Thames and Hudson, 1996.

Jamot, Paul, and Georges Wildenstein. *Manet.* 2 vols. Paris: Beaux-Arts, 1932.

Jones, Pamela M., et al. *Edouard Manet and the "Execution of Maximilian."* Exhibition catalogue. Providence, R.I.: List Art Center, Brown University, 1981.

Mauner, George. *Manet peintre-philosophe: A Study of the Painter's Themes.* University Park: Pennsylvania State University Press, 1975.

McCauley, Elizabeth Anne. *Industrial Madness: Commercial Photography in Paris, 1848–1871.* New Haven: Yale University Press, 1994.

Moreau-Nélaton, Etienne. *Manet raconté par lui-même.* 2 vols. Paris: Henri Laurens, 1926.

Perutz, Vivien. *Edouard Manet.* Lewisburg: Bucknell University Press, 1993.

Pointon, Marcia. *Naked Authority: The Body in Western Painting, 1830–1908.* Cambridge: Cambridge University Press, 1990.

Proust, Antonin. "Edouard Manet: Souvenirs," *La Revue blanche,* February–May 1897, 125–35, 168–80, 201–7, 306–15, 413–24.

Edouard Manet: Souvenirs. Paris: A. Barthélemy, H. Laurens, 1913.

Rand, Harry. *Manet's Contemplation at the Gare Saint-Lazare.* Berkeley: University of California Press, 1987.

Reff, Theodore. *Manet and Modern Paris.* Exhibition catalogue. Washington, D.C.: National Gallery of Art, 1982.

Rewald, John. *The History of Impressionism,* 4th ed. New York: Museum of Modern Art, 1973.

Richardson, John. *Manet.* Oxford: Phaidon, 1967.

Roos, Jane. *Early Impressionism and the French State.* New York: Cambridge University Press, 1996.

Rouart, Dennis, and Daniel Wildenstein. *Edouard Manet: Catalogue Raisonné.* Lausanne: Bibliothèque des Art, 1975.

Rubin, James H. *Manet's Silence and the Poetics of Bouquets.* Cambridge, Mass.: Harvard University Press, 1994.

Sandblad, Nils Gösta. *Manet: Three Studies in Artistic Conception.* Lund: C. W. K. Gleerup, 1954.

Tabarant, Adolphe. *Manet et ses oeuvres.* Paris: Gallimard, 1947.

Tinterow, Gary, and Henri Loyrette. *Origins of Impressionism.* Exhibition cata-
logue. New York: Metropolitan Museum of Art, 1994.

Wilson-Bareau, Juliet. *The Hidden Face of Manet: An Investigation of the Artist's
Working Processes.* Exhibition catalogue. London: The Courtauld Galleries,
1986.

———. *Manet: "The Execution of Maximilian"; Painting, Politics and Censorship.* Exhi-
bition catalogue. London: National Gallery, 1992.

Zola, Emile. *Edouard Manet: Etude biographie et critique.* Paris: Dentu, 1867;
reprinted in Zola, *Mes Haines.* Paris: Bernouard, 1928.

IMPORTANT CRITICAL STUDIES

Andersen, Wayne. "Manet and the Judgment of Paris," *Art News* 72, no. 2
(February 1973), 63–9.

Armstrong, Carol. "Manet/Manette: Encoloring the I/Eye," *Stanford Humani-
ties Review* 5, nos. 2–3 (Spring 1992), 1–46.

Bourdieu, Pierre. "Manet and the Institutionalization of Anomie," *The Field of
Cultural Production.* New York: Columbia University Press, 1973, pp.
238–53.

Carrier, David. "Manet and His Interpreters," *Art History* 8 (September 1985),
320–35.

Dunlop, Ian. "The Salon des Refusés (1863)," in *The Shock of the New.* New
York: American Heritage Press, 1972, pp. 10–53.

Egan, Patricia. "Poesia and the 'Fête Champêtre'," *Art Bulletin* 61, no. 4
(December 1959), 302–13.

———. "Manet's Bathers," *Arts Magazine* 54, no. 9 (May 1980), 124–33.

———. "Manet's 'Espada' and Marcantonio," *Metropolitan Museum Journal* 2 (1969),
197–207.

———. "Manet's 'Nymphe surprise'," *Burlington Magazine* 127 (April 1975), 244–9.

Fried, Michael. "Manet's Sources: Aspects of His Art 1859–1865," *Artforum* 7
(March 1969), 28–82.

———. "Painting Memories: On the Containment of the Past in Baudelaire and
Manet," *Critical Inquiry* 10 (March 1984), 510–42.

Haskell, Francis. "Giorgione's 'Concert champêtre' and Its Admirers," *Past and
Present in Art and Taste: Selected Essays.* New Haven: Yale University Press,
1987, pp. 141–52.

Hauptman, William. "Some new nineteenth-century references to Giorgione's
'Tempesta'," *Burlington Magazine* 136 (February 1994), 78–82.

Howard, Seymour. "Early Manet and Artful Error: Foundations of Anti-Illu-
sion in Modern Painting," *Art Journal* 37 (Fall 1977), 14–21.

Huston, Lorne. "Le Salon et les expositions d'art: réflexions à partir de l'expérience de Louis Martinet (1861–1865)," *Gazette des Beaux-Arts* 116 (July–August 1990), 45–50.

Hyslop, Lois Boe, and Frances E. Hyslop. "Baudelaire and Manet: A Reappraisal," in Lois Boe Hyslop, ed., *Baudelaire as a Love Poet and Other Essays.* University Park: Pennsylvania State Press, 1969, 87–130.

Jamot, Paul. "The First Version of Manet's 'Déjeuner sur l'herbe'," *Burlington Magazine* 58, no. 339 (June 1931), 299–300.

Krauss, Rosalind E. "Manet's 'Nymph Surprised'," *Burlington Magazine* 109 (November 1967), 622–7.

Krell, Alan. "Manet's 'Déjeuner sur l'herbe' in the 'Salon des Refusés': A Reappraisal," *The Art Bulletin* 65 (June 1983), 316–20.

Lajer-Burchart, Ewa. "Modernity and the Conditions of Disguise: Manet's 'Absinthe Drinker'," *Art Journal* 45 (Spring 1985), 18–25.

Lipton, Eunice. "Manet: A Radicalized Female Imagery," *Artforum* 13 (March 1975), 48–53.

Locke, Nancy. "New Documentary Information on Manet's 'Portrait of the Artist's Parents'," *Burlington Magazine* 133 (April 1991), 249–52.

Mesnil, Giacomo. "'Le Déjeuner sur l'herbe' di Manet ed 'Il Concerto campestre' di Giorgione," *L'Arte,* N.S. 5 (1934), 250–7.

Nochlin, Linda. "The Invention of the Avant-Garde in France: 1830–80," *Art News Annual* 34 (1968), 11–18; reprinted in Linda Nochlin, *The Politics of Vision: Essays on Nineteenth Century Art and Society.* New York: Harper and Row, 1989, pp. 1–13.

Nord, Philip. "Manet and Radical Politics," *Journal of Interdisciplinary History* 19, no. 3 (Winter 1989), 447–80.

Pauli, Gustave. "Raphael und Manet," *Monatschefte für Kunstwissenschaft* 1 (January–February 1908), 53–5.

Reff, Theodore. "Courbet and Manet," *Arts Magazine* 54 (March 1980), 98–103.

"Manet and Paris: Another Judgment," *Artnews* 72, no. 8 (October 1973), 50–6.

"Manet's Sources: A Critical Evaluation," *Artforum* 8 (September 1969), 40–8.

Shaw, Jennifer L. "The Figure of Venus: Rhetoric of the Ideal and the Salon of 1863," *Art History* 14, no. 4 (December 1991), 540–57.

Van Liere, Eldon N. "Solutions to Dissolutions: The Bather in Nineteenth-Century French Painting," *Arts Magazine* 54, no. 9 (May 1980), 104–14.

Wechsler, Judith. "An Apéritif to Manet's 'Déjeuner sur l'herbe'," *Gazette des Beaux-Arts* 91 (January 1978), 32–4.

Wildenstein, Daniel. "Le Salon des Refusés de 1863: catalogue et documents," *Gazette des Beaux-Arts* 66 (September 1965), 125–52.

Wilson, Mary G. "Edouard Manet's 'Déjeuner sur l'herbe'. An Allegory of Choice: Some Further Conclusions," *Arts Magazine* 54, no. 5 (January 1980), 162–7.

CONTEMPORARY CRITICISM OF *LE DEJEUNER SUR L'HERBE* AND THE SALON OF 1863 CITED IN THE TEXT

(For additional references, see Christopher Parsons and Martha Ward, *A Bibliography of Salon Criticism in Second Empire Paris.* Cambridge: Cambridge University Press, 1986.)

Astruc, Zachaire. "Le Salon de 1863," *Le Salon de 1863, feuilleton quotidien, no.* 16 (May 20, 1863), 5.

Auvray, Louis. *Exposition des beaux-arts. Salon de 1863.* Paris: A. Levy, 1863.

Bouniol, Bathold. "L'Amateur au Salon – Critique et Causerie," *Revue du Monde Catholique* (June 10, 1863), p. 383–94.

"L'Amateur au Salon (portrait sculpture). La Morale de ces Messieurs," *Revue du Monde Catholique* (July 10, 1863), pp. 592–5.

Bourgeois de Paris, un [Villemot, Auguste]. "Lettres d'un bourgeois de Paris: Salon de 1863," *La Gazette de France* (May 8, 17, and 29; June 6, 12, 19, and 27; July 4, 7, 11, and 21, 1863).

Bürger, W. (Théophile Thoré). "Salon de 1863," *L'Indépendance belge* (June 11, 1863); reprinted in *Salons de W. Bürger 1861 à 1868,* vol. 1. Paris: Librairie Internationale, 1870, pp. 424–5.

Brun, Charles. "L'Exposition des refusés," *Le Courrier artistique* (May 30, 1863), pp. 101–2.

Castagnary, Jules. "Le Salon de 1863, les Refusés," *Le Courrier du dimanche* (June 14, 1863), pp. 4–5.

"Le Salon des refusés," *Le Courrier artistique* (May 16, 1863), p. 1.

"Le Salon des Refusés," *L'Artiste* (August 1, 1863), pp. 49–52; (August 15, 1863), pp. 73–6; (September 1, 1863), pp. 95–7; reprinted in *Salons (1857–1870).* Paris: Bibliothèque Charpentier, 1892.

Cham. *Cham au Salon de 1863.* Paris: Martinet, 1863.

Cham au Salon de 1863 – Deuxième Promenade. Paris: Martinet, 1863.

"Promenades à l'exposition de peinture." *La Vie parisienne* (May 23 and 30; June 6, 13, 20, and 27; July 4 and 11, 1863).

Chesneau, Ernest. "L'Art contemporain," *L'Artiste* (April 1, 1863), pp. 145–9.

"L'Ecole française au Salon de 1863," *L'Art et les artistes modernes en France et en Angleterre.* Paris: Didier, 1864, 283–4.

"Le Salon de 1863," *Le Constitutionnel* (May 19, 1863).

"Le Salon des Refusés," *Le Constitutionnel* (June 1 and 5, 1863).

"Le Salon des Refusés," *L'Art et les artistes modernes en France et en Angleterre.* Paris: Didier, 1864, pp. 188–91.

Claretie, Jules [Jules Arsène Arnaud]. "Lettres familières sur le Salon de 1863," *Jean Diable* (June 6, 1863), pp. 494–5.

Cupidon, M. de [Charles Monselet]. "Les Refusés," *Le Figaro* (May 24, 1863), pp. 5–6.

Danban, C. A. *Le Salon de 1863.* Paris: Renouard Librairie, 1863.

Desnoyers, Fernand. *Salon des Refusés: La Peinture en 1863.* Paris: Azur Dutil 1863.

Du Camp, Maxime. "Le Salon de 1863," *Revue des deux mondes* (June 15, 1863), pp. 886–918.

Du Pays, A. J. "Salon de 1863 – La Mythologie et l'Allégorie," *L'Illustration* (May 20, 1863), p. 348.

Enault, Louis. "Le Salon de 1863," *Revue français,* vol. V (August 1, 1863), pp. 456–78.

"Le Salon de 1863," *La Gazette des étrangers* (May 24, 1863).

Etienne, Louis. *Le Jury et les exposants: Salon des Refusés.* Paris: E. Dentu, 1863.

Fillonneau, Ernest. "Salon des Refusés," *Moniteur des arts* (June 6, 1863).

Fournel, Victor. "Les Beaux-Arts en 1863. Le Salon – Salon des élus et Salon des refusés," *Revue de l'année* (1864), pp. 388–99.

Gautier, Théophile. "Salon de 1863," *Le Moniteur universel* (June 13, 1863), p. 863.

"Salon de 1863," *Le Monde illustré* (August 8, 1863), pp. 89–90.

Girard de Rialle, J. *A travers le Salon de 1863.* Paris: E. Dentu, 1863.

Graham, J. [Arthur Stevens]. "Un Etranger au Salon," *Le Figaro* (May 31, 1863), pp. 2–4; (July 2, 1863), pp. 4–5; and (July 16, 1863), pp. 3–4.

Gueullette, Charles. *Les peintres de genre au Salon de 1863.* Paris: Gay, 1863.

Guyot de Fere. "Salon de 1863," *Journal des arts, des sciences et des lettres* (May 8 and 21, 1863), pp. 56, 65–7; (June 3 and 19, 1863), pp. 73–6, 81–3; (August 2, 1863), p. 108.

Hamerton, Philip Gilbert. "The Salon of 1863," *Fine Arts Quarterly Review* (October 1863), pp. 225–61.

Houssaye, Arsène. "Variétés – Giorgione et Titien," *La Presse* (May 12, 1863), p. 1.

Lafenestre, Georges. "La Peinture au Salon de 1863," *Revue contemporaine* 33 (June 15, 1863), pp. 603–6 and 812–4.

Laverdant, Désiré. "Littérature et Beaux-Arts – Esprit du Salon de 1863 – Bilan de l'art après dix-huit siècles d'évangélisation," *Le Mémorial Catholique*

(August 1863), pp. 311–6; (September 1863), pp. 354–5; (October 1863), p. 392–5; (November 1863), pp. 428–34.

Lefranc, Aristide. "Le Salon de 1863," *Revue nationale et étrangère* (May 10, 1863), pp. 190–4; (June 10, 1863), pp. 314–32; (July 10, 1863), pp. 534–57.

Legrand, Géry. "Le Salon de 1863," *Revue du mois littéraire et artistique,* no. 7 (May 25, 1863), pp. 332–44.

Leroy, Louis. "Les Refusés," *Le Charivari* (May 20, 1863), p. 3.

Lockroy, Edouard. "L'Exposition des refusés," *Le Courrier artistique* (May 16, 1863), pp. 93–5.

"Salon de 1863," *L'Esprit publique* (April 29, 1863), p. 4; (May 24, 1863), p. 3; (May 31, 1863), p. 2; (July 17, 1863), p. 4.

Louvet, Arthur. "Exposition des Refusés," *Le Théâtre* (July 12 and 19, 1863), p. 2.

Madelène, Henry de La. *Salon de 1863.* Paris: J. Lecuir, 1863.

Mantz, Paul. "Exposition du boulevard des Italiens," *Gazette des Beaux-Arts* 14 (April 1, 1863), 380–3.

"Salon de 1863," *Gazette des Beaux-Arts* 14 (June 1, 1863), 481–506 and (July 1, 1863), 32–64.

Mennith, Courcy. *Le Salon des Refusés et le jury.* Paris: J. Gay, 1863.

Merson, Olivier. "Salon de 1863," *L'Opinion nationale* (May 2 and 9, 1863), pp. 1–2; (June 1, 6, and 20, 1863), pp. 1–2; "Les Refusés" (July 25, 1863), pp. 1–2.

Monchaux, Didier de. "Salon de 1863," *La Patrie* (May 16, 1863), 3.

"Salon de 1863," *La Patrie* (May 21, 1863), 2.

Monselet, Charles. "Les Refusés ou les héros de la contre-exposition," *Le Figaro* (May 24, 1863), pp. 5–6.

Montlaur, Eugène. *L'Ecole française contemporaine – Salon de 1863.* Besançon: Librairie Dodivers, 1863.

Nilda, Félix de. "Les Refusés," *Le Monde dramatique* (June 11, 1863), pp. 2–3; (June 25, 1863), pp. 3–4.

Paul, Adrien. "Beaux-Arts. Salon de 1863," *Le Siècle* (May 24 and June 3, 1863), p. 1.

"Salon de 1863: Les Refusés," *Le Siècle* (July 19, 1863), pp. 1–2.

Pelloquet, Théodore. "Salon de 1863," *L'Exposition* (July 2, 1863), pp. 1–3.

Pesquidoux, Dubosc de. "Salon de 1863," *L'Union* (July 10, 1863).

Pompilius, Le Capitaine [Carl Desnoyers]. "Lettres particulières sur le Salon," *Le Petit Journal,* no. 131 (May 3, June 1, 5, and 11, 1863).

Saint-Victor, Paul de. "Beaux-Arts: Salon de 1863," *La Presse* (May 10, 1863), pp. 2–3.

"Société des Acqua-fortistes. Eaux-fortes modernes, publication d'oeuvres originales et inédits," *La Presse* (April 27, 1863).

Sault, Charles de. *Essais de critique d'art: Salon de 1863*. Paris: Michel Lévy frères, 1863.

Stevens, Arthur. *Le Salon de 1863*. Paris: Librairie Centrale, 1866.

T., Louise. "Salon de 1863," *Gazette des dames et des demoiselles* (June 15, 1863), n.p.

Tremblay, Léon. "Un mot sur la question pendante au sujet de l'Exposition des Refusés," *Le Petit Journal* (June 8, 1863), p. 1.

Veron, Pierre. "Les Refusés," *Le Monde illustré* (May 30, 1863), p. 343.

Viel-Castel, Comte Horace de. "Salon de 1863," *La France* (May 10 and 21, 1863), pp. 1–2; "Les Refusés" (May 24 and 27, 1863), pp. 1–2.

Vignon, Claude [Naomie Cadiot]. "Salon de 1863," *Le Correspondant* (June 18, 1863), pp. 363–92.

INDEX

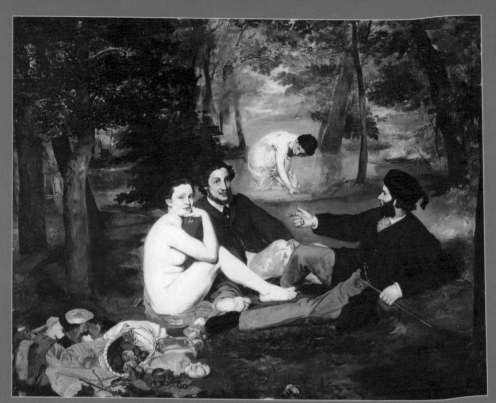

E DOUARD MANET'S controversial painting *Le Déjeuner sur l'herbe* is one of the best known images in French art. The subject of critical analysis for more than a century, it still defies singular interpretations. This book offers six different readings of the painting. Based on new ideas about its context, production, meaning, and reception, these essays, written specially for this volume by the leading scholars of French modern art, incorporate close examinations of its radical style and novel subject, relevant historical developments and archival material, as well as biographical evidence that prompts psychological inquiries. Shedding new light on the artist and the touchstone work of modernism, *Manet's "Le Déjeuner sur l'herbe"* also introduces readers to current method and the multiple ways this com

PAUL HAYES TUCKER is Profe
Art History at the University o
Massachusetts, Boston. He is t
Monet in the 90s: The Series Pai
and *Claude Monet, Life and Art*

Cover illustration: Edouard Manet, *L*
Photo: Courtesy Art Resource, New Y
Cover design: Jeffrey J. Faville